ARTS AND CRAFTS OF INDONESIA

Anne Richter

Special Photography by
John Storey

With 199 illustrations, 156 in colour

Thames and Hudson

To Robert, Louis and Jessica

Previous page A contemporary Balinese stone wall panel carved with a *widyadhari* (a heavenly nymph).

Printed and bound in Singapore by C.S. Graphics

CONTENTS

INTRODUCTION 7

JEWELRY AND METALWORK 25

CERAMICS 41

WOOD, BONE, HORN AND STONE 57

TEXTILES AND BEADING 89

EPHEMERA FROM PARADISE 113

MASKS AND PUPPETS 129

COLLECTING INDONESIAN ARTS AND CRAFTS 145

MAP AND GLOSSARY 154

BIBLIOGRAPHY 157

ACKNOWLEDGMENTS 158

INDEX 159

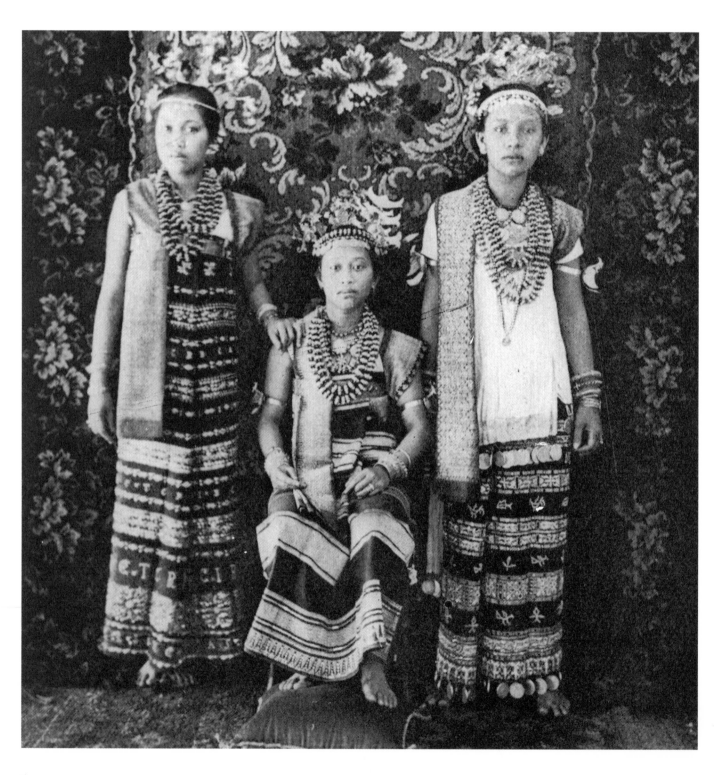

INTRODUCTION

Indonesia is an archipelago composed of a string of over thirteen thousand tropical islands stretching roughly three and a half thousand miles (more than five and a half thousand kilometres) along the Equator. It has the fourth largest population on earth, which is divided into over three hundred and fifty ethnic groups. A clearer view of its extraordinary diversity may be formed if it is notionally divided into inner and outer cultural and geographical entities.

In Java and Bali, the heartlands of inner Indonesia, the intricately terraced green rice fields have supplied substantial surplus wealth and supported glittering courts and vital traditions of orchestral music, dance and drama. Borobudur, the Buddhist mountain-mandala, and the Hindu temples of Prambanan in Java, are thought to be among the greatest works of religious architecture. Nevertheless, the courts, towns and villages of these islands have always existed in the threatening shadow of the blue, mist-shrouded volcanoes that rear above the fields and forests of the steaming lowlands. Perhaps it is the constant awareness of uncontrollable natural forces as the authors of both abundance and destruction that lends Javanese and Balinese art a vitality and purpose that has tended to dissipate in societies in which human achievements are no longer perceived to be so fragile.

The Islamic communities of coastal Sumatra, Kalimantan (Borneo) and Sulawesi (Celebes) share some of the historical and cultural experience of Bali and Java. The religious beliefs and artworks of inner Indonesia have been strongly influenced by cultural models from outside the archipelago. The islands formed a chain of entrepôts on the trade routes between the Middle East, India and China. For centuries, Indonesia's wealth in gold, gems, spices, camphor, aromatic woods, dyes, resins and balms brought Arab, Indian and Chinese traders to the archipelago, and sent local merchants to mainland Asia. Geographical location and nautical expertise enabled Sumatran and Javanese coastal kingdoms to control the sea lanes and international trade routes. Island emporia flowed with merchandise from all over the world; commodities and ideas were traded up and down the rivers between coastal and inland communities. Early Western chroniclers tell of 'Indies Fairs' at which goods from Java would be set out in splendid array on the shores of the eastern islands, and how the boats would return with the seasonal winds, replenished with new cargoes.

The gradual process of Indianization of Indonesia, which commenced in about the third century AD, seems to have been a result of spontaneous admiration for Indian religious thought, aesthetic traditions and styles of

Ornate headdresses, jewelry and gold embroidered *tapis* sarongs contributed to the lavish ceremonial costume of Lampung, south Sumatra, at the turn of the century.

kingship. The last Javanese Hindu empire, that of thirteenth-century Majapahit in East Java, was arguably larger than the republic of today. Its architecture and sculpture in bronze, stone and terracotta displayed a glorious and final flowering of Hindu tradition into a fully and distinctively Javanese style. The ideal of Majapahit, and its motto 'Unity in Diversity', now provides a political and cultural model for the modern state. The great Buddhist empire of Srivijaya, founded in the seventh century at Palembang, in South Sumatra, stretched as far north as Thailand; its wealth was founded on maritime commerce and the ability of its large ships to sail directly to India and China. Although Srivijaya left neither great monuments nor the survival of Buddhist religious practice, it did bequeath an entrepreneurial culture orientated toward the Southeast Asian mainland and the world beyond coastal Sumatra.

The coming of Islam to the archipelago was also largely the result of voluntary identification with the religious culture of Islamic India and the Middle East that was brought by merchants, and by the end of the thirteenth century, Aceh, in north Sumatra, was thoroughly Islamicized. In Indonesia, Hindu-Buddhist and animist beliefs fused easily with a style of Islamic observance that had already been transformed by Indian and Persian Sufism and the syncretic traditions of Mogul India. Brilliantly coloured Indian textiles from Gujarat were traded throughout the archipelago and served as models for local textile design; their influence is still apparent today. Chinese merchants brought rich silks and porcelain. The splendour of the embroidered court dress of imperial China, which was used as ceremonial costume by expatriate Chinese communities, also played an influential role in the textile traditions of Indonesia. Immigrant craftsmen introduced Chinese motifs into metalwork and pottery as well as new forms of furniture. Portuguese spice traders and later the Dutch colonists left a legacy of Christianity and European style in popular song, costume, furniture and architectural design.

Indonesian societies were by no means passive receptors of foreign cultures. The multiplicity of imported goods and religious, political and intellectual concepts carried by waves of immigrants, priests, traders, missionaries and colonial officials fused with the ancient cultural ideals brought from the Asian mainland in prehistoric times by the ancestors of most modern Indonesians. The majority of Indonesian languages derive from those of the Austronesian seafarers who established ancient settlements throughout the islands which were to extend eventually from Madagascar to the Pacific islands. The Dong-Son civilization of North Vietnam and southern China, with its sophisticated technologies of bronze-casting, weaving with tie-dyed threads and wet rice agriculture, had spread to the archipelago by the second century BC. The erection of megaliths, stone monuments and sarcophagi was widespread in the archipelago and continued until comparatively recently. On the island of Sumba, in Nusa Tenggara, massive memorials in stone are still built, and today the Batak people of North Sumatra construct portrait sculptures of their dead in cement.

The artistic styles and belief systems of these earlier civilizations are very much a part of the Indonesian world-view today. This is particularly so in those parts of the archipelago that were distant from the coastal courts and trading centres of inner Indonesia. Inland and mountain-dwelling societies, like those of the Batak in North Sumatra, the Toraja of Sulawesi, and the various Dyak

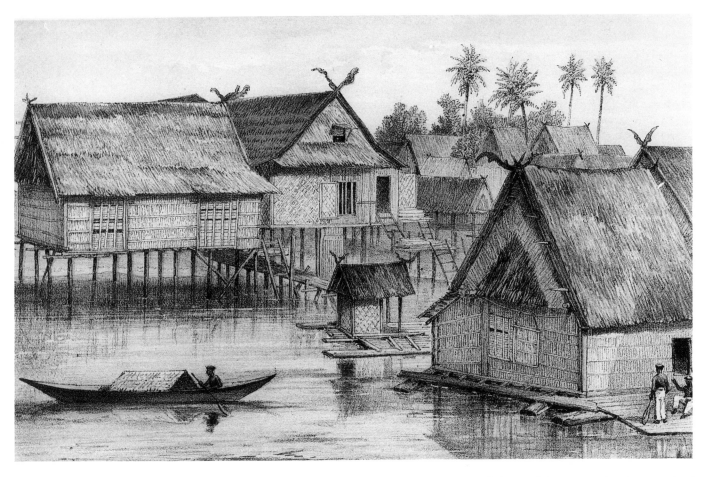

Tenggarong, capital of the Kutai kingdom on the Mahakam river in East Kalimantan (Borneo), in the nineteenth century. Rivers transported imported prestige goods and cultural influences inland.

communities of inner Kalimantan, as well those of the outer-island societies of Nusa Tenggara and parts of Maluku, retain many ancient beliefs. In contrast to the delicate gold jewelry, batiks and shiny silks preferred by coastal and Islamic communities, the costume of outer-Indonesian societies has consisted of splendid cotton textiles dyed with intricate and dynamic patterns, barkcloth, colourful beads, ivory and shell ornaments and bold metal jewelry. Their traditional architecture and styles of ornament on utilitarian and ritual artworks are not the same; however, they do share a very obvious relationship which derives from a common heritage of thought and similar interpretations of the nature of the world.

Southeast Asian animist cosmologies contrast the upper and lower worlds of spirit and instinct, male and female, light and darkness, sun and moon, air and water. Imagery in art reflects the structure of the layered cosmos. Birds inhabit the upper world of intellect and spirit; the realm of gods and ancestors. Reptiles symbolize the lower world of fertility, instinctive energy and supernatural forces which may be not only creative, but also demonic. Human beings occupy the space between the upper and lower worlds, and in order to prosper, must draw on the strengths of both. The horned water buffaloes that plough the rice fields represent fertility and self-defence; horses and deer symbolize nobility and male power. Ancestral figures and ships summon the protection and intervention of the spirit world and the authority of the past. Fantastical composite creatures

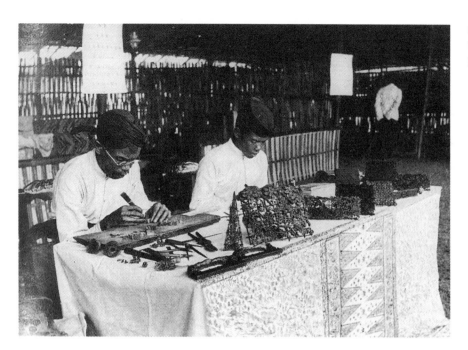

Coppersmiths in Batavia (Jakarta) early this century making the metal stamps for producing *cap* (hand-printed) batik.

that combine the features of birds, reptiles and warm-blooded beasts confer protection and good fortune. The function of this art is to represent and invoke the unity of differing realms to create cosmic balance and beneficence. Consequently the image of the married couple (pl. 1) and the frequent pairing of masculine and feminine motifs evokes a more complex response than it might in the West ... In Indonesian art the unity of male and female is a powerful symbol of the ordered universe rather than a subject of sentimental interest. In the animist world of equal and opposing opposites, the status of women and wife-giving families was naturally high, and consequently the arts of women have never been perceived as merely domestic or decorative, nor has the distinction between arts and crafts, which is often drawn in the West, been of great importance in Indonesian thought. In cultures as far apart as those of Kalimantan and the eastern islands of Nusa Tenggara, weaving has been described as the war-path of women; the equivalent in social value and glory to the male pursuit of head-hunting.

In some respects, aspects of these ancient, but persistent, patterns of thought resemble the Chinese concepts of Yin and Yang. They also account for Indonesian attitudes towards the materials from which art and craft works are made, and the role that gender plays in production. Substances or objects that are considered to be naturally hard, or hard and hot, are thought of as male; these include metal and wood, which are traditionally worked by men. Those that are cool and soft, like cloth and unfired pottery, are the province of women. In conservative batik-making villages, blue indigo dye, which is derived from soft leaves, is prepared and stored in earthenware pots; the hard bark chips of the *soga* tree that produce a brown dye are kept in metal containers.

In animist thought, there is little distinction between the abstract and the concrete, or between what is living and what, according to a scientific interpretation of the world, is not. Consequently, houses, boats, weapons, masks

Wooden sculptures of crowned and bejewelled aristocratic ancestors from Nias island, to the west of Sumatra.

Iban Dyak weavers of inner Kalimantan working on backstrap looms at the turn of the century.

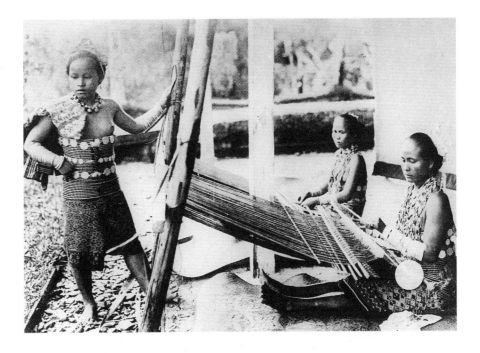

and puppets are believed to interact and pulse with the potentiality of life. Textiles are not seen as mere items of clothing, but as essential equipment in ceremonies performed to invoke agricultural and human fertility; they also offer magical protection to wearers at times of transition and danger. The use of earthenware vessels is integral to important ceremonies; and the lore associated with trees and other plants used in homes, boats and other utilitarian items, is rich in symbolism. Abstractions, such as power and sometimes even love, are perceived as dynamic forces that act quite independently of their subjects or objects; they must, therefore, be consciously and deliberately attracted and invited to dwell in people and in such items as weapons.

Despite the relative predominance of ancient beliefs in outer Indonesia, they are by no means restricted to these regions, nor are the influences of foreign cultures only found in the more cosmopolitan coastal regions. In Indonesia, the practice of Islam, Hinduism and Christianity has tended to co-exist with animist belief, and the same clusters of ideas are found throughout the archipelago, but are expressed in different ways. In Java and Bali, the nexus between reptiles, water, earth, fertility and femininity is linked to the Hindu goddess of agrarian fertility, Dewi Sri, or to Ratu Kidul, the Javanese goddess of the Southern Ocean. In Dyak societies in Kalimantan, a version of the Chinese dragon is described as a dog. It is, nevertheless, associated with the reptilian goddess of the underworld. In the mountains of South Sulawesi, in Sumba and elsewhere, water buffalo are sacrificed to honour the dead in funerary rites, and in the ground-breaking ceremonies that precede the construction of the gleaming new hotels and banks of Bali, offerings of buffalo heads are made to propitiate the earth spirits.

The vitality of Javanese and Balinese dance, drama and shadow and puppet theatre partly derives from a blending of the power of religious ritual with the narrative richness of the Hindu epics and lively Islamic tales. The *Mahabharata* and the *Ramayana* were, and still are, an important source of inspiration in

mystical thought and folk lore, not only in Hindu Bali, but also in Islamic Java, where the vast majority of Indonesians live. Despite the frequency of radio and television broadcasts of traditional drama and its ready availability in audio and video cassette form, village performances are common at times of communal crisis and on the happier occasions of holidays, harvest time and celebrations of births, circumcisions and marriages. Traditional drama is thus intimately bound up with the material and spiritual wellbeing of ordinary people, and the work of dancers, puppeteers, mask- and puppet-makers continues to be highly valued. Spectacular dance performances are sponsored by the royal courts and ASTI (the Indonesian Academy of Dance) in Central Java, and in the countryside and towns travelling players and village communities perform folk versions of courtly drama. Plays and trance dances are often performed by people who usually work as agricultural labourers or craftsmen. The music of Javanese and Balinese orchestras, which are composed of drums, gongs, metallophones, lutes and flutes, enchanted Western composers at the turn of the century; Debussy compared it to moonlight and flowing water.

In Bali, young children learn to dance and play musical instruments, so that by the time they reach adulthood, they are accomplished performers and seasoned critics. A peasant farmer is expected to be able to play a flute or gong well, or be capable of dancing with at least some grace, if not excellence, in a traditional drama. In Indonesia, artistic accomplishment has been regarded

At the royal courts of Java, elaborate dance spectacles and sacred performance were accompanied by gamelan music.

traditionally as a normal and essential pre-condition to full membership of the community. It is through the making of art that a complete and adult understanding of social and religious thought can best be expressed. In many parts of Indonesia, girls were required to weave fine cloths to indicate their preparedness for marriage and responsibility, and this expectation survives, in part, today. A contemporary Iban Dyak song tells of a rather pert modern girl's attempt, despite her failure to take much heed of weaving lessons, to prove her maturity by producing a magnificent textile. Female deities and ancestors come to her aid and transmit the essential knowledge in dreams. She is thus able to complete a cloth embellished with complex motifs and powerful symbols and convince her incredulous elders of her readiness for her suitor. In the past, the ability to create objects of beauty and significance was also thought to demonstrate fine character and fitness for high office. The *Raja Kapa-kapa*, a medieval Javanese guide to the administration of the state and justice, recommends excellent horsemanship, the ability to handle an elephant and a profound knowledge of music and historical, legal and religious texts as essential qualities for a ruler. These accomplishments are only to be expected; however, the text also contains an unusually long list of artistic skills thought to be obligatory ornaments to social position: painting, carving in wood, iron-work, gold-work, musical instrument making, kris-sheath making, literary composition, sewing with a needle, jewelry, gilding and the application of quicksilver.

Chinese merchants and immigrant artisans contributed to the stylistic development of Indonesian art forms and the diversity of urban life. A Chinese street musician in Batavia.

Indonesian artists and craftsmen draw on a complex and yet coherent body of artistic traditions and techniques. They are exceptionally curious, receptive and creative, and their remarkable ability to absorb, blend and transform new ideas and images has long been a source of great strength in design. Their eclectic approach is not a thing of the past, but is very much a continuing process. The coastal cities still have resident communities of Indian and Arab merchants who deal in modern versions of the goods their ancestors traded four hundred years ago. Colourful Chinese temples and high-walled houses cluster together as they have for centuries. The silk weavers of Samarinda in East Kalimantan, who originate from South Sulawesi, now incorporate up-river Dyak motifs into their designs; some women in Timor and Sumba, impressed by metallic decoration on textiles from other parts of Indonesia, now incorporate gleaming silver threads when weaving their cotton cloths. Balinese craftsmen have an unerring ability to select those elements of contemporary Western fashion and popular culture that will most successfully combine with their own sense of aesthetics and humour.

The establishment of the Republic of Indonesia in 1949 and major improvements in mass communications, transport, education and general standards of living over the last two decades have had a major impact on widely scattered traditional societies and the meaning and purpose of artistic expression. Many outer-Indonesian societies, such as those of Nias, Sumba and Toraja, and those of the Dyak in Kalimantan, were slave-holding aristocracies until the late nineteenth century, and, in some cases, until well into this century; textiles and jewelry articulated social distinctions which are now in a state of flux. The wearing of gold jewelry and the magnificent handwoven cloths that speak of ancestral nobility and power, spiritual riches and mastery over enemies is still valued as an expression of high social standing, but it is increasingly less

important than the possession of a formal education, a successful business or a permanent job in the civil service or the army. This extract from an elegy from the island of Nias eloquently expresses the emotions experienced as a result of such social dislocation:

The earth is topsy turvy,
the world is standing on its head.
The noble is impoverished,
princes live from hand to mouth.
We float on as driftwood,
The shores of the firmament have flown
 up like a bat,
swirled past like a whirlwind.

When the earth was young
you remember how fine our ornaments were?
Glittering necklaces have dulled,
The world is on the point of going under.

People of humble origin have moved to the towns or to other islands in search of educational and economic opportunities. Those who are successful are able to provide handsomely for the refurbishment of the family home back in the village, or to contribute generously to grander celebrations and ancestral memorials. Families that in the past could neither afford, nor would have presumed, to deck their brides with lavish gold wedding jewelry, now order new finery or rent it from the aristocracy. In Bali, family and clan histories are being rewritten on palm leaf manuscripts to accord with new-found wealth and status. Indonesian television commercials not only show prosperous families surrounded by modern gadgets, but also show them in settings of the splendid traditional furniture that was once only available to the nobility. The clothing and appurtenances of the upper classes of the past have become symbols of ethnic identity and success for the whole community.

Conversion to world religions, particularly Christianity, has, in some communities, meant a permanent and tragic loss of some types of ritual art; in others, it has led to the development of new forms of expression. Kenyah Dyak sculptures of the crucifixion may be among the most vital examples of Christian art being made today.

Tourism is often thought of as having an especially destructive effect on the arts and crafts of traditional societies, but this need not always be the case. The influx of visitors to Bali has made many islanders acutely conscious of the value their traditional culture has for outsiders, as well as for themselves. This awareness has, to some extent, provided them with immunity from the loss of cultural self-confidence so often experienced in societies subjected to rapid social change. In Bali, the frequency of dance performances and the lavishness of ritual celebrations has, if anything, increased with the ability of communities and families to fund them.

For the Batak carvers of Lake Toba, in North Sumatra, and the gifted weavers of East Sumba, in Nusa Tenggara, the production and sale of traditionally styled works is an important source of income. It is also a way of

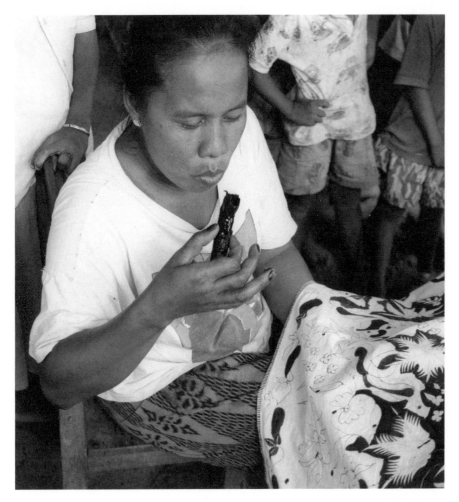

A batik-maker blows congealed wax from the hollow nib of her *canting* (wax-drawing pen) in the village of Tanjung Bumi, Madura.

gaining cultural recognition from others in a world in which the same television dramas are viewed all over the planet and even Dyak tribesmen paddling dugout canoes wear fake Lacoste T-shirts. Traditional arts and crafts forcefully communicate local cultural ideals to outsiders, whether they are officials from Jakarta, the burgeoning number of upper- and middle-class tourists from within Indonesia, or international visitors.

The Indonesian government is sensitive to cultural diversity and places a high value on the preservation of regional arts and crafts. Textile techniques, ceramics, music, dance and drama are taught in schools and in some cases in specialized tertiary institutions. Nevertheless, most items continue to be made as a matter of course, just as they have been in the past. Many are produced for utilitarian reasons, to embellish and sanctify everyday life and as offerings to the gods. Children are taught art and craft skills at home as a natural part of growing up. Wooden sculptures and furniture are well carved; baskets and containers are ingeniously constructed from a variety of tropical plant fibres, and pottery is made with a simplicity and sincerity that is entirely absent in mechanically produced wares. The old court centres retain their excellence in mask- and puppet-making, in the production of particularly luxurious textiles and in

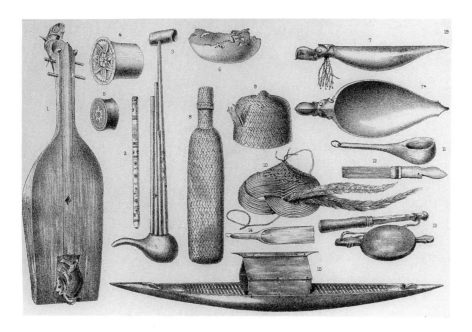

Dyak musical instruments, domestic utensils and a canoe. These are nineteenth-century examples, but similar items are made today.

working fine and base metals. Traditional and modern jewelry, daggers, musical instruments and bronzes are still made by hereditary smiths. In outer Indonesia, handwoven and naturally dyed cloths are easily among the finest available in the world today. The handiwork of urban and rural craft workers and folk artists who make naive toys, bird cages or simple kitchen utensils displays a delightful vitality and, on occasions, considerable wit. In remote parts of Indonesia, such as Irian Jaya (West New Guinea) and parts of Kalimantan and Maluku, people live in tribal societies; on them, the influence of the modern world is, as yet, comparatively superficial. Artistic energy is directed towards the decoration of ritual objects and utilitarian items such as costumes, canoes, food bowls and hunting and fishing equipment.

In Indonesia, the aesthetic traditions of great prehistoric cultures and the Eastern and Western civilizations of the ancient and modern worlds all find expression in objects being made today. This book is but an introduction to the extraordinary diversity, skill and creativity of Indonesia's contemporary artists and craftsmen.

1 Painted earthenware money boxes shaped as the *loro blonyo* (inseparable couple). They represent Dewi Sri, the Hindu goddess of agrarian fertility, and her consort Sadono. Their presence in the home brings the blessings of a happy marriage, fertility and prosperity. Yogyakarta, Central Java. H approx. $12\frac{1}{4}''$ (31 cm).

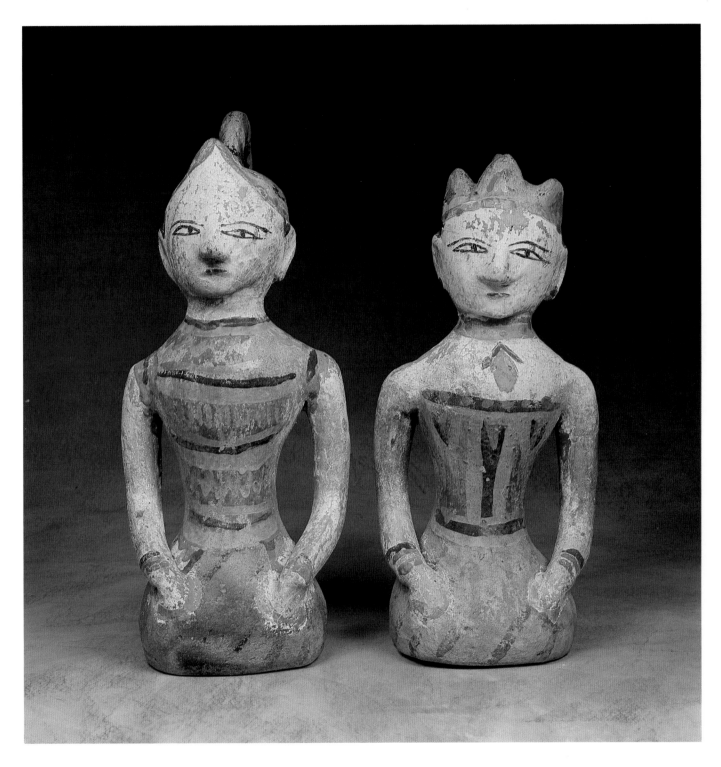

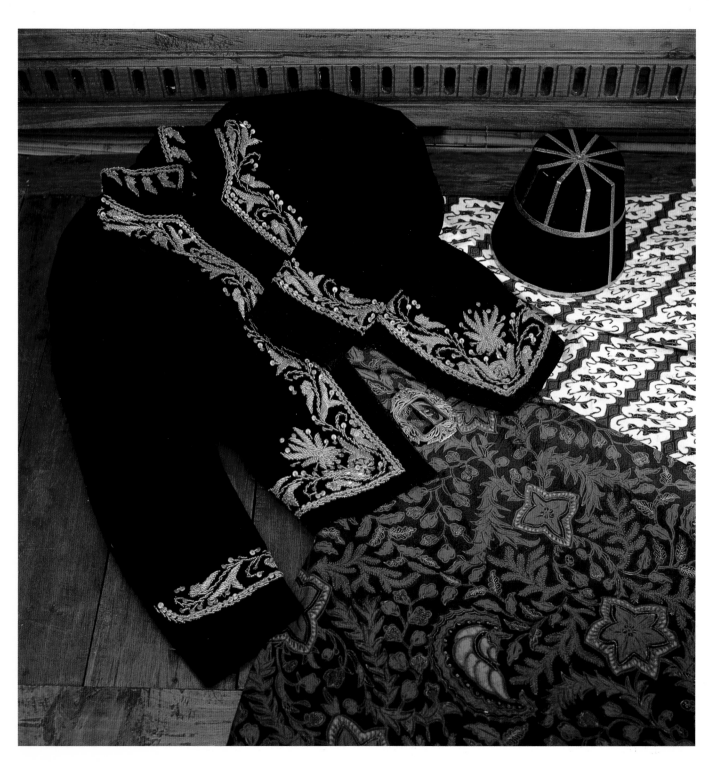

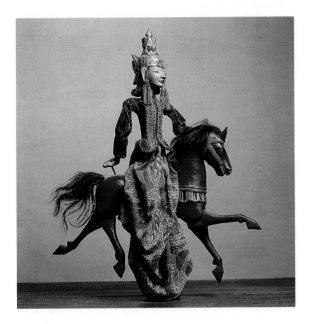

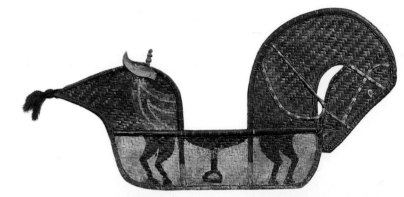

2 *Opposite* The bridegroom's velvet sequined and embroidered jacket, the *kuluk* (hat), and the darker batik *kain* (waist-cloth) are from Surakarta, Central Java, and are the traditional costume of royalty; the light batik is from Yogyakarta, also in Central Java. The patterns on both are drawn by hand and coloured with blue indigo and brown *soga* natural dyes. At most modern weddings, the bridegroom changes from these clothes into a costume similar to that seen in plate 45 for the reception.

3 *Above* Wayang golek (rod puppets) of a mounted central Javanese princely hero from historical cycles or of the noble character, Wong Agung Jayagrana (Amir Hamza) from the adventurous Islamic Menak cycle of puppet plays. Softwood, acrylic paint, horsehair, cloth and beads. Sentolo, near Yogyakarta, Central Java. H 21¾" (55 cm).

4 *Above right* A hobbyhorse for riding in the *kuda kepang* ensemble trance dances performed in the countryside and in towns in Java. Painted bamboo and rattan. Ponorogo, East Java. L 51½" (131 cm).

5 *Right* A Central Javanese rod puppet of a princess, a Balinese carved and painted architectural panel depicting a festive procession, an old Indian silk cloth and a Chinese screen. The mask, carved and painted head and decorative mirror frame are Balinese. The coiled rattan basket below is from Lombok.

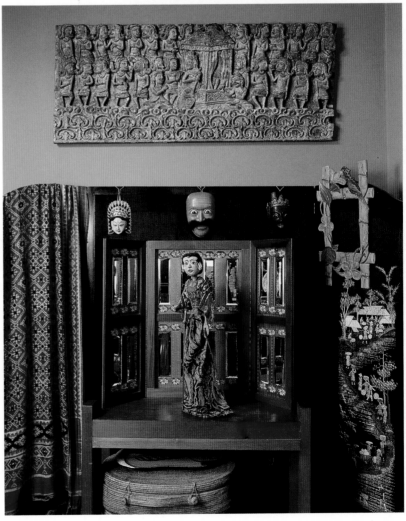

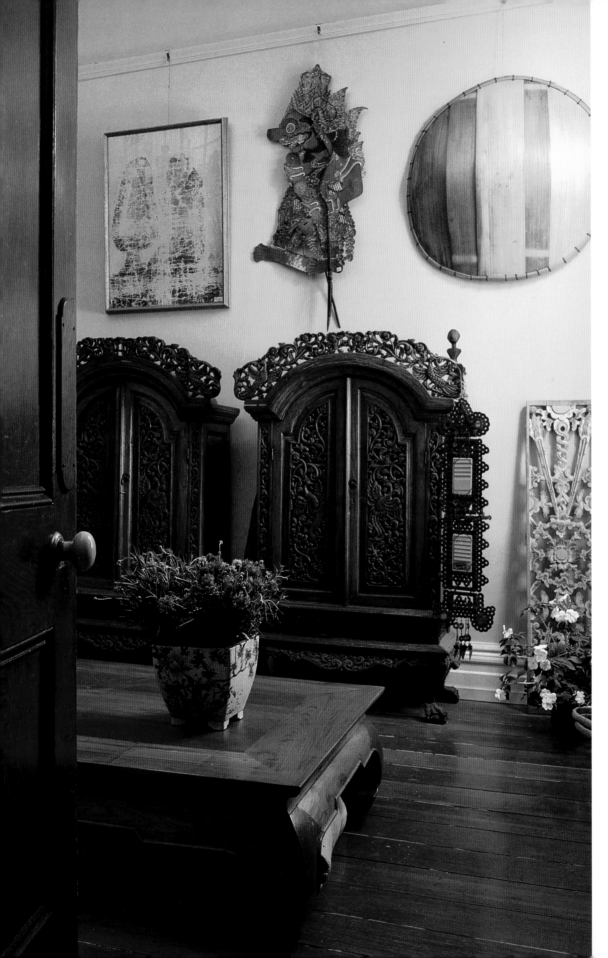

6 These finely carved
cupboards were
collected in Yogyakarta,
Central Java, and the
low, Chinese-inspired
table was made in
Gresik, East Java.
A large leather puppet
is hanging on the wall
with a rice tray which
can also serve as an
umbrella. To the right
of the cupboards is a
Balinese *lamak* (temple
altar hanging) made
with old Chinese coins
and a carved and
painted Balinese
architectural panel.
The blue and white
jardinière was imported
from China.

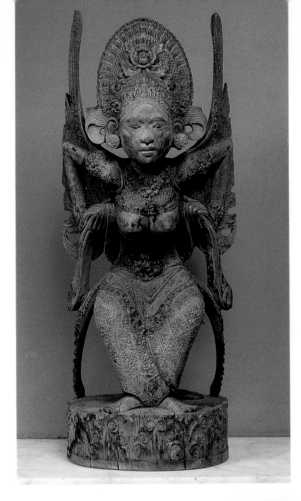

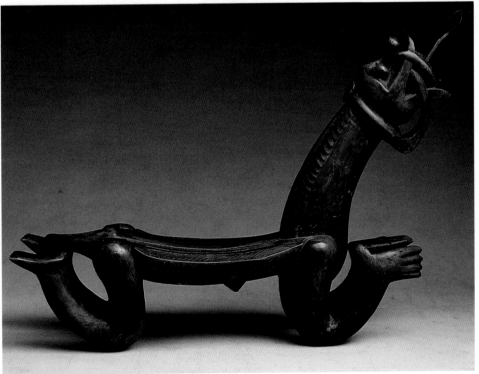

7 *Above* Traditional wood-carving of a *widyadhari* (heavenly nymph), carved in the Gianyar district of Bali. H 13¾″ (35 cm).

8 *Above right* A carved wooden box for *sirih* (betel ingredients) with separate sections for the lime and spices mixed with Areca palm nuts (betel) and leaves required to make a mildly intoxicating chewing plug. Sumenep, Madura. L 8¾″ (22 cm).

9 *Right* The form of this wooden work stool from the island of Nias, to the west of Sumatra, is based on the ceremonial stone seats of the nobility and is carved in the shape of the mythical beast, the *lasara*, that combines the anatomy of a deer, crocodile, hornbill and tiger. The notched iron tongue is used to scrape out the meat from a halved coconut. 20½″ × 13¾″ (52 × 35 cm).

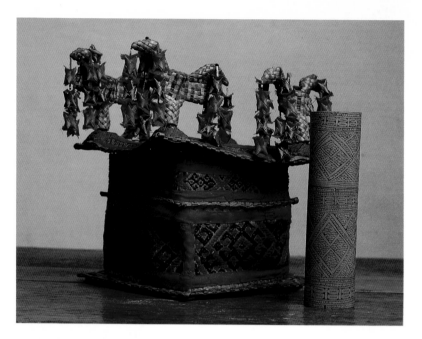

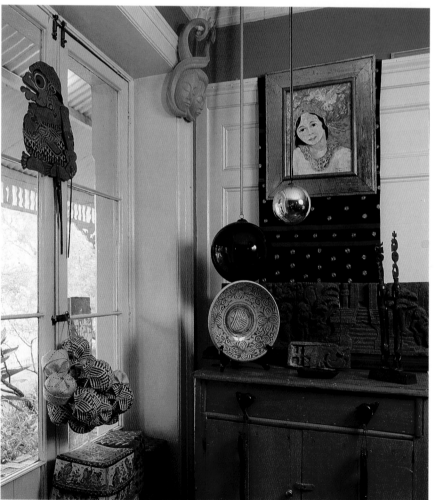

10 *Above* Horses and streamers made from dyed leaves of the *lontar* palm (*Borassus sundaicus*) decorate a basket from central West Timor used for serving betel (*sirih*) in the home and at weddings. Chewing plugs and ingredients are placed in the basket, and lime, an essential active ingredient, is offered from the etched bamboo cylinder. Panels of cotton embroidery and commercial cloth provide additional decoration. H 11″ (28 cm).

11 *Left* This painting of a *legong* dancer is by the Balinese painter Nunu, and the non-traditional paired masks to the left were carved by Ida Bagus Oka in Mas, Bali. The dark *tapis* cloth with embroidered gold disks is from Lampung, South Sumatra. A frieze of old Javanese terracotta tiles provides a background to a Madurese betel box and a pair of Timorese carved wooden marriage figurines. The paired hooks hanging from the cupboard are from Sumba.

12 *Opposite* These decorative boxes are shaped like the traditional houses of the Islamic Sasak communities of Lombok, Nusa Tenggara. They are constructed with split bamboo, palm leaves, wood and bark and are decorated with *nassa* shells. The roof, which is a separate storage compartment, forms the lid. H 28¼″ (72 cm).

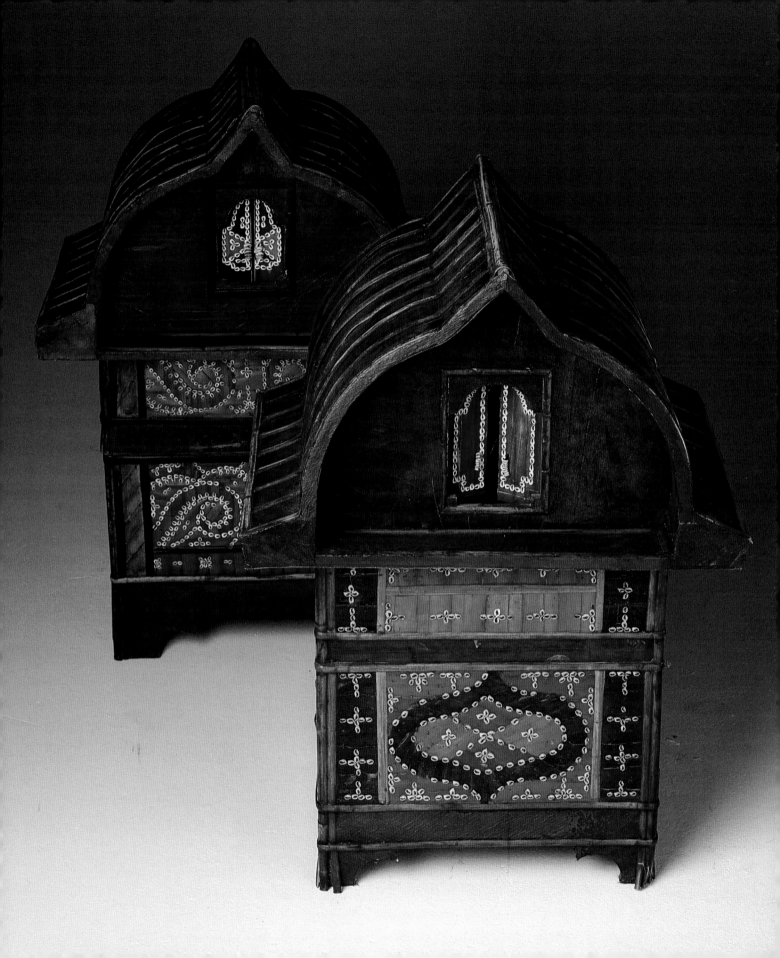

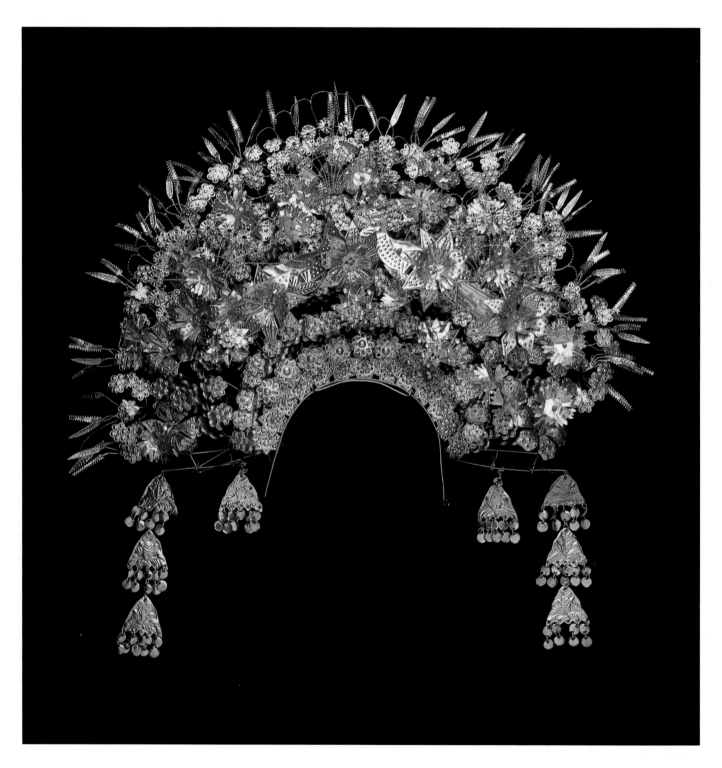

JEWELRY AND METALWORK

In Hindu cosmology, the triple peaks of Mount Meru, the abode of the gods and centre of the world, are made of gold, silver and iron. This belief and Islamic and Southeast Asian animist thought combine to imbue these metals with supernatural significance. Gold symbolizes superior moral and spiritual status and the majesty of Hindu kingship. In the aristocratic animist societies of Nias, Toraja and Nusa Tenggara, the wearing of gold and gold-coloured ornaments was reserved for the nobility. Iron forms a barrier against malevolent influences and keeps wayward spirits in their appropriate realms. A piece of iron might be buried under the centre post of a new house, or included in offerings to keep disturbed earth spirits down in their proper place; a nail might be hidden in the corner of a rice field to bar marauding insects. Protective gold, silver and iron objects are used in ceremonies held for new boats.

The skill of the master smith in forging and transforming metals serves as an analogy for the creation of the world and humanity. When Allah first attempted to create man, the clay manikin exploded; Adam was made from clay mixed with iron. In Torajan legend, the creator, Puang Mata, forged the heavens, earth, cool water, fire and mankind. Similar beliefs are expressed in Iban Dyak poetry :

> Behold him who forges expertly, Selampeta,
> Him who shapes men deftly, Selampandai!
> Diligent women he tempers in a trough of heartwood
> So they will be able to weave beautiful baskets
> Brave men he tempers in a trough of iron
> So their courage will remain steadfast unto death.

Smiths were held in awe for their spiritual power and specialized knowledge. The Indonesian word *pandai* means not only 'smith', but also 'clever'; by definition smiths are set apart from ordinary men. Generally, it is *pandai* who panel beat smashed cars and motorcycles. The clan of Balinese smiths who consider themselves direct descendants of Brahma, the fiery Hindu god, maintain their own temples and marry within smithing families.

In the past, ironsmiths were armourers and forged the weapons on which the military power of empires and the political survival of kings depended. Of all weapons, the kris has entered Indonesian cultural fantasy at its deepest levels. It is a long dagger with a blade that is either straight or formed with a number of curves like a wavering flame or a serpent. There are regional variations in hilts, blade forms and names for the class of Indonesian stabbing weapons to which the kris belongs. Some blades are composed of welded layers of iron and nickel,

13 Sumatran bridal crown decorated with flowers, birds and leaves attached to wire springs so that they tremble and sparkle. Such crowns are worn in West Sumatra by Minangkabau brides and also in Aceh. They are made of copper alloy, tin and wire. Collected in Padang, West Sumatra. $20\frac{7}{8}'' \times 15\frac{3}{4}''$ (53 × 40 cm).

beaten and folded many times to obtain bright and dark patterns. These become visible when the blade is finally polished and treated with citrus juice and arsenic. The damascene or *pamor* finishes on blades are given poetic titles such as 'sea sand', 'golden rain' and 'newly-sprouting tree trunk'. Names of blade shapes are derived from proverbs, episodes from the Hindu epics, natural phenomena (such as orchids, clouds in the sky or coconut milk) and the number of curves in the blade.

A kris should be selected very carefully and intricate numerological calculations made to ascertain that it will fit the hand of its owner and is appropriate to his station in life; otherwise it may turn against him. Magic krises sigh for blood, shrivel and kill plants and animals in their vicinity, and fly invisibly through the air to wreak anonymous destruction on the enemies of their owners. Even now, the krises in the royal collection at Surakarta (Solo), in Central Java, are reported to have a marked, but harmless wanderlust.

Fine krises, possibly with modest magical properties, can be commissioned from the smiths at Gatak, Sumberagung, Moyudan, near the court centre of Yogyakarta, and Komlang, near Surakarta. Ciwidey, in West Java, and Kusamba, in Bali, are also kris-making centres. It takes at least ten days to make a simple, but genuine kris. In the main square of Surakarta, kris-sellers sit carving hilts by their racks of weapons, while parties of young men amuse themselves discussing those on offer. Specialist dealers sell old krises with hilts and scabbards ornamented with exquisite gold and silver scroll-work, ivory, rubies, rare woods and demon-, deity- and bird-shaped hilts. Imitation krises are simple daggers of a correct shape made without essential rituals or special care; these are sold in the markets.

Krises are now an integral part of formal male costume and are no longer used as weapons. In Bali, special offerings are made to the kris on the day of Tumpek Landep, when sharp metal objects such as knives and scissors are honoured, and cars and bicycles, which are placed in the same category, are festooned with colourful palm leaf decorations.

Parang, another important group of Indonesian weapons, are cutlasses. The Dyaks of inland Kalimantan are highly respected swordsmiths. Their finest *parang* are used ceremonially, but the plainer ones serve a variety of practical domestic purposes such as slaughtering animals, slashing vegetation and splitting coconuts in half with a single blow. Earlier this century, *parang ilang* or *mandau* were used for head-hunting. The individual qualities and histories of *parang*, like those of krises, are the subject of legend and song:

This sword is made of poisonous steel
The treasure of the past
Honoured by blood many times
By fighting wildly it became famous.
This special steel has been
Carried along rivers,
Never abandoned, morning or evening.
Body protection everywhere.

Iron was extracted from jungle mines until comparatively recently, but now Kenyah Dyak swordsmiths forge *parang* from scrap metal obtained from truck

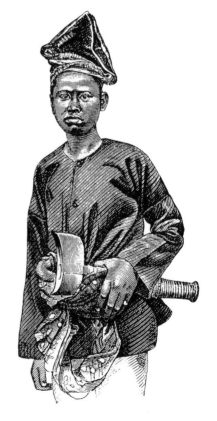

This nineteenth-century young man from Gorontalo, in North Sulawesi, wears a kris as an essential part of his costume.

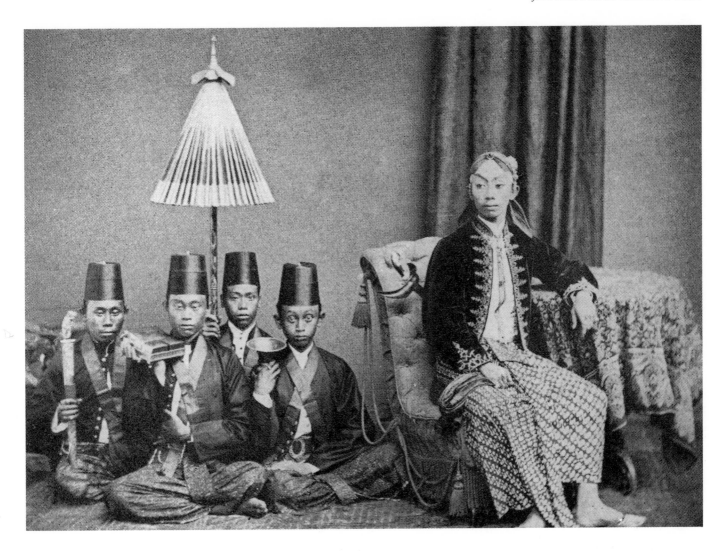

Javanese royalty and members of the nobility had a retinue of servants to bear essential personal accoutrements, such as an additional kris, a parasol and finely worked metal containers and equipment to use with betel and tobacco.

springs, broken tools or disused logging machinery. The blade is beaten and folded and hardened in cold river water. Social status is equated with spiritual strength, and the dangerous and potentially debilitating work of forging important ceremonial *parang* is largely restricted to aristocrats. The equipment employed by these Dyak smiths is similar to that used elsewhere in Indonesia. Cylindrical bellows several feet tall are made from a pair of massive hollow bamboos fitted with feather-lined pistons. Air is sucked in when the pistons are pulled up from above by the smith's assistant; when they are pushed down, oxygen is forced into the fire through nozzles at the bottom.

Ironsmithing is usually practised in cohesive craft communities in which each household specializes in making particular kitchen and agricultural implements, or knives, daggers and swords. A dim, slatted shed, with a pit of coals and an earthen floor caked with ash and charcoal, serves as a forge. Wives may assist by operating the bamboo bellows, but women do not usually forge or work on iron itself. At local markets, the smiths display their chopping, digging, scraping and grating implements or spread out plain or ornamental, straight or curved steel-bladed knives and cutlasses.

Ironsmiths also ritually forge the long blades that are attached to the legs of cocks in the fights that are of consuming interest to men in the countryside in many parts of Indonesia. In Bali, cock fights serve a sacrificial and propitiatory function, as well as providing an opportunity for passionate gambling. Men pass the heat of the afternoon in languid conversation and endlessly massage and play with their handsome birds so as to alternately soothe and stimulate aggression.

The religious art of the great Buddhist and Hindu kingdoms and empires of Java and Sumatra, which prospered and waned between the eighth and fifteenth centuries, was guided by Indian traditions in stone and bronze. Magnificent bronzes of Buddha and the Hindu deities, vases, gargoyles, sacred bells and hanging lamps were cast in Indonesia. The last of the great Javanese Hindu empires was Majapahit in East Java, which reached its apogee in the fourteenth century and disintegrated towards the end of the fifteenth under pressure from neighbouring Islamic principalities. The villages of Mojoagung and Trowulan, in East Java, are built amid the widely scattered ruins of the Majapahit capital. In Mojoagung, the yards of houses and foundries are filled with phalanxes of bronze hippopotamuses, rhinoceroses, prancing horses, toads with teeth, crowned *nagas* (dragon-serpents) and the waisted drums that form an essential part of the bride price on the distant island of Alor, in Nusa Tenggara.

In Mojoagung, young men sit at veranda tables shaping sheets of hard wax into models; these are filled with core material of crushed, fired clay, encased in a ball of fresh clay, and then set out in the sun on the bamboo drying racks lining the paths between the houses. When the clay mould is baked, the wax melts and runs out of the channels made for that purpose. A narrow cavity is left between the mould and the core, into which the molten metal is poured. In the dark, sand-floored foundry, small boys help by working the bicycle-powered bellows; men heat and test the metal in long-handled containers over a charcoal hearth. From their long intimacy with fire and metal, they know when the molten bronze is ready for pouring. When the liquid has cooled and set, the mould is broken open to reveal the statue inside. Older boys file and polish these by hand in the shade under trees, while flocks of life-sized bronze cocks, ducks and geese are gathered at the pump in the garden for grandfathers to dig and wash out the core.

The nearby village of Trowulan produces smaller and more refined hollow and solid lost-wax castings. Copies of excavated Hindu and Buddhist bronzes, outer-island artefacts, deer- and bull-head door knobs, tableaux of figurines from the Hindu epics, and a variety of small sculptural works are cast in bronze and low-grade silver.

At Jatiteken, close to Sukoharjo, near Surakarta, the finest orchestral gongs are forged from bronze ingots. In stifling heat and in shadow lit only fitfully by bursts of light from the central pit of red-hot coals, the gong-smiths work barefoot and semi-naked, beating out huge discs. The bronze is repeatedly heated and then dragged by long tongs away from the fire. Half a dozen men with blackened bodies pound with all their strength; while one man raises his arms, another goes down on the ingot. The physical co-ordination required for the gong-smiths to avoid hitting each other is balletic in its finesse. Similar gongs and the bronze keys for the xylophone-like instruments in gamelan orchestras are cast and forged at Blahbatuh in Bali.

Brasswork is also common in Indonesian communities influenced by Indian and Islamic cultures. Brass is copper mixed with zinc and is cheaper and softer than bronze. It is often cast, but is also easily beaten into shape and worked with punches and chasing tools to create decorative borders and repoussé ornamentation. At Desa Pura, in the mountains of West Sumatra, zoomorphic water pots, vases with nickel silver ornamental scroll-work and the kettle gongs used in traditional Minangkabau music are cast in brass. Vases, lamps, platters and spouted water containers are made in Yogyakarta, Tegal and Gresik in Java. Negara, in the swamplands of South Kalimantan, is also known for fine brass candlesticks and bowls, as is the island of Buton off the southeast coast of Sulawesi.

Gold and silver smithery has a long tradition in Indonesia: early visitors to the archipelago were lavish in their praise of workmanship in precious metals. The sixteenth-century Italian traveller Ludovici di Varthema reported that the most beautiful works of art he had ever seen in his life were some gold boxes offered for sale in Aceh. The Dutch sea captain Arnoudt Lintgens, who visited the court of the kingdom of Gelgel in east Bali in 1597, was clearly impressed by the richness of the royal parasol fittings, the extravagance of the golden lances and daggers borne by the ruler's bannermen and the bejewelled splendour of his kris, which was heavy with exquisitely fashioned gold.

Design in Indonesian metalwork draws on a variety of sources: floral and leafy scrolls, lotuses, gargoyle heads and reptile and bird images originate in Indian metal forms and the stone carving on Hindu and Buddhist monumental buildings; curling arabesques, roses, stars and crescent moons derive from Ottoman and Mogul decorative traditions; Chinese geometric borders and the propitious motifs of the dragon, bat and butterfly contribute to the eclectic, but nevertheless distinctive style. Bronze Age design and surviving animist belief are expressed in the bold spirals, stylized ancestral figures, fertility symbols, houses, reptiles, birds and buffalo horns on outer-island jewelry.

Gold ornaments are sometimes given a red sheen, and silver is customarily accented with black. Gold and gilded ornaments are reddened by steeping and heating in a variety of chemical and plant decoctions, and by the application of transparent pigmented pastes. In north Sumatra, gold is mixed with a high level of copper to form the alloy *suasa*, which has a distinctly reddish appearance. Old methods of fire, water and cold gilding are still practised.

Stones favoured in traditional jewelry include rubies, garnets, diamonds, emeralds, coral, blue and black star sapphires, crystal and coloured glass cut into a rounded cabochon or left in a natural shape (if it suits the piece of jewelry). Changes in taste tend towards more elaborate facetting. Some stones are imported, but the gem fields of South Kalimantan provide diamonds, amethysts, garnets and sapphires; black opals are mined in Java.

The techniques of lost-wax casting, repoussé, chasing and engraving are all practised by Indonesian gold- and silversmiths; however, they are particularly admired for the great delicacy of their filigree work. Thin strips of metal are hand-drawn into wire by pulling them through an iron plate drilled with holes of decreasing size. The smith holds the end of the wire firmly and deftly twirls it to form curlicues and rosettes. The assemblage of parts is gently hammered flat and

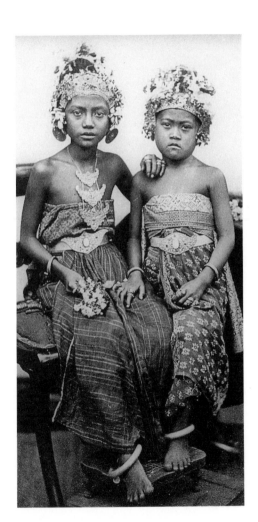

Golden crowns, jewelry, chased ornamental belts and heavy anklets indicate the nobility of these Balinese children who were photographed in the nineteenth century.

brushed over with a torch which melts and fuses the webs. Banda Aceh, in Aceh, north Sumatra, is renowned for filigree and for the peculiarly Acehnese motif, the *Pintu Aceh*, based on the gates to the city's peaked and petalled Gunongan edifice that symbolizes the Hindu-Buddhist cosmic mountain. The smiths of Ujung Pandang, in South Sulawesi, are famed for their light and flowery forms. Gold and silver filigree jewelry and miniature ships are fashioned at Kendari in southeast Sulawesi. At the Minangkabau village of Kota Gadang, in West Sumatra, traditional scrolling vegetal designs are worked in jewelry and on tiny traditional houses with filigree of such refinement that it seems impossible that they could have been made by human hands.

Balinese smiths excel at granulated decoration which requires enormous skill. Small clippings of gold or silver are heated over a bed of charcoal until they form tiny globules which are positioned on a piece of jewelry with a dab of bean paste or solder, and then heated with a torch. Temperature and timing must be very finely judged to provide melting and adhesion without affecting the decorative surface or form of the piece.

Street vendors in provincial town squares offer bowls of amulets and polished semi-precious stones of all colours to fit the empty ring settings spread out on cloths on the ground. Men sift through the stones and try on the rings. In the carnival atmosphere induced by the coolness of evening, promenading girls and young couples inspect gold jewelry glittering under fluorescent lights or pulsing pressure lamps in the night markets and rows of gold shops. Chains, rings, brooches and earrings in the form of golden balls, filigree flowers and circlets of twined gold wire are sold by the gram.

Gold jewelry is made in Surabaya, East Java, and also in the nearby town of Bangil, where the smiths are of Arabic and Indian origin. Javanese gold jewelry is sent to the gold dealers of other towns and islands; however, proprietors of provincial gold shops and their families are often accomplished smiths who practise their skill on pieces which more closely reflect regional tastes.

Gold jewelry plays an essential role in major lifecycle celebrations in many parts of Indonesia. At Hindu and Islamic wedding festivities, the main participants are arrayed in gold ornaments. Brides are adorned by professional dressers with glittering golden hair combs, shimmering headdresses, ornamental collars, rings, bracelets, anklets, dangling earrings or massive studs, breastplates of three crescents on chains, chased metal belts and sparkling hairpins mounted on springs so that they tremble and catch the light. The bride is a queen, and the style of her adornment is inspired by the full regalia of local royalty. At her wedding, she will sit perfectly still for many hours, like a coruscating icon, while other girls, bejewelled and dressed like the heavenly nymphs of Hindu and Islamic legend, cool her with fans.

Despite Islamic disapproval of gold jewelry for men, the groom may also be decked with bracelets, anklets, a shining belt with an ornamental buckle and a kris sheathed in a gleaming scabbard. When his attendants lead him to his place before the ritual marriage bed, it is as a magnificent king. Boys are dressed like bridegrooms for their circumcision festivities.

The quantity of gold jewelry required to outfit a bride and groom respectably means that some items must either be rented or be made from gilded silver or base metal. Cheap traditional jewelry is sold in the market of almost

This turn-of-the-century bridal couple from West Sumatra wear heavy and ornate jewelry and *songket* cloth garments woven with silk and probably real gold or silver thread.

every large town and is handmade in villages which specialize in gold and silver or tin and copper smithery. Designs are stamped onto very thin sheets of copper alloy, tin or aluminium. Elaborate pieces are a miracle of the art of jewelry-making.

The bolder and simpler metal jewelry of the Christian and remaining animist societies of Nusa Tenggara serves a different social purpose. Magically potent gold and silver jewelry is given by the groom's family to the bride's in exchange for handwoven ikat cloths; metal and cloth are bound together in social meaning and ritual significance. Cloth is soft and female; its coolness balances the hot, hard brightness of the objects made and given by men.

Gold and silver ear ornaments and pendants are frequently in the form of stylized female genitalia; the mitre, diamond and U-shaped pieces have an open-ended cavity in the centre; in Sumba these are called *mamuli*. *Mamuli* are male because they are metal, but their shape invigorates them with the female capacity to nurture life. When worn by women they enhance fertility. According to the Manggarai people of Flores, in the past they were also worn by men to grant them multiple lives in battle. Some of the larger, very powerful Sumban *mamuli* are elaborated with tiny horses and riders, birds and tableaux of ceremonial activities; as heirloom treasure, they are wrapped in magic cloths in the rafters of clan houses and are only brought down to summon up the guidance of ancestral spirits.

Much of the traditional jewelry of the islands of Nusa Tenggara is made by the tattooed smiths of the small island of Ndao off the west coast of Timor. In the dry season they wander from one community to another, equipped with the simplest of tools to fashion jewelry to local tastes out of scrap aluminium, ingots and old coins. Ndao smiths cast with clay moulds and beat sheet metal into pendants, bracelets, ear clips and hair combs with a variety of forms and motifs which include *mamuli*, images of plants, birds, buffalo horns, horses, human figures and houses. Like that of Nusa Tenggara, elements of Karo Batak jewelry of North Sumatra, which also represent buffalo horns and houses, reflect the gendered nature of the cosmos. In both regions, bold, even heavy, granulation and filigree is worked in powerful designs, rather than with the spidery delicacy preferred by coastal Islamic societies.

Some communities of former royal artisans seem almost untouched by the modern world, but others have become centres of mass production. The small town of Kota Gede, in Central Java, near the royal city of Yogyakarta, was the early site of the late sixteenth-century Mataram empire. Artisans provided the court with the paraphernalia of royal power: jewelry, military accoutrements, fine furnishings and musical instruments. Legends were woven around the miraculous skills of the great craftsmen of long ago; the names of neighbourhoods record the craft specialities of the past. Today, there are large factories and many small workshops specializing in repoussé bowls, cutlery, fine filigree, jewelry and small ornaments especially designed for the tourist market, such as miniature silver *andong* (Javanese horse carriages). Jewelry and trinkets are sent to be sold in Bali, Jakarta and elsewhere.

At the royal courts of Bali, sacred and temporal power was expressed through art. Precious metal ornaments, architecture, poetry, dance and orchestral gong music contributed to a world of timeless and ethereal beauty. The

village of Kamasan (in Indonesian *mas* means gold), near Klungkung, is still a centre for Balinese court arts such as traditional painting and work in silver and gold. Leafy lanes lead to walled family courtyards; ornamental gateways carry small signs announcing the type of work carried out within. Kamasan produces objects for ceremonial and festive occasions: receptacles for holy water, large silver bowls for offerings, repoussé silver and brass vessels, amulets, gem-studded gold and silver kris handles, lost-wax cast statues of the Hindu deities and crowns with flowers of beaten gold. Skills are handed on to children by relatives living in the family compound. Work is carried out amid the hurly-burly of family life and against the sound of hammering and the ceaseless crowing of the fighting cocks set out in their baskets to enjoy the spectacle. Equipment is simple: a tree stump base for hammering the metal, a selection of punches, chasing tools, nippers and plates for drawing gold and silver wire and a small bed of charcoal for heating the metal are all that is necessary.

The village of Celuk, also in Bali, is near the court town of Gianyar and the noble houses of Sukawati and Ubud. Of more recent importance is its proximity to major tourist resorts. The main road that dissects Celuk is lined with emporia filled with gold and silver filigree flowers, chains, rings and pendants and bangles thick with beading. The larger workshops employ the labour of up to two or three hundred local smiths and apprentices to supply the domestic and international jewelry market. Smiths in Denpasar and Kuta are similarly occupied. Down the side streets and lanes of Celuk, some traditional work continues in the family courtyards, but many smiths are now engaged in copying or adapting designs from photographs or drawings brought to them by tourists and local or international dealers and designers.

Enthusiasm for traditional Indonesian forms and motifs is increasing among local and international buyers. *Mamuli* and other types of jewelry from Nusa Tenggara provide inspiration for new designs. Excellent reproductions of outer-island jewelry are sold in Jakarta too. Balinese smiths also produce finely crafted adaptations of modern Western and Art Deco jewelry. Indeed, the Art Nouveau style is thought to be partially derived from Javanese design traditions and is another important influence in the gold and silver pieces set with shell, polished fossil, semi-precious stones and gems.

The Balinese silver industry has burgeoned so rapidly that it has been essential to train new craftsmen with no family background in metalwork. Other communities continue as they have for a millennium or more, because their products and skills are inseparable from traditional life.

14 This ceremonial brass *kendi* used to hold purifying water was cast and engraved at Tegal, Central Java. H $9\frac{3}{8}''$ (24 cm).

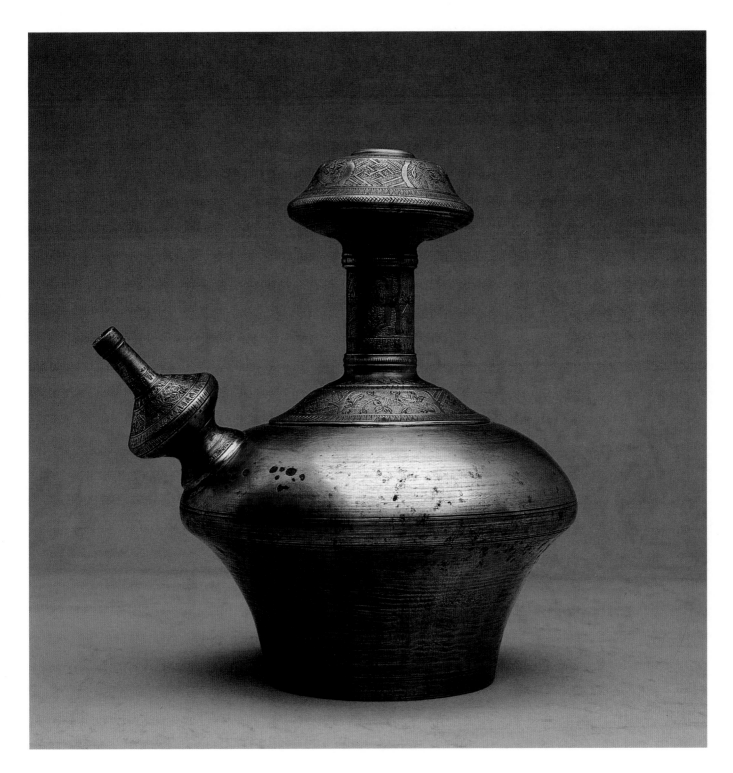

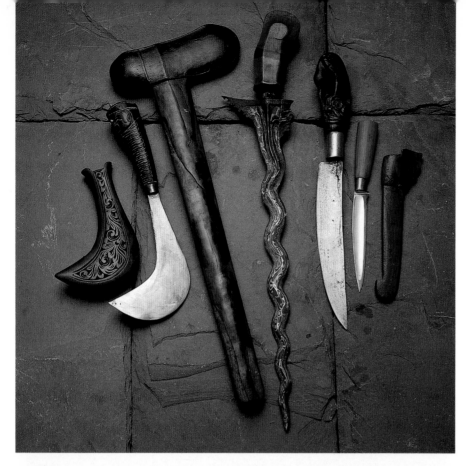

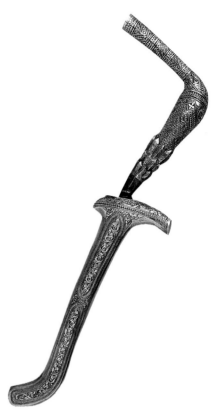

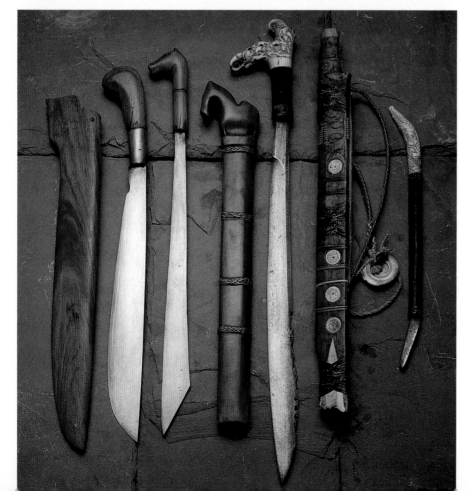

15 *Above left* Ornamental knife with
a softwood sheath. Its horn handle is
carved with a demon's face. Ciwidey,
West Java. Kris with a *pamor* blade,
wooden hilt and scabbard with a
coloured glass and silver ornament.
Kusamba, Bali. Knife with a carved
wooden bird-shaped handle from
central Lombok, Nusa Tenggara.
Small knife with a wooden sheath
from Savu, Nusa Tenggara.
L of Lombok knife $11\frac{3}{4}$" (30 cm).

16 *Left* (from left to right)
Utilitarian cutlass (*parang*) with a
wooden scabbard and hilt. Savu, Nusa
Tenggara. Ceremonial *parang* with a
horse-shaped bone hilt and a wooden
scabbard carved with a horse and
trimmed with rattan. East Sumba,
Nusa Tenggara. Ceremonial *parang
ilang* or *mandau* with a deer-horn
handle and a bone-handled knife; both
fit into the wood and rattan scabbard
ornamented with coins. Kenyah Dyak,
Central Kalimantan. L of *parang ilang*
$23\frac{5}{8}$" (60 cm).

17 *Opposite* Sumatran dagger (*rencong*) with an engraved silver scabbard and hilt. Banda Aceh, Aceh, North Sumatra. The unusual shapes of parts of the *rencong* form the Arabic letters necessary to make up the words for 'In the name of Allah'. *Rencong* are worn by bridegrooms and on ceremonial occasions. L 13¾″ (35 cm).

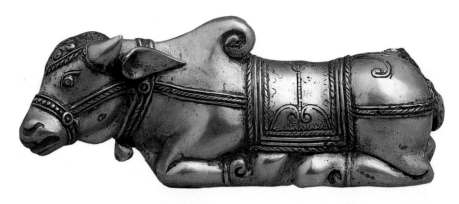

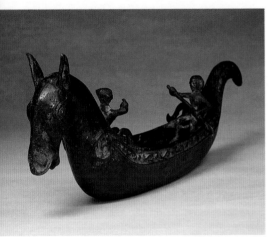

18 *Above* Horse-shaped boat with passengers; cast and worked in bronze at Trowulan, East Java. L 14¼″ (36 cm).

19 *Above right* The bull Nandi, the steed of Shiva, the Hindu Lord of Beasts, was cast in low-grade silver at Mojoagung, East Java. L 7⅞″ (20 cm).

20 *Right* These bronze cocks, the hen and the duck-shaped oil lamp or vase were cast at Mojoagung, East Java. Tallest H 13⅜″ (34 cm).

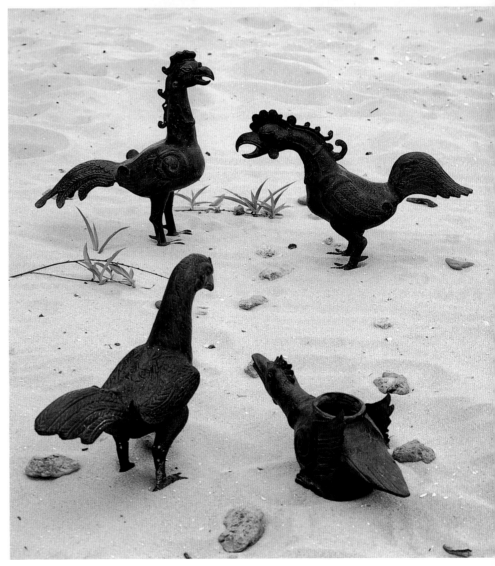

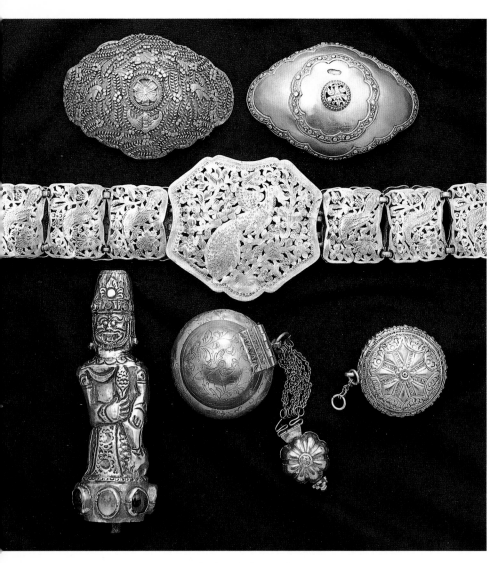

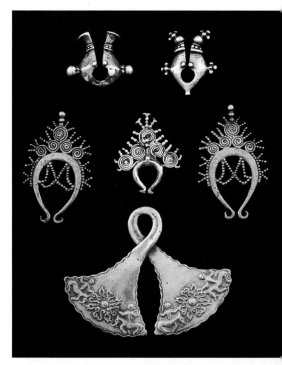

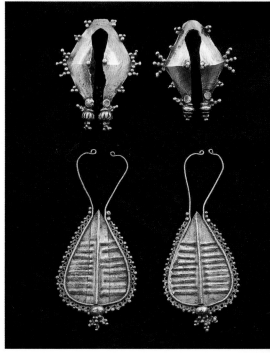

21 *Above* The cast nickel-silver belt buckles at the top are from West Java. The cast and etched lead-alloy belt and buckle are from Aceh in North Sumatra. The kris hilt was made with copper shaped over an iron form and coated with silver at Kamasan, Bali. The pewter tobacco box and small attached lime container are from Bukittinggi, in West Sumatra, and the Torajan copper and silver tobacco container from Rantepao, South Sulawesi. L of kris hilt 5¾″ (15 cm).

22 *Above right* Silver ear ornaments or pendants. The upper *mamuli*-shaped silver ornaments were collected in West Timor and are similar to those of Tanimbar, in Maluku. Their form represents a stylized image of female genitalia. The ornaments with spiral decoration are worn and exchanged in marriage by Tetum people in central Timor. The large pendant is a copy of an heirloom piece from Sumba. L of central spiralled ornament 1¾″ (4.5 cm).

23 *Right* Gold ornaments or *wea* worn in Lio communities in Ende, Central Flores. The lower pair of gold earrings or *iti bholo* are given as engagement presents to Nage women in Boawai, Central Flores, but are also just worn to festivities in the surrounding districts. L of *wea* 1⅝″ (4 cm).

24 *Right, above* (from left to right)
Gold earstuds from Kota Gede, Central
Java. The assembled stud is on the left
and the separate parts are in the centre.
The circular gold base is composed of
discs of such fine filigree work that the
individual wires are barely visible.
Additional fittings are silver gilt set with
natural crystal. Gold earrings with very
fine granulated decoration. Celuk, Bali.
Silver gilt earstuds ornamented with
filigree and set with glass stones from
Kota Gadang, West Sumatra. These and
the Javanese earstuds are designed to
resemble traditional earstuds which
required a much larger hole in the lobe.
Gold earstuds ornamented with filigree,
granulation, rubies and sapphires made in
Klungkung, Bali. Gold filigree earstuds
from Surabaya, East Java. These could be
combined with other fittings.
D $\frac{5}{8}$″ (1.5 cm).

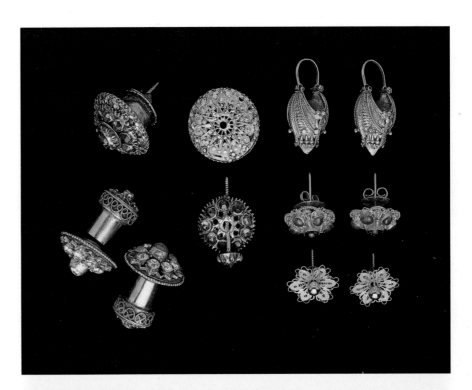

25 *Right, below* Copper-alloy *mamuli*
ornaments from Sumba in the form of
stylized female genitalia. That with a
silver coating is from West Sumba and is
$2\frac{3}{4}$″ × $2\frac{5}{8}$″ (7 × 6.5 cm). The silver bracelets
with internal rattles are held in the hand
by dancing women and are from
Atambua, central West Timor.

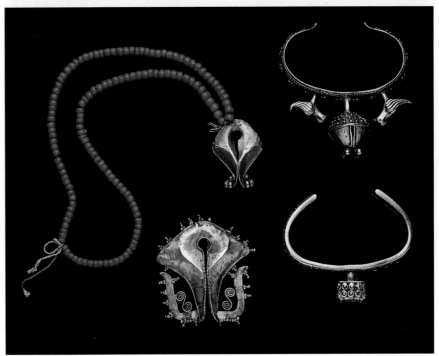

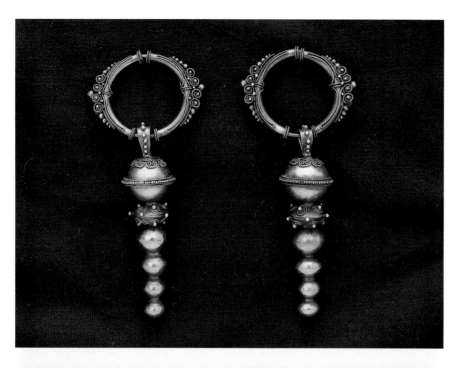

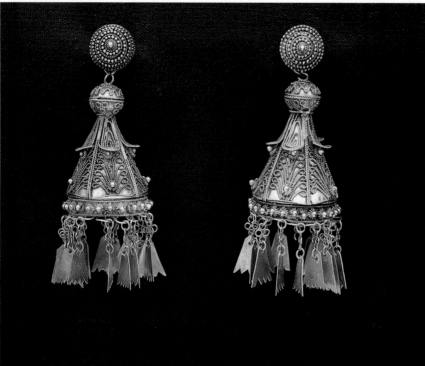

26　*Left* Silver gilt earrings or *kudung-kudung* worn by Karo Batak women. Brastagi, North Sumatra. L 3½″ (9 cm).

27　*Below* Silver gilt earrings or *padang curu-curu* worn by Karo Batak women. The form is based on the nest of an acquisitive bird. Brastagi, North Sumatra. L 2¾″ (7 cm).

28　*Opposite* Karo Batak necklace of gilded and stained silver-alloy pieces threaded onto black cotton rope. The ornaments combine stylized buffalo-horn and house-roof motifs and thus symbolize the unity of male and female. The central ornament is 3½″ (9 cm) long. More complex ornaments are worn around the neck and on headcloths by men and women at Karo Batak weddings and other celebrations. These necklaces are also worn in Aceh in North Sumatra. The Karo Batak bracelet or *gelang sarung* would be worn by men at funerals, weddings and important festive occasions and is made with silver gilt and copper. Brastagi, North Sumatra. D 3½″ (9 cm).

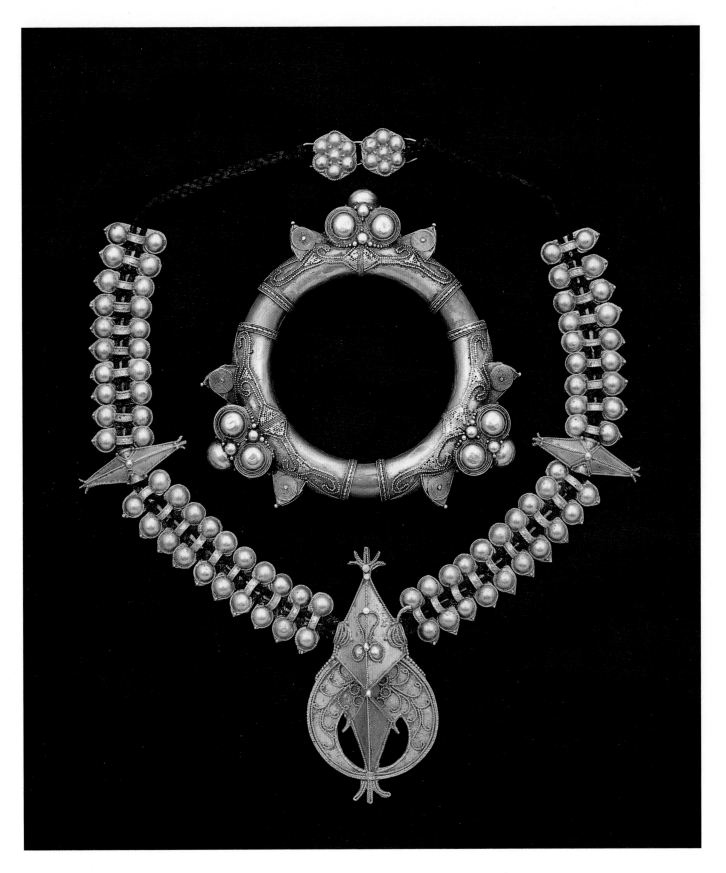

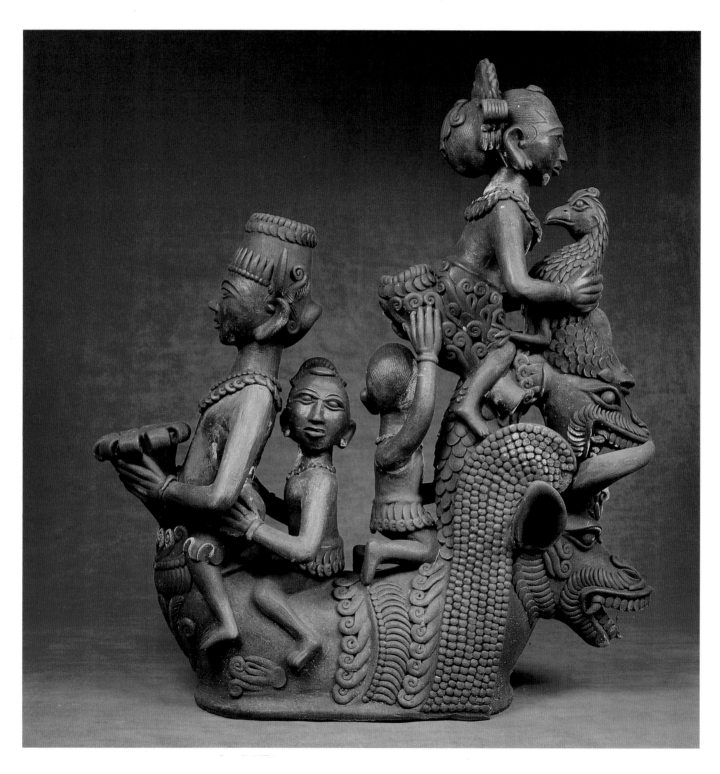

CERAMICS

The Austronesian ancestors of most modern Indonesian peoples brought pottery technology to the archipelago from southern China in Neolithic times, more than four thousand years ago. Earthenware vessels have been traded throughout the archipelago for millennia, and the ancient network of the great inter-island trading routes intersects at important clay deposits and coastal potting villages. Old patterns survive. Double outrigged canoes ply the islands and the magnificent schooners of the Buginese still occasionally call in at coastal pottery villages to exchange their cargoes of commercial cloth, kerosene or timber for earthenware vessels.

Pottery is only made in villages with a traditional specialization in the craft, and in most parts of Indonesia it is only women who make clay vessels. Old customs and beliefs place potting firmly in the female domain of human and agricultural fertility. Pots and wombs are containers for riches in the form of rice and children. Until very recently, in Lombok, pots used for storing rice were only made during the month of Muhammad's birthday by a pregnant woman to ensure a bountiful rice harvest. When a child is born in Java and South Sulawesi, the afterbirth is placed in an earthenware pot and ceremonially buried in the garden. The placenta is thus provided with a symbolic womb that it inhabits as a shadow companion and spirit guardian for the person throughout his or her life.

At Ouw, on Saparua Island in Maluku, men may not enter the parts of the forest where the women collect clay for their dappled red-brown pots. In the potting villages of the Ambeno (Oekussi) district of central Timor, women marry within their own communities and, if they do marry out, they cease working with clay; outsiders marrying into the villages do not learn the craft. This custom is also practised in potting villages in Papua New Guinea that share the Austronesian ceramic heritage. According to legends, long ago, star maidens or enchanting strangers visited the women and taught them how to make pots, and they in turn handed on this special skill to their female descendants exclusively. Thus, only the women of a few communities are privileged with the knowledge of ceramic technology.

Vessels are shaped by primordial beliefs which link pottery forms to fertility in human beings, crops and animals. In the old ritual pottery of south Sumatra, figurines of Lampung brides with parted lips crouch between branching buffalo-horn spouts. They gaze through narrowed lids from under enormous sculpted headdresses with an intensity that is now beyond precise interpretation.

In Tembayat, near Klaten, in Central Java, women pot black pitchers with breast-shaped spouts. At weddings, these are filled with water offerings to Dewi

29 Terracotta sculpture entitled *Perahu Wayang* (boat drama). It symbolizes marriage and depicts a bride and groom, the children they will have and the children they once were. The joined animals represent the unity of the upper and lower realms of the cosmos. Jumbal workshop, Kasongan, Central Java. H 25¼″ (64 cm).

Sri, the Hindu goddess. Dewi Sri, Sri, the Rice Mother or Grandmother is the ancient goddess of agrarian fertility; she pre-dates Hinduism in Java and Bali, and comes in many guises. Her realm is the bounty of the fields and fertility in marriage. In traditional songs accompanying the planting and harvesting of rice she is described as the eternal guardian and the essence or 'atom' of love. Rice is life. Javanese rice farmers, despite their formal affiliation to Islam, honour the power and generosity of Sri.

Some potters in Central Java still make painted earthenware *loro blonyo*, or 'inseparable couple', money box sculptures of the fertility goddess, Dewi Sri, and her consort, Sadono. *Loro blonyo* figurines infuse the home with the presence of the goddess and her blessings for a successful marriage. Regal wooden *loro blonyo* were traditionally placed at the foot of an ornate bed, which served as a resting place and shrine for Dewi Sri in the homes of the aristocracy of Central Java. Pottery *loro blonyo* are much humbler. Some are vigorously individual, others may be more impersonal, but still express a naive and numinous grace which successfully evokes the ideal of sacred domesticity.

Terracotta dolls modelled in Takalar, in South Sulawesi, are made as paired figurines like the Javanese *loro blonyo* and are sometimes mounted together on horseback. Takalar dolls are always serenely moon-faced with high foreheads, and are either washed over or banded with red slip over the local grey clay. In the cool work space beneath the stilted bamboo and palm leaf houses, the women potters work in the striped shadows making braziers, spherical cooking pots, oatmeal-coloured frying pans with streaky rust-coloured leaf patterns and huge water barrels.

In Bali, Dewi Sri, the Rice Mother, seems to be everywhere. Her face, fanning headdress and huge *subang* or earstuds appear in palm leaf decorations, shrines and on pottery. At Pejaten, in Bali, small, barrel-shaped, stumpy-legged saté braziers, incense burners, perforated candle holders and little water pots are made in her image. Scenes of village life are evoked by small earthenware figurines playing traditional musical instruments or clasping precious fighting cocks. Jolly, fat peasants with bulging cheeks and erect penises are made to sell to tourists, but explicit sexual symbolism and earthy comedy has always had an established place in traditional Balinese pottery, stone-carving and dance drama.

Water is used in both Hindu and Islamic ritual celebration, and in Sumba and Lombok, purifying water gushes from the mouths of old demon-faced pots and earthenware fountains. Pottery pitchers or *kendi* are containers for ritually cleansing water to rinse the hands before prayer or a meal. In Bali, small *kendi* contain libations for the spirits. Drinking water can be stored and cooled in an unglazed *kendi*. The water seeps slowly through the porous earthenware; as it evaporates, the temperature of the water inside is lowered. Drinking from a spouted *kendi* entails holding it aloft at an angle, so that an arc of cool water jets into the mouth. The lips need never come into contact with the spout, and in the countryside a full *kendi* may be left in the shade outside the house for passing neighbours or travellers to refresh themselves.

There are fascinating differences in the shapes, sizes and decoration of *kendi*. The elongated, red and black burnished *kendi* of Bali and Lombok have wide dish-like mouths, and vie in elegance with the refined simplicity of those

made in Sumba. In Plered, in West Java, the pale red *kendi* have painted designs of leaves and wings and gracefully outward-curving spouts; in East Java spouts are little more than a nipple on the side. The finest red and black burnished *kendi* in Java are made at Mayong, near Kudus, on the north coast. Spouts and necks are formed separately, pierced with bamboo, and smoothed onto the bodies.

South Sumatran *kendi* with multiple spouts branching energetically from the top have been made since at least the eighth century and are still made at Kayu Agung, south of Palembang. Those with double spouts are placed in the rafters of a new house together with fruit and flower offerings, to encourage the spirits to bring good fortune to the household.

The dark smoky Gayo pottery of the central highlands of Aceh, in north Sumatra, is incised with delicate patterns; the spidery whorls and fine geometric incisions recall Gayo embroidery and the carving on old longhouse walls. Some water vessels especially made for men were formed with arched and hooded phallic spouts. Tall *kendi* with protuberant spouts were reserved for fathers, middle-sized ones for mothers, while children used smaller gourd-shaped flasks. These traditional Gayo *kendi*, which were made for generations in the mountains and in villages near Takengong, are now only produced near the old northern trading port of Pidie.

The first reference to pottery in Javanese literature comes from the fourteenth-century narrative poem, the *Negarakertagama*, which celebrates the splendour of the imperial city of the empire of Majapahit in East Java, where the roofs of the houses were topped with ornamental cocks. Terracotta cocks with male riders, which symbolize the upper world, form the roof finials of the old, beautifully carved, teak houses of north Java.

Small terracotta sculptures are still being unearthed among the scattered Majapahit ruins of bathing pools, temples and ornamental gateways of the lost empire near Trowulan, East Java. Beautifully proportioned female heads and figurines of fluid grace and beauty have serene and strongly individual faces; immediacy and truth are conveyed by attention to detail in clothing and jewelry. The potters in the *kampongs* (sub-villages) of nearby Mojokerto model similar female heads and terracotta animals today. Trenggalek, in East Java, also continues antique tradition with incised, squat water pots with necks formed by lively female heads and spouts shaped as bulbous nippled breasts.

Majapahit bird- and animal-shaped money boxes were used to collect Hindu temple offerings, and represented the vehicles of the Hindu gods. Shiva, the Destroyer, Lord of the Dance and of Beasts, was symbolized by his companion, the bull Nandi; Indra, god of storms, by the elephant; Brahma, the Creator, and his consort Saraswati, goddess of music and poetry, rode a white goose. The merciful Vishnu, the Preserver, flew on the back of the eagle Garuda, who was also represented as a cock at Majapahit.

Bird, animal and gourd shapes are common today in the money boxes that are sold for small sums along with the cooking pots and water jars in the pottery stalls of every market in Java and Bali and in parts of Nusa Tenggara, South Sulawesi and Sumatra. Money boxes are usually daubed with bright industrial paint and are rather roughly made. But the simple and exuberant moulding and modelling can make for a vivid expression of the cock's vainglory and the hen's self-satisfaction that are so familiar to rural children.

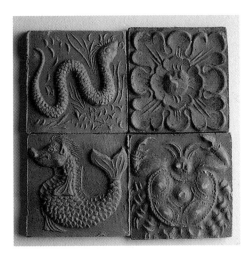

Balinese terracotta tiles from Pejaten with Hindu and astrological motifs.

On holidays and festivals, such as New Year or the birthday of the Prophet Muhammad, potters from outlying villages bring their wares into the squares of large towns. In the park in front of the Surakarta Palace, in Central Java, local potters display giant painted geese which could easily accommodate a full-sized deity, or even a small Javanese family. Snarling tigers, gaudy cocks, shocking-pink cats, children's tea sets in red, green and silver, rabbits, elephants, flower pots and *kendi* are set out in rows on the pavement. Frog and bird whistles and little horses, cows and birds were also common before the advent of plastic factory-made toys. Therese Waryarti, a young Yogyakartan potter, calls on her memories of childhood to inspire her modelling of miniature cooking pots and toys. Her money boxes are topped by animals, characters from Javanese folk tale and scenes of daily life.

Folk ceramics made in Kasongan, near Yogyakarta, are brought into the city's markets, and are either brightly painted or covered with trailing beads of clay and rolled, curling ornament. Fantastic animal money boxes and figurines are so elaborated by appliquéd frills and coils that they are only just recognizable as elephants, horses and cocks. The traditional male realms of wood-carving, painting and metal-casting provide a precedent for men to work on such sculptural terracottas.

Closer to the dramatic sculptural traditions of Majapahit are the fearsome *naga* heads that thrust up from the rims of scaly bowls and the cocks with their feet entangled in serpents' coils. Lively dolls engaged in daily tasks of cleaning fish and preparing food and buxom hens sheltering chickens under outstretched wings bear a clear stylistic relationship to the comical and expressive clay toys and tableaux excavated in East Java.

Traditional animal figures are also found on the Kasongan boat sculptures that symbolize marriage. In these, the bodies of a bull, a cock and a *naga* are joined to form a hull. A boy and girl and a bride and groom are conveyed through life on a zoomorphic ship. The vessel occupies the humanized social space between the dim, lower realm of instinctive energy, and the upper world of the spirit. Such sculptures are images of creative unity in which dual elements of the cosmos are in active harmony.

Images of ancestral ships represent the authority of tradition and the social order in which the institution of marriage plays a central role. Boats are vehicles for the soul through the great transformative episodes in human life – birth, marriage and death. Simpler, crescent-shaped boat and passenger sculptures embody important stages in the male life journey; an old man, his head wound in the batik head-cloth worn in the district of Yogyakarta, is at the prow; nimble boys scamper and cling to the hull; and a solemn bridegroom forms the stern.

In Banyumelek, Penujak and Masbagik Timur, in Lombok, potters make brightly painted and sleekly burnished black cock money boxes and enormous apricot-coloured water vats with appliquéd lizards and frogs slithering up their sides. Fine utilitarian vessels are decorated with creamy geometric clay patterns, stamped motifs and large slivers of pearly seashell inlay. The potters' pleasure in their materials is evident in the richly mottled black and russet dishes and the dark smoked cooking pots studded with tiny shell fragments. In Bagu, in west Lombok, cock-shaped *kendi* have plumes and bottle necks gaily decorated with brilliant dots and lines in red, black and golden-yellow paint.

Cocks welcome the dawn after the darkness of night and symbolize new life. Cock-shaped *kendi* were used at South Sumatran weddings to symbolize the new adult identities assumed by the bride and groom. At Rambatan, in West Sumatra, small, bird-shaped containers and deep black, incised cooking pots and other utilitarian wares are made in the clustering pottery *kampongs*. In nearby Tanjung Baruh, near Payakumbuh, potters model bright-red, painted money boxes in the shape of elephants, monkeys and fish, as well as unpainted clay ones shaped like mangosteen fruits, and rounded cock-shaped containers with combs and tail feathers reduced to an expressive minimum. The women of Sungai Janiah, near Bukittinggi, make black cooking pots and enormous water barrels.

In Indonesia, making pottery depends on simple tools and the essential elements of earth, water and fire. The clay may be dug from a nearby fallow rice paddy or collected from more distant deposits near rivers or hillsides. It must be picked clean of roots and stones by spreading it out to dry so that it can be crushed or sieved. Water and sand are then added gradually until the right consistency is achieved. Women potters take pleasure in kneading the sticky mass between their toes or stretching and pummelling it by hand until it is smooth and pliant. Prepared clay is either used straight away or carefully wrapped in leaves or a plastic sheet and stored in a sheltered spot to keep it damp and to induce souring. Souring the clay increases its elasticity.

The potter works under her stilted house or in the shade of a tree so the clay will remain moist. The simplest and most ancient method of producing pots is by the paddling technique. From a ball of clay, the potter creates a cup that she spreads out until it is large enough to be pressed onto a ring of twisted rattan. This will form and hold the shape of the rim. She takes a rough wooden paddle and a rounded, river-washed stone about the size of a fist; a really fine stone is often a treasured heirloom. She holds the stone against what will be the inside wall of the pot and paddles the outside surface. Each blow from the flat paddle is met by the stone inside. She holds the pot in her lap and wets the stone and paddle as she stretches and beats the swelling shape. Her rough paddle is exchanged for smoother ones to compress the clay to a thin shell. As the belly of the pot expands, her wet hands and a damp rag wipe over the surface and round the lip more elegantly. When the walls are of an even thickness, and the pot is fully formed, she puts it out to dry in the wind and sun. Then it is polished all over with a smooth pebble, a seashell or a piece of glass. Water pots are thoroughly burnished to close the pores of the outer skin and reduce porosity, but often less trouble is taken with cooking pots. They may leak a little at first, but cooking residues soon seal the inner surface.

In some villages, pots are formed by coiling tubular lengths of soft clay and pinching and pressing them into the general shape and size of the pot required. Coiling is usually done on a flat board or clay slab. This can be balanced on top of a rounded tree stump or an upturned pot so that it can be twirled around by hand or foot and smoothed and shaped with stones or sharp blades of bamboo. Paddling may also be used to stretch and refine the coiled pot further.

The mechanically rotating potter's wheel with a fixed axis is not common in Indonesian pottery villages. Its use is mostly confined to Java and Bali, where the potters use an unusual type of foot-powered kick-wheel which is, however, also

found in Africa and India. The wheel is set at an angle sloping away from the potter, and is mounted on a pin fixed to a block which is buried in the ground. In some villages, the use of the wheel allows pottery to be redefined as a craft in which men may participate. In Kesambi, near Ciruas, in West Java, men monopolize the wheels to produce rather coarse, bottle-shaped *kendi* with painted stripes and leaves, while the women continue to make finely polished, red clay water barrels by hand.

Most pots are given a wash of red clay to enrich their colour and to help seal the surface. Geometric patterns are incised with a sharp bamboo stick or with the fingers. Handles and moulded decorative elements may be applied as well, but very often the pot is left plain, its simple shape amply satisfying utilitarian and aesthetic needs. Symbolic plant or animal motifs may be painted in lime or clay mixed with oil, in order to enhance the appearance of the vessel or, as with the application of red paint, to indicate a ritual function. The women of Boti, in West Timor, decorate their pots in clay and lime with the same Bronze Age interlocking hook designs that they produce in their weavings. The Atoni textile motifs of stylized reptiles and human figures are also painted and moulded on vessels made in nearby villages.

When the pots are sufficiently dry they are ready for firing. In small villages, this is done in the open. Roads provide a safe, clear area; however, the women of the remote island of Tayandu, in the Kei archipelago of southeast Maluku, fire their strikingly painted black and white pots on the beach. For village firings, vessels are stacked in a single layer in a trench, or on top of each other, and surrounded with branches, coconut husks, leaves, dung and any other combustible material. The women arrange fast-burning, ash-forming fuel on top, to form an insulating layer to trap the heat. The bonfire is then set alight, and burns for twenty or thirty minutes. A second, quick reduction firing will make the pottery jet black. Hot vessels are covered with rice husks or green leaves which quickly catch fire and create a dense oxygen-reduced smoke.

Potting communities in Java and Bali also use enclosed, brick updraught kilns. These are usually circular brick ovens that are protected from drenching tropical downpours by palm leaf or galvanized iron roofs. Higher and more stable temperatures, and thus more durable pottery, can be produced in such simple kilns. After firing, water pots may be coated with a variety of plant decoctions. Damar resin from Irian Jaya, coconut oil, mixtures of coconut milk and *kemiri* nuts, or *lerak* fruit provide an attractive, but impermanent glossy finish, which reduces excessive porosity.

Women potters make vessels for their own use, exchange the surplus with neighbours and sell the rest. Pottery may be a source of additional income for a family of farmers, share croppers or agricultural labourers, and the women will only pot when there is a lull in the cycle of work in the rice paddies and vegetable gardens.

On market days, pottery-laden bicycles are carefully pushed along country roads leading to the nearest town, and pedestrians with vessels ingeniously arranged and slung on bamboo poles nimbly negotiate their way. Somewhere in the market, in among the shrieking chickens, baskets of brilliantly coloured fruit, trays of chillies, cones of rice, scented flowers, racks of sunglasses and bolts of bright textiles, there will be a pottery stall, with teetering towers of money boxes,

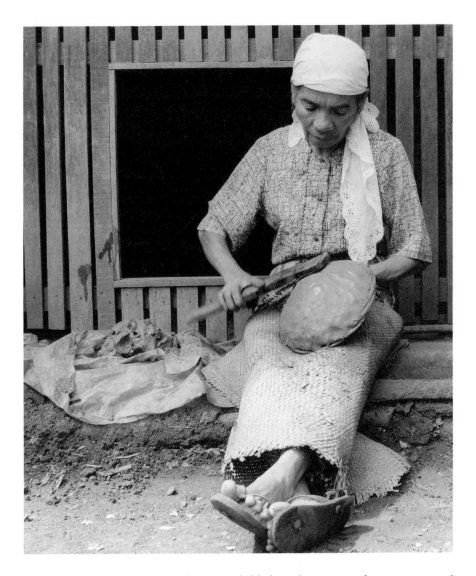

This woman in Sungai Janiah, West Sumatra, is making a cooking pot by beating the clay with a wooden paddle against a stone held inside the vessel.

water jars, *kendi*, charcoal braziers, lidded cooking pots, frying pans and teapots. Waisted pots with upper and lower interior sections are used for steaming, and rectangular moulds divided into sections for moulding sago cakes are also sold in eastern Indonesia, where sago is an important part of the diet. In parts of Maluku, these are sometimes formed to produce cakes in the shape of little human figures.

In some parts of the archipelago, pottery villages still thrive; in others, the craft is dying. Pottery manufacture is declining in Kalimantan now, and elderly women are the last potters in some traditional centres of Irian Jaya. However, the ritual, decorative and utilitarian pottery of numerous small villages scattered through the archipelago has never been exhaustively researched, and there are undoubtedly many active centres of production which are, as yet, unrecorded.

In Indonesia, the greatest admiration has always been reserved for imported glazed Chinese, Thai or Vietnamese ceramics. In Bali and Java, colourful Chinese plates were set into the walls and gateways of temples and palaces as architectural ornament. Blue and white Ming trade ceramics were used as

funerary treasure in Nusa Tenggara, and huge jars were used as markers of status by the Dyak communities in Kalimantan.

Most centres of glazed ceramic work imitate Chinese models. In Bandung, West Java, the Ceramics Research Institute produces extremely fine copies of Chinese porcelain; wares of similar quality are made at Dionyo, near Malang, in East Java. At Sinkawang, near Pontianak, in West Kalimantan, Indonesian-Chinese potters produce traditional Chinese wares, including the jars prized by Dyak communities in the past.

In Bali, experiments with glazing are being conducted at Pejaten. Celadon wares, ranging from soft grey to deep green, are incised with leaf patterns and spear-shaped bamboo shoot motifs to form shallow decoration on plates, bowls, jugs and pots. Lid handles are shaped as spirited *naga*. These and other applied hand-modelled elements have a peculiarly Balinese curvilinear energy, that distinguishes them from the more static serenity of similar Thai and Vietnamese glazed pottery. Jane Chen's Jenggala studio, also in Bali, has successfully combined Balinese sensibility with glazing. Gleaming blue and milky, matt-glazed household and decorative china is ornamented with tiny appliquéd frogs. Salt cellars and candlesticks are modelled in the form of Dewi Sri, and blue and white china with Balinese lotus motifs delightfully combines local and Chinese decorative traditions. Klampok, near Banjarnegara in Central Java, which produces brown glazed and unglazed wares, has adopted motifs of shadow puppet figures and *naga*. Lombok potting villages have been assisted in marketing and design by visiting experts; the acquisition of kilns has been sponsored by the New Zealand government; and pottery is now successfully exported beyond Indonesia.

Developments in terracotta sculpture, finely crafted earthenware vessels and the new experiments that combine glazing with distinctively Indonesian aesthetic traditions will be of the greatest interest in the future.

30 Left to right: small incised earthenware container from Savu, Nusa Tenggara. Double-spouted *kendi* from Alor, Nusa Tenggara; the spout on the left is false. H 10⅝″ (27 cm). Earthenware bottle figurines from Mojokerto, East Java. Earthenware bowl with red clay decoration from Boti, central West Timor. Stoneware sugar bowl with celadon glazing from Pejaten, Bali. Incised black water pot from Barombong, near Ujung Pandang, South Sulawesi. Small earthenware water pot with raised figures of lizards and human forms and ochre and lime decoration. Soe district, central West Timor. Small earthenware cooking pot with ochre decoration from the Watampone (Bone) district, South Sulawesi. The earthenware cock-shaped *kendi*, zoomorphic teapot and cock-shaped money box (below) are from Banyumelek, Lombok, Nusa Tenggara.

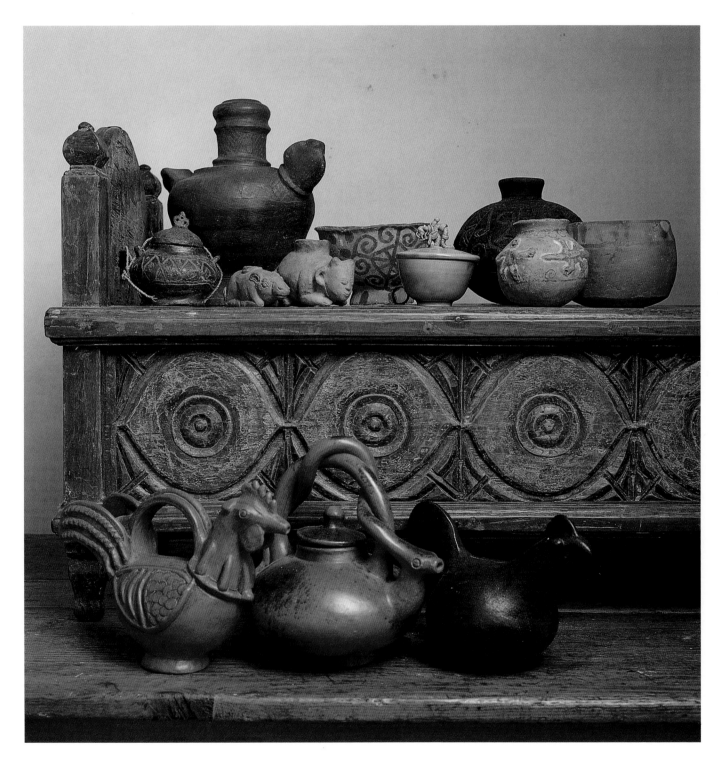

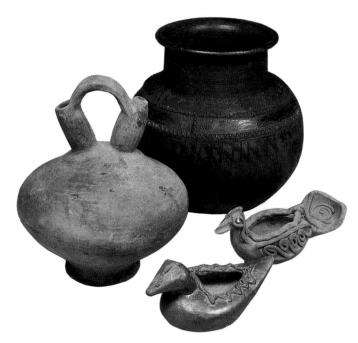

31 *Right* Double-spouted earthenware *kendi* are filled with water and included among offerings made for new houses in South Sumatra. Kayu Agung, near Palembang, South Sumatra. H 10⅛″ (25.5 cm). The black, paddled cooking pot and hand-modelled bird-shaped earthenware containers were made in Rambatan, near Payakumbuh, West Sumatra.

32 *Below* On the right is an incised pot from South Sumatra. The two in the middle were made in West Timor, Nusa Tenggara, and have been decorated with lime and red clay. H approx. 5½″ (14 cm). The pot on the left is from East Sumba, Nusa Tenggara, and has been used to hold blue indigo dye.

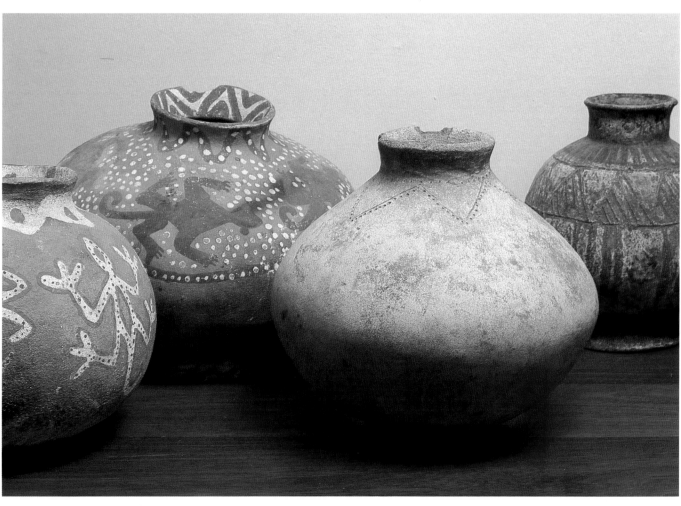

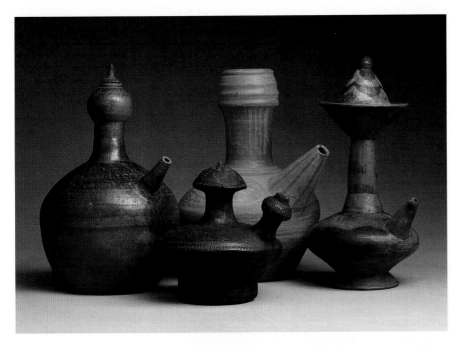

33 *Left* The red *kendi* with leafy scrolls and wing motifs is from Plered, West Java, and is 12⅝″ (32 cm) high; the darker one was collected in Surakarta, Central Java. The small incised Gayo *kendi* at the front is from Aceh in North Sumatra, and the taller *kendi* is from Banyumelek in Lombok, Nusa Tenggara.

34 *Below* Earthenware footed dish inlaid with seashell. Masbagik Timur, central Lombok, Nusa Tenggara. H 4¼″ (11 cm). Earthenware plate with stamped decoration. Penujak, central Lombok. The *naga* (dragon-serpent) bowl was moulded and modelled at the Jumbal workshop in Kasongan, Central Java. The carved and painted door in the background is Balinese.

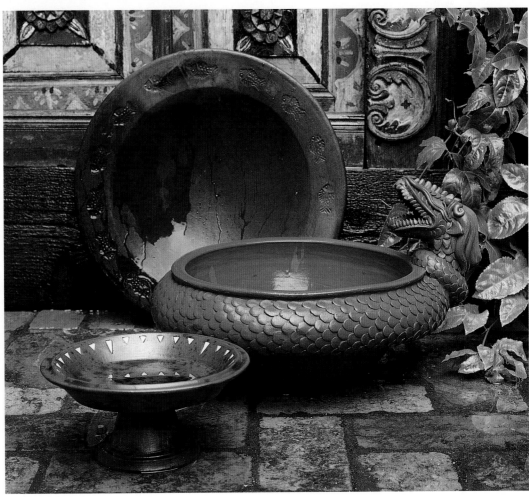

35 Small braziers made from moulded and modelled earthenware; these are
filled with hot coals for cooking saté over the wire racks inside. Pejaten, Bali.
The top brazier is ornamented with the face of Dewi Sri, the rice goddess,
and is $5\frac{1}{8}'' \times 7\frac{1}{8}''$ (13 × 18 cm).

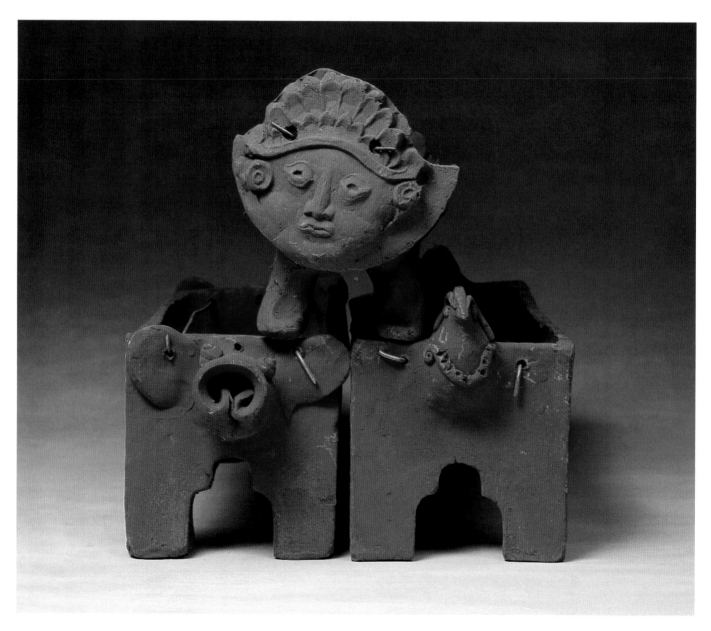

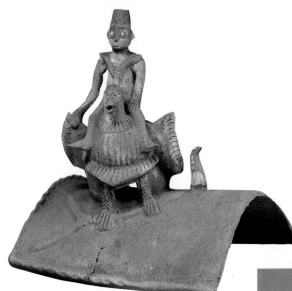

36 *Above* The Hindu god Vishnu flew on the back of the eagle, Garuda. In old Javanese terracottas, heroic male figures are mounted on cocks instead. Roof gables are traditionally ornamented with figurines of cocks, or bird riders that symbolize masculinity and the brightness of day. Mayong, north Central Java. $17\frac{3}{4}'' \times 14\frac{5}{8}''$ (45 × 37 cm).

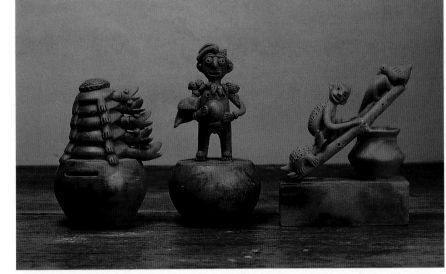

37 *Right, above* Earthenware money boxes. Turtles (on the left). H $5\frac{1}{8}''$ (13 cm). Son of the South Sea Goddess (in the centre). Ratu Kidul, the goddess, protects the royal houses of Yogyakarta and Surakarta. On the coast at Parangaritis, where the currents are swift and dangerous, she takes the lives of unwary young men clothed in her sacred colour of green. They become her sons and are adorned in suitably submarine court dress. A Man and his Pets (on the right). Many Javanese families have dovecotes and pet songbirds. Turtles and lizards are also popular as pets as they eat mosquitoes. Hand-modelled by Therese Waryarti of Yogyakarta, Central Java.

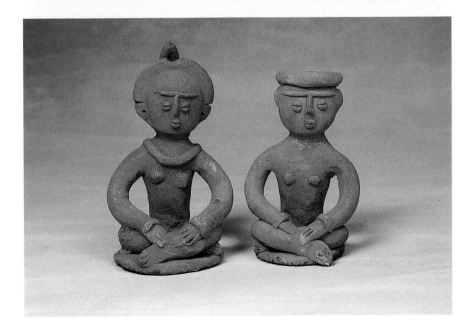

38 *Right, below* Hand-modelled terracotta dolls from Takalar, South Sulawesi. The height of the female figurine on the left is $5\frac{1}{4}''$ (13.5 cm).

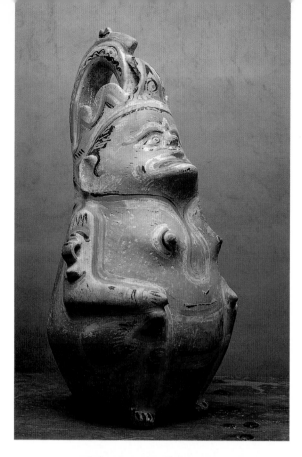

39 *Left* Large money box resembling Semar, a character from traditional drama. Semar is a clown and yet a god, but does not usually wear a crown. He is earthy, a little untidy, but full of sympathy and great wisdom. Earthenware and commercial paint. Kasongan, Central Java. H 26″ (66 cm).

40 *Below* Earthenware cow with clay bead necklace. Plered, West Java. $20\frac{1}{8}″ \times 15\frac{3}{8}″$ (51 × 39 cm).

41–44 *Opposite (clockwise from top left)* Earthenware gourd-shaped money boxes, decorated with commercial paint. Collected in Yogyakarta, Central Java, and probably made at Kasongan. H approx. $5\frac{7}{8}″$ (15 cm). Gourd- and fruit-shaped money boxes are common in Indonesia.

Painted earthenware bird whistles. Collected in Jakarta, Java. L approx. $2\frac{5}{8}″$ (6.5 cm).

The cock-shaped earthenware money box, decorated with commercial paint, was collected in Surakarta, Central Java. H $11\frac{3}{8}″$ (29 cm).

Hen-shaped earthenware money box decorated with commercial paint. Kasongan, Central Java. H $9\frac{5}{8}″$ (24.5 cm).

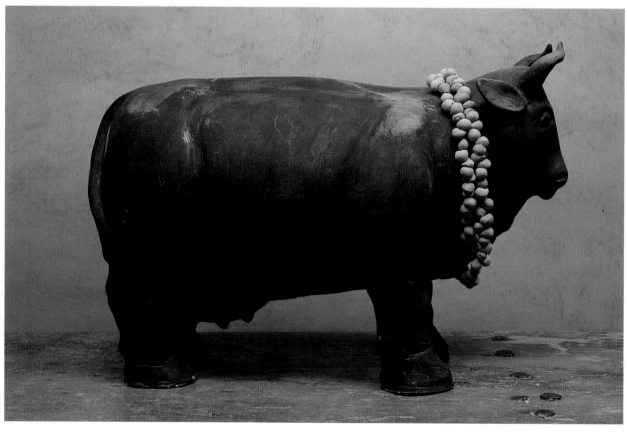

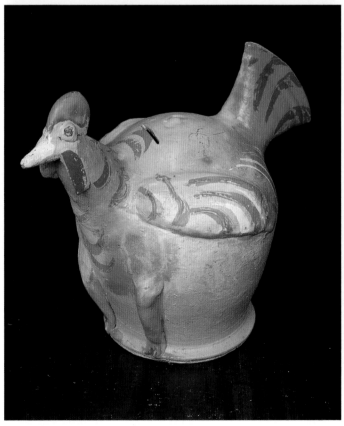

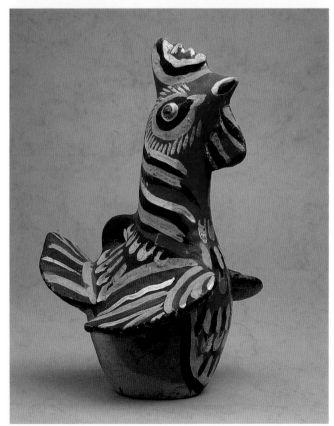

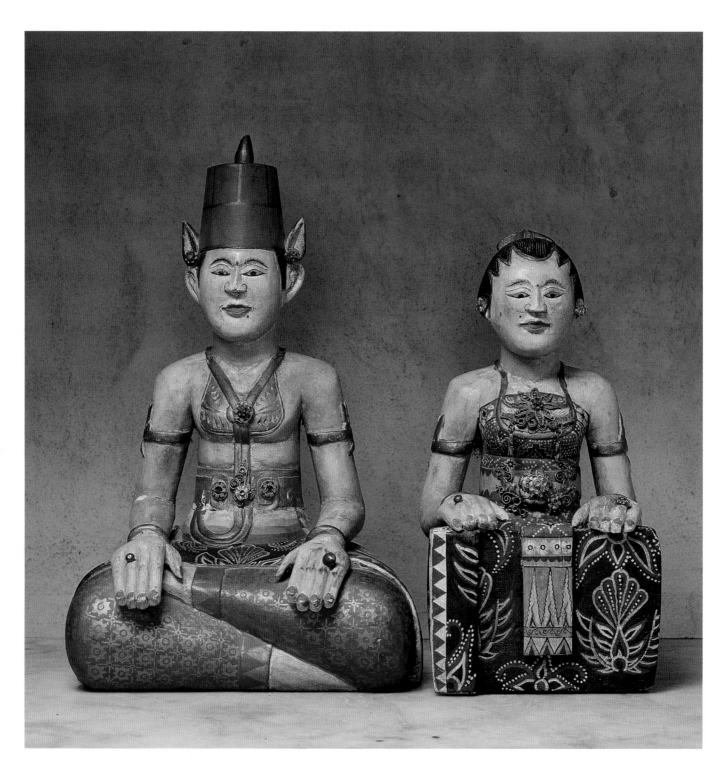

WOOD, BONE, HORN AND STONE

The branches of the tree of life reach up into the sky, and its roots plunge deep down into the soil; it is a symbol of unity and power because it inhabits the upper and lower realms of the cosmos. Images of the munificent tree are found in textiles, wood and also in poetry, as in this example from the Minangkabau *Si Ramboen Djaloee*:

> Fruits hang like small diamonds,
> twigs bear copper and gold.
> On the boughs are bees,
> a parrot alights near the summit.

The spirits of the tree must be propitiated before it is felled, and house posts are planted in the ground so that the grain runs up from root to tip.

A house is suffused with life and energy; posts and lintels are male and female. There are a variety of ways in which a dwelling can be imagined: as a human body with a head, feet and limbs and with a navel at its innermost core; as an ancestral ship with a rising prow at the front; or as the body of a protective water buffalo represented by the carved heads on Batak and Toraja facades and the horned gables on houses from North Sumatra to Timor. Internal spaces may also be experienced as maternal; their intimacy, safety and potential as a source of renewed vitality are associated with the womb. Cosmic duality is reflected in the meaning of upper and lower, dark and light, left and right and back and front spaces. A house is a transformer; as such, it tames the terrifying vastness of the universe and at the same time inflates human concerns with cosmic grandeur. Its structures mirror the system of thought by which social, religious and psychic reality is ordered.

In Islamic coastal communities, stilted wooden houses are graced with shutters, fretworked verandas and balustrades which recall Edwardian summer-houses. Toba Batak houses are carved and painted with black, lime and red ochre interlocking curlicues, lizard earth spirits, rounded breasts and protective figures of the composite protective mythic beast, the *singa* (lion). Minangkabau houses with massive sweeping roof lines and rearing gables suggest the heads of water buffaloes. Walls are carved with vertical bands of scrolling patterns painted in bright red and green and inset with flashing mirrors so that houses appear like sumptuous tents. In the Belu district of West Timor, doors have breasts and protective buffalo-horn motifs, and the jambs are carved with geometric patterns of birds and lizards. The pillars and doors of Dyak longhouses are carved with lizards, serpents and dynamic swirling *asoq* (dragon-dog) motifs. Painted

45 *Loro blonyo* figures representing Dewi Sri, the rice goddess, and her consort, Sadono, bring fertility and prosperity to the Javanese home. They are traditionally placed by a bed similar to that illustrated in plate 50. They are carved in softwood, decorated with commercial paint and ornamented with small base-metal items of jewelry set with glass stones. Their dress is based on the wedding costumes of the royal court of Yogyakarta. The traditional Javanese wedding is considered to be a re-enactment of the birth of the universe, and the design of various items of clothing is dense with symbolic association. The figures were made in Sentolo, south of Yogyakarta, Central Java. H of the figure of the groom $14\frac{3}{8}''$ (36.5 cm).

wooden sculptures of wildly curling human figures and hornbills ornament the roof lines of Kenyah Dyak houses and funerary structures. In many Indonesian societies, graves are sometimes described as the houses of the dead or those from which no smoke rises, and are modelled on those of the living. The traditional house, with its rice barns, shrines, guardian figures and ancestral effigies is lavished with decoration which communicates its immense significance.

Indonesian furniture was, in the past, restricted to storage chests, low stools and worktables. Some of these, such as the massive chests with *singa* heads owned by Toba Batak aristocrats, were ornamented with forceful carvings. Most people sat, ate and slept on woven mats. The megalithic culture of Nias island, to the west of Sumatra, is notable not only for the majesty of its architecture and stone plazas, but also for the manufacture of ceremonial stone seats and the wooden versions of these that are used inside houses. Stools, chairs and tables are ornamented with lizards and the *lasara*, a creature combining crocodile, tiger, deer and hornbill features. Human and animal bodies form supporting caryatids. The Portuguese origin of Indonesian words for table and cupboard indicates the comparatively recent adoption of these furniture forms.

European and Chinese influence is thus very evident in the furniture of coastal Islamic communities. As in India, European furniture was adapted to the tropical climate and local materials and tastes in ornamentation. The traditions brought by Dutch East India Company traders and by former slaves of the Portuguese and Chinese mercantile communities fused into a style that became distinctively Indonesian and was adopted by local elites. Wooden sections were carved with native floral, vegetal, bird and animal motifs and were often painted or lacquered. Seats were woven in rattan and tables topped with cool marble instead of polished wood.

The graceful simplicity of eighteenth-century European classicism, the more florid ornamentation of the nineteenth century and the European Art Nouveau style, which is thought to be a partial adaptation of Javanese aesthetics, have all been absorbed into Indonesian furniture forms. Most items are hand- rather than machine-carved; claw feet have a prehensile energy, and the scrolling ornament a liveliness which is absent from much of the mass-produced furniture of the Victorian and Edwardian periods.

Chinese influence at the Palembang court in South Sumatra accounts for its long tradition in lacquerwork. Cupboards, tables, betel serving boxes, jardi- nières and baskets are painted deep red or gold, covered with black ink paintings of flowers and coated with a lacquer derived from ants' nests. Chinese craftsmen working in Bali also had a noticeable impact on the style of decoration on the colourfully painted carving on doors, window lattices and pillars.

The enormous ceremonial beds used for wedding festivities in the Islamic communities of coastal Sumatra, Kalimantan, Sulawesi, Java and Madura are embellished with motifs of flowers, birds and stylized lotuses that are often painted in the Chinese style in red and gold. Other beds have latticework walls of intricately carved and gaily painted leaves, sunflowers and roses and graceful triple-arched entrances reminiscent of Mogul architecture. In Java, such beds (*kobongan*) were used as shrines to Dewi Sri, the goddess of fertility whose attributes combine those of Aphrodite and Demeter.

A nineteenth-century Modang Dyak mausoleum in Kalimantan decorated with carved hornbills and painted dragon motifs. Similar ornament is used on some contemporary buildings.

A Minangkabau house in West Sumatra. Wall panels are carved and sometimes gaily painted, and gable horns suggest those of the buffalo.

The nine Islamic saints or *wali songo* began their mission of converting the Javanese to Islam in the coastal towns of the north. Islamic disapproval of the representation of human and animal forms resulted in a style of carving on doorways and walls in geometric and leafy designs of such vitality and refinement that it has rarely been excelled outside Indonesia. Screens and lattices of polished teak, which were designed not only to divide houses into public and private areas, but also to allow for the circulation of cooling air, are especially notable for the excellence of their craftsmanship.

Jepara is a historic and important centre for this type of carving. At the turn of the century, Raden Ajeng Kartini, daughter of the Regent of Jepara and an early feminist, nationalist and author, was passionate in her patronage of local craftsmen, and encouraged them to develop small, saleable products such as the little boxes, buttons, chess sets and picture frames that are sold in Jepara today. Unpainted screens, chests, modern and four-poster beds and baroque armchairs are also carved in teak, mahogany and ebony in the town and nearby villages. Furniture in the Jepara style is carved by cabinet-makers in other towns in Java.

Blue, green, red and yellow paint is used on the bolder carving of stylized leaves and flowers, birds and distinctively Indonesian dragons on the traditional furniture of the island of Madura. Barley sugar and Classical columns suggest European influence. The red and gold paintwork on chests with elaborate mirror frames and on stepped pyramidal spice or jewelry boxes reflects a taste for Chinese style as well. Brass or iron handles allow large chests to be pulled along with ease.

At Kardaluk and Sumenep, in the southeast of Madura, wardrobes, screens, four-poster beds, huge ornamental bird cages and carved chests and wardrobes in various stages of completion spill out from roadside workshops. Cabinet-makers work in pairs to saw the teak and cheaper hardwood logs into planks. Work is carried out with the simplest of tools, and, like other traditional Indonesian furniture, that of Madura is made without nails or screws. Until

recently, the paints used had an unstable, pigmented lime base which deteriorated rapidly into a chalky softness, but some cabinet-makers have now turned to the bright gloss paints used by local boat builders.

Minangkabau carvers of Pandai Sikat, in West Sumatra, continue to produce banded leafy wall panels for clan houses, as well as ornate doors for smaller modern homes and wardrobes with traditional carving. Torajan wood-carvers in K'ete' Kesu', near Rantepao in South Sulawesi, have borrowed motifs from house and rice barn walls to decorate plaques, boxes, trays and panels with interlocking spirals and fine incisions filled with black, white and red pigments.

Some Indonesian societies have recently experienced profound changes which are reflected either in alterations to, or even the entire loss of, some forms of traditional carving. Some evangelical Protestant missionaries have discouraged the production of ritual artwork essential to communication with ancestral spirits in several parts of Indonesia. However, in Catholic communities, the preservation of some ceremonies and traditional ornamentation on utilitarian items and communal buildings used for worship is actively encouraged by the Church. Catholic missionaries have also played a role in reviving the traditional craft of wood-carving, which had all but disappeared, in the Tanimbar islands of Maluku. Spindly, but elegant, figures are carved in Tumbur and sold in Saumlaki, Ambon and very occasionally in Jakarta and Bali.

The case of the Asmat of the southern coastal swamplands of Irian Jaya provides an example of the effects of social and spiritual dislocation on the meaning and purpose of traditional art. Among the Asmat, beliefs about personal identity, social status and the accumulation of spiritual power for the community were, until fairly recently, bound up with ceaseless inter-tribal conflict. Battle shields were carved dynamically with motifs that invoked victory for the head-hunter; canoe paddles displayed images of those who had been taken by the enemy. Memorial *bis* poles up to twenty-six feet (eight metres) high were carved with figures of the vengeful dead and the mythic birds and animals that inhabit the Asmat spirit world. Michael Rockefeller, who disappeared mysteriously near Agats in 1961, considered the ritual artwork of the Asmat to be exceptionally powerful. In the early 1960s, the celebration of warrior culture in wood-carving was prohibited as part of the Indonesian government's determination to extirpate head-hunting and cannibalism. To restore meaning and self-respect to the disoriented Asmat, the United Nations, the Indonesian government and the Catholic Crosier Fathers developed co-operative projects at Agats to encourage the production and marketing of traditional carving. Shields, plaques, poles, drums, sago bowls and open-work canoe prows are carved from hardwoods and the sacred mangrove, rubbed with shells and stained with lime, charcoal and red clay dye.

On the island of Nias, prior to conversion to Christianity, striking wooden figurines of dead noblemen were kept inside houses to grant protection to the living. Through these, contact could be made with the dead in the world beyond to inform them of important events and to call on them to exercise their powers of positive intervention. Ancestral figures with tall or triangular branching crowns were placed in altars, fixed to house posts, lashed together and suspended on carved interior walls. Most of the original figures were burned by missionaries or removed to European museums. The new ones offered for sale have an

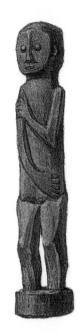

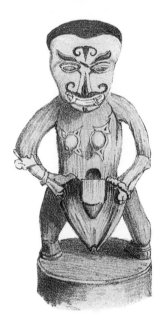

A wooden statuette from East Kalimantan (*top*) and a nineteenth-century dragon-faced painted sculpture.

ambiguous role in contemporary religious thought in Nias, and may be best assessed as symbols of ethnic identity and admired for the quality of their carving.

Since the early decades of the twentieth century, the Lake Toba district in North Sumatra has been an established destination for tourists and collectors. Christian Batak craftsmen living around the lake carve charm figurines and shaman's wands with the upper section of the shafts composed of mythic human figures rising one above another to a tuft of hair at the top. These are rarely in use today. Carvings on sale display, to a greater or lesser extent, the dynamic Batak sculptural style with its motifs of the protective *singa* head, heroic mounted riders, birds and reptiles. There are noticeable variations in the sculptural qualities of the wood-carving of the past, as well as that produced today.

Utilitarian items that have a role in contemporary life, such as small items of furniture, musical instruments, toys, containers, storage chests and implements for cooking and preparing food, may be of more interest to some collectors. A two-stringed Toba Batak lute (*hasapi*) ornamented with a carved figure, if it has been made as a genuine instrument with good tonal qualities, is of considerable interest to musicians. It also has the advantage of being in common use at dances, funerals and weddings. In Torajan mountain villages near Rantepao, in South Sulawesi, bowls and spoons with geometric and simple zoomorphic sculptural decoration are carved from a single piece of wood. These are used for serving food at funerary and agricultural ceremonies.

Ritual artefacts and practical items for daily life in Central and East Kalimantan are made for local use. Serving bowls, stools and low tables for beadwork are carved with dragon forms in ironwood or mahogany. Bahau wooden baby-carriers are ornamented with friezes of protective motifs. Shamans carve sickness figures which are placed in miniature boats and floated down the river to carry illness away. Small wooden effigies are positioned in various parts of a village to confuse the spirits of disease and ill fortune; bundles of tiny charm figures bring good luck. The tall funerary poles representing ancestors that stand outside longhouses and guard tombs are also carved by shamans. Crouching human and animal figures watch over the fields.

Little ironwood carvings and other handicrafts are occasionally offered in small settlements and those villages more accustomed to receiving visitors, such as Tanjung Isuy and Mancong. Painted shields and copies of ritual artefacts are commissioned by art dealers in Samarinda and Balikpapan from a small number of carvers in villages such as Tering Lama and Long Bagun Hilir on the middle Mahakam river. Immigrant Dyak families in the towns also produce copies of traditional artefacts for sale.

Dyak carving techniques are unusual in that the long-handled, short-bladed knife is held in position between the upper arm and torso, leaving the hands free to direct the knife accurately. The body of the carver applies force against the knife and wood. Ironwood must be chipped with a heavy adze, and now modern chisels are used as well. Most Indonesian carving is done with hand-held knives, and chisels and mallets are used so that the wood is chipped away from the body of the carver. Bone and horn utilitarian items are also decorated with carving. The deer-horn handles of Dyak cutlasses, which are carved with *asoq*, serpent,

reptile, human and plant motifs, are some of the finest examples of Dyak artwork.

Hollowed bones and horns used to hold lime for betel chewing are simple sculptural works in their own right. In central Timor, containers are incised and stained with geometric motifs and stylized lizards; wooden stoppers are carved in the form of a human head or a bird. Horses of carved bone form the hilts of Sumban swords, and tortoiseshell is fretworked with bird, reptile, deer and horse motifs on the tall hair combs worn by Sumban women. At Ambon, in Maluku, sprays of roses are inlaid in mother-of-pearl on trays and plaques. Ivory tusks are carved with Hindu subjects in extraordinary detail at Tampaksiring and Bangli in Bali; some tiny lizards, demons, deities and Buddhas carved in bone are almost as refined in their workmanship as Japanese netsuke. Balinese ivory, tortoise-shell and carved bone and horn boxes are ornamented with silver. Crescent-shaped Karo Batak medicine containers are carved from horn and ornamented with *singa* heads and human figurines. Toraja knife handles are carved with *naga* dragons in protective buffalo horn, and the ceremonial horn spoons of Timor are outstanding for the delicacy of their geometric, bird and reptilian motifs. The horn handles of Lombok betel nut crushers display humour and precision in a more sculptural rendering of human figures and birds.

Lombok's proximity to Bali's tourist market has created specialist craft communities in villages such as Gunung Sari, near Mataram, Beleka, in central Lombok, Senanti and Sukaraja. Ornamental boxes, gaily painted wooden horses on which Muslim boys are borne to their circumcisions and toys are carved and painted in traditional styles. Adaptations of ethnographic art forms, such as masks and primitive supporting figurines for clothes hangers, are imaginative, but entirely inauthentic.

Dutch control of Bali was not complete until the end of the first decade of the twentieth century. Until then, royal and aristocratic patronage of artists and craftsmen had remained undisturbed, and the island's great agricultural wealth had not been subjected to colonial rationalization or the economic and cultural distortions created elsewhere by the colonial plantation system. *Pratima* (small figures of the Hindu gods with large animal and bird vehicles) and characters from myth and folk tale provided a host of animal forms for decorative purposes: frogs or monkey warriors formed racks to hold krises; *naga* bared their teeth at the bottom of mirrors; swans sacred to Saraswati, the goddess of music and poetry, framed musical instruments. Statues of Garuda (the eagle steed of Vishnu) were placed in ceiling spaces where supporting pillars met transverse roof beams.

By the 1930s, the Western artists Walter Spies and Rudolph Bonnet were already living and working on the island and beginning to influence the direction Balinese arts were to take. Economic pressures brought a decline in court and temple patronage, but the increasing number of fashionable Western visitors to the island provided traditional artists with new means of support. Spies and Bonnet donated Western artists' materials to painters in Ubud, Batuan, Mas and Sanur. Startlingly fresh paintings of ordinary peasant life showed people working in the rice fields, shopping at crowded markets, preparing for festivals and performing dances. These still owed a great deal to the painstaking linear detail and shallow picture plane of traditional work and showed the same

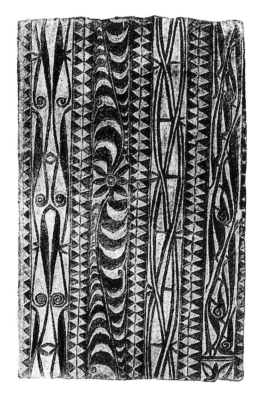

Detail of a carving and painting on a Batak house column in North Sumatra. Traditional paintwork is coloured white, black and red ochre.

pleasure in minute detail as medieval and Persian miniatures. Tiny monsters and glimpses of insect and plant life could fill the canvas. Religious themes were presented more naturalistically; in traditional painting, figures were extremely stylized, and dramatic action was presented sequentially in cartoon form. Characters and episodes became detached from the narrative to form subjects in their own right, and the demonic aspects of Balinese culture expressed in drama and dance could be explored in permanent visual form.

Today, Batuan style paintings reflect current Balinese social and economic life by including surfing and camera-wielding tourists along with local fishermen and tiny cavorting sea creatures, butterflies, birds, flowers and wildly curling waves and plants. I Made Budi is perhaps the most admired of Batuan's painters, and his subject matter reflects his interest in the collision of contemporary experience and traditional values.

In the mid-1950s, the Dutch artist Arie Smit introduced young boys in Penestanen to Western paints and brushes. They painted naive, but vigorous images of their world which were bolder in colour and coarser in line than those of the prewar generation. These bright and distinctive interpretations of Balinese life continue to be produced by the Young Artists' or Peasant Painters' school.

Wood-carvers in the 1930s also began to sell their work to outsiders; just as the new paintings were framed for sale, wood was carved without an architectural or religious purpose. With the redefinition of wood-carving as sculpture, the custom of applying paint was overshadowed by new interest in the textures and colours of exposed timber. The work of twentieth-century Western sculptors like Alberto Giacometti and Constantin Brancusi, which emphasized non-functional abstracted forms, could not have been more remote from the spirit of traditional Balinese wood-carving, with its wild and colourful demons, heavenly nymphs and magically protective deities. And yet some carvers, influenced, no doubt, by the tastes of resident Western artists and the emerging tourist market, began to produce radically simplified sculptural works that displayed exceptional sensitivity to local woods.

Lively, individualized carvings of the Hindu deities and surreal and expressionistic figurative forms are now produced by a number of successful sculptors working in and around the villages of Mas, Batuan and Kemenuh. Technical excellence is the standard by which works of art are measured traditionally, and realistic figures of dancers and fishermen are also carved with extraordinary attention to detail. Other carvers prefer to work with trunks, twisted roots and branches, wood damaged by parasites, or pieces retaining their bark coating.

In Batubulan, the carving of light, grey volcanic tuff into Hindu gods and protective gargoyle masks for gateways and temples is largely unaffected by tourism, because the stone sculptures are a little too bulky and brittle for convenient air transport. However, stone carvings on temples on the north coast of Bali share some of the humour and whimsy of wood-carving and painting: at Kubutambahan, a man rides a bicycle with flower petals in the wheel spokes; and at Jagaraga, a bandit holds up plump Europeans in a Model-T Ford; a Dutch steamer is attacked by a sea monster and an aeroplane plunges into the sea. Columns of stone frogs are used as garden ornaments, and carved panels illustrating epic literature are set into the walls of brick buildings.

Many carvers prefer to continue the tradition of painting carved wood. Garuda statues, which increasingly tend towards the gigantic, are carved and brightly painted at Pujung; however, other craftsmen have adapted or abandoned traditional forms. Flying goddesses recall the *widyadhari* (heavenly nymphs) and the hanging altars suspended over sleeping babies for the god of infants, Sanghyang Rare Kumara. Dangling mermaids peer into mirrors to enjoy their own beauty like legendary nymphs and the goddess of the Southern Ocean. Balinese folk tales and the popular culture hero, 'Superfrog', partly account for the bright green frogs carrying leaf umbrellas, dancing the lambada and driving Volkswagens. Like the recent paintings from Batuan, these colourful woodcarvings also record contemporary Balinese life. Cocks and frogs, dressed in resort fashions and armed with Japanese cameras, reflect back the tourists' own image. Balinese perceptions transform themes taken from television, American films and magazines, books and catalogues on Western art and contemporary popular culture, as well as those on the art of other Indonesian societies.

New ideas are endlessly copied, and respected sculptors do not necessarily do all their own carving. The work of Ngurah Umum of Gianyar, the originator of colourful wooden ducks, and Nyoman Togog of Peliatan, who created the first miniature tree and tropical fruit carvings, is reproduced in numerous workshops. The gracefully elongated and rounded reposeful bodies carved by Ida Bagus Nyana and his son, Ida Bagus Tilem of Mas, are constantly imitated by other craftsmen. Art markets and tourist shops are crowded with wares; carvers and painters without established retail outlets must hawk their work.

Signs along the roads in the carving villages and numerous galleries and workshops read, 'Son of the First Frog Carver'; 'Family of Young Artist'. In staking a claim to creative originality and the vicarious authority of the master as well, these express, perhaps better than anything else, the conflict between artistic individualism and the values of traditional ateliers and craft communities in which new techniques and ideas were automatically handed on and made available to all.

46 This chair, carved from a solid log, is typical of some Javanese country furniture made in hill villages or in districts where timber is available, as well as the more common bamboo. The rice pounder, with the carved lizard symbolizing agricultural fertility on the handle, is from north Lombok. With the introduction of modern strains of rice and mechanical mills, the use of rice pounders and the songs and games that accompanied the husking of the grain are disappearing. H of chair $38\frac{5}{8}''$ (98 cm).

47 *Left* Seat carved in teak and decorated with lime-based paint. The back is ornamented with propitious *naga*. Collected in Sumenep, Madura. $36\frac{5}{8}'' \times 51\frac{5}{8}''$ (93 × 131 cm). The large pot on the right is Chinese.

48 *Below* Cupboard made of carved teak with a hardwood carcase. The carved columns, which are common in Madurese architecture and furniture, suggest European influence. The cupboard is decorated with lime-based paint and was collected in Sumenep, Madura. $65'' \times 50\frac{3}{8}''$ (165 × 128 cm). The old bowls, which are common in Indonesia, were imported from China.

49 *Left* Teak chest carved with flowers and leaves decorated with oil paint. Iron handles and wooden wheels enable this small, but heavy, chest to be moved easily. Collected in Sumenep, Madura. Approx. 21″ × 34″ (53.5 × 86.5 cm).

50 *Below* Ceremonial marriage bed made from carved teak with a hardwood carcase and decorated with lime-based paint. *Loro blonyo* figurines (pl. 45) are traditionally placed by such a bed along with cosmetic containers, jewelry boxes and decorative mirrors. The figurines may also be placed before a similarly carved screen. Either may be used to represent a shrine for the goddess Dewi Sri, whose attributes are a combination of those of Aphrodite and Demeter. This bed was collected in Surabaya, East Java. 108¼″ × 99⅝″ (275 × 253 cm).

51 Split bamboo and wooden cupboard collected in Yogyakarta, Central
Java. The pottery is from Kasongan and Plered in Central and West Java.
The basket and broom are Balinese and are typical of utilitarian wares offered
in markets in many parts of Indonesia. H of cupboard 68½″ (174 cm).

52 *Opposite* (*inset*) Detail.

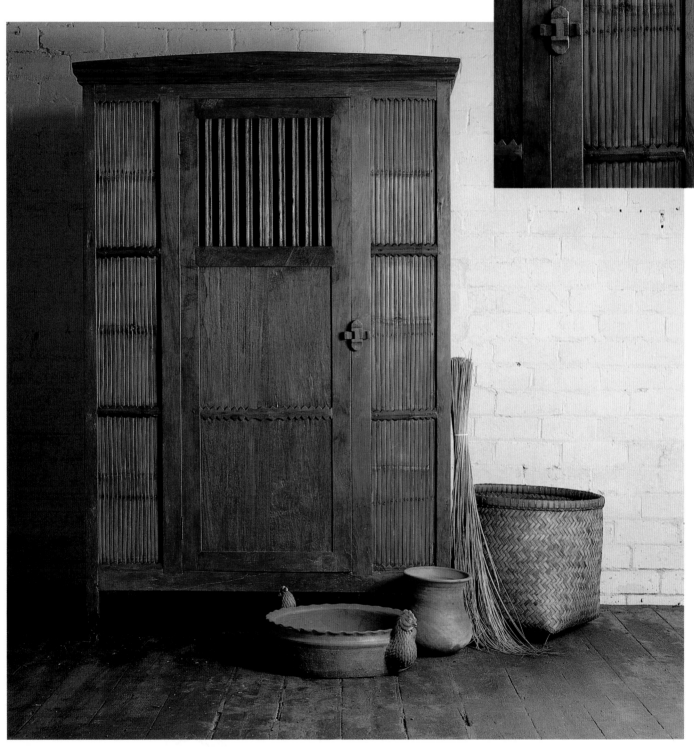

53 *Above* Bird cages from central Lombok are made with carved and stained wood, split bamboo and woven wire. The wire cages may also be used as bird traps. An additional thin bamboo stick smeared with a sticky substance is fitted into the frame to provide a perch. Alighting birds are swiftly dispatched into the cage. Each wire cage is approx. $23\frac{5}{8}''$ (60 cm) from hook to base.

54 *Right* The bird cage on the left is from Yogyakarta, Central Java, and is made of painted tin, wire and carved wood. That on the right was collected in the Jakarta bird market and is made of painted wood. The sliding door is one of many available in the market that are carved with the heads of comical characters from traditional drama. H $17\frac{3}{4}''$ (45 cm). The painted wooden cupboard is East Javanese.

55 *Right* Baby-carrier of carved white *meranti* wood inlaid with pig bone and decorated with pig teeth, beads and a brass bell. The motifs and added decorations protect the baby from harm. Bahau Dyak people, Long Hubung district, Middle Mahakam River, East Kalimantan. H 14¾″ (37.5 cm).

56 *Below left* Flask carved from softwood in Kenyah style, with stylized double dragon and foliate motifs carved on the side. The form is similar to that of the decorative gourds used to hold the flights attached to blow-pipe darts. Collected in Samarinda, East Kalimantan. With the stopper in place the container is 10¼″ (26 cm) high.

57 *Below right* Bahau Dyak stool of ironwood carved in an *asoq* (dog-dragon) shape and inlaid with shell. Middle Mahakam River district, East Kalimantan. L 15¾″ (40 cm).

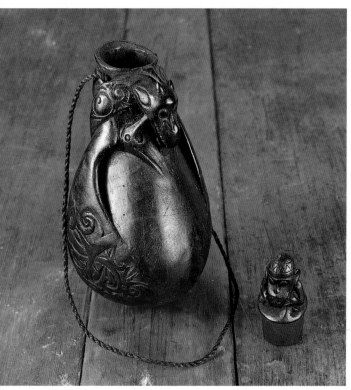

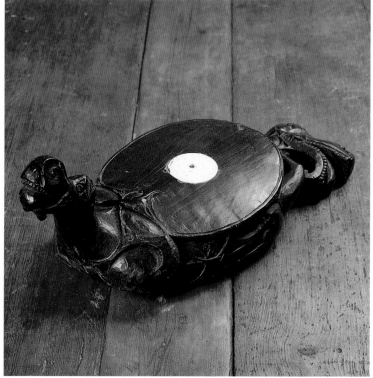

58 *Above* Asmat decorative shield made of carved and stained mangrove wood. Ancestral figures ornament the top, the turtles symbolize fertility. Sawa Erma, Agats district, Irian Jaya. H 40¼" (102 cm).

59 *Right* Wooden ancestral figurines holding betel containers. Tumbur, Tanimbar islands, Maluku. These were taken on sea voyages and placed on house altars to offer protection and guidance. The taller one is 11¾" (30 cm).

60 *Left* Ceremonial buffalo-horn spoons carved in Tetum style. The motif of the cross suggests the integration of Christian symbolism into the traditional Timorese repertoire of motifs. Central West Timor. L 5⅓″ (13.5 cm).

61 *Below* Torajan carved softwood serving dishes and spoons are used at formal festivities, funerals and weddings and to honour guests. Collected in Rantepao, South Sulawesi. Footed bowl 4½″ × 7½″ (11.5 × 19 cm).

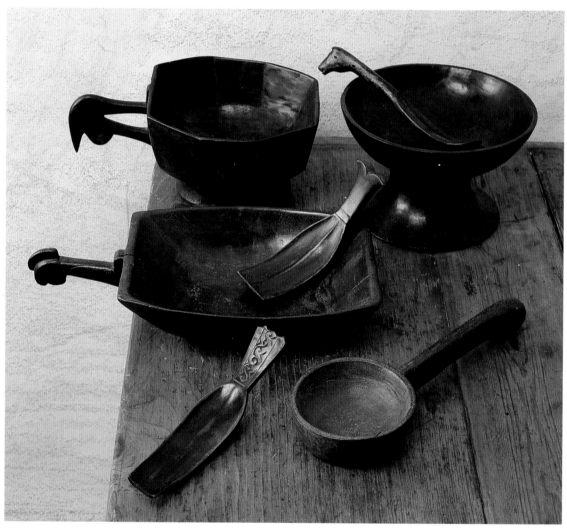

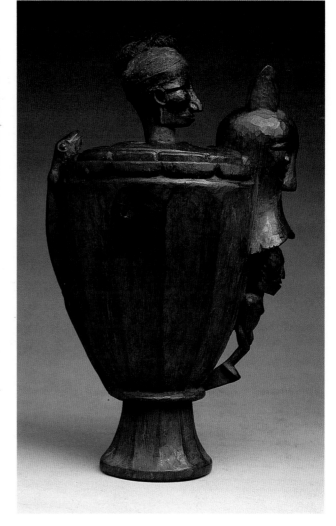

62　*Top*　These mahogany lacquered boxes were painted, decorated with ink drawings and lacquered in Palembang, South Sumatra. D of the largest $9\frac{3}{8}''$ (24 cm).

63　*Right*　Lidded wooden container for medicinal herbs carved with an ancestral head, a lizard earth-spirit and a protective *singa* (lion-like beast). Toba Batak, Lake Toba, North Sumatra. Wood, hair, cloth. H $12\frac{5}{8}''$ (32 cm).

64　*Above*　Balinese hardwood offering stand and birds carved in softwood. All are decorated with commercial paint. Offering stands are turned on a lathe and painted as above or in bright red and yellow. They are used as a base for tall towers of fruit and colourfully dyed and wrapped rice offerings. H of birds $7\frac{1}{2}''$ (19 cm); offering stand $9\frac{7}{8}'' \times 13\frac{3}{8}''$ (25 × 34 cm).

65 In Nusa Tenggara, *tongal* (wooden boxes) are attached to a belt
or strap at the waist and used for carrying jewelry or money. These are from
East Sumba and the largest measures 5⅞″ × 5⅞″ (15 × 15 cm). The cloth behind
is made from artificially and naturally dyed cotton yarn and was handwoven
in Flores, Nusa Tenggara.

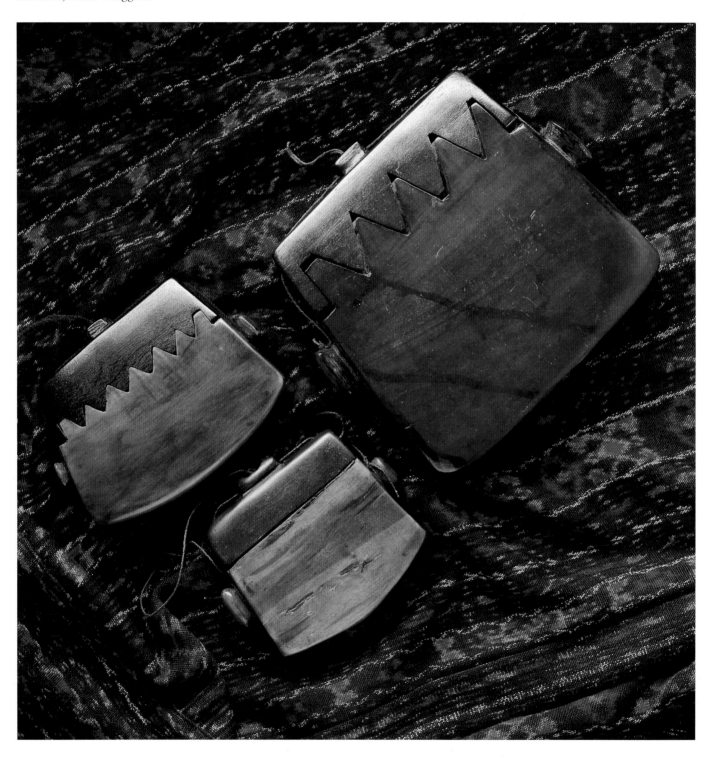

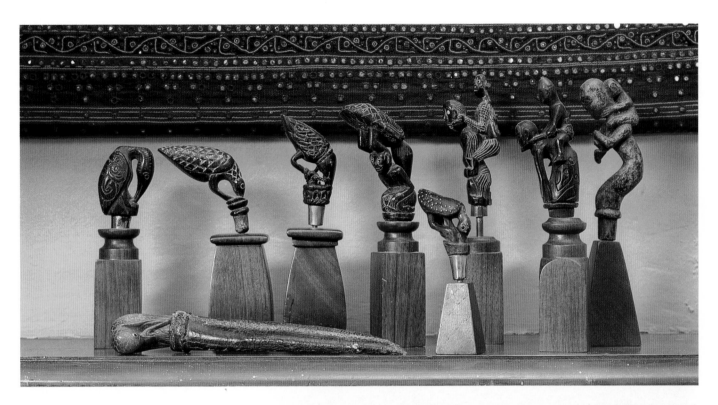

66 *Above* A collection of carved buffalo-horn handles for betel nut crushers. Central Lombok. Nuts are placed in the bottom of a hollow bone or horn tube and crushed with an iron prong or blade that is forced up and down inside. The handles provide an opportunity for carving birds, animals and scenes from folktale and also for ribald humour. The long-necked bird handle on the left is 6¾″ (17 cm) high. The cloth behind is an old Kauer *tapis* from southwest Lampung, South Sumatra.

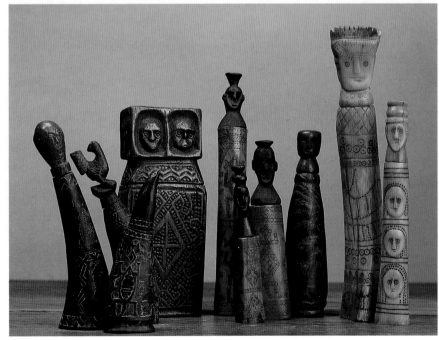

67 *Right* Carved wood, horn and bone lime containers. The pale bone containers on the far right are from east Sumba; the others are from the Soe district in West Timor. H of tallest container 9⅜″ (24 cm).

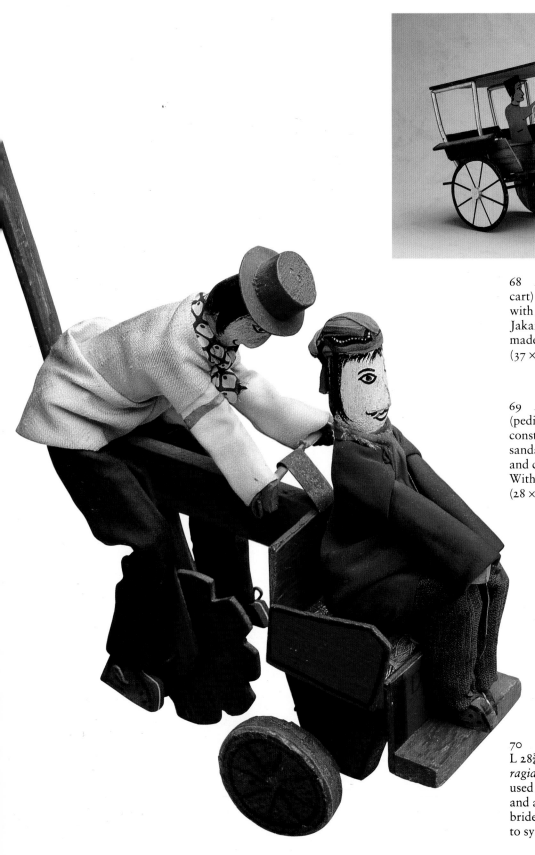

68 *Above* Javanese toy *dokar* (horse cart) made of plywood and decorated with commercial paint. It was collected in Jakarta, but is typical of wooden toys made in Central Java. $14\frac{5}{8}'' \times 8\frac{1}{4}''$ (37×21 cm).

69 *Left* The push-along toy *belak* (pedicab) with a driver and passenger is constructed from painted wood, rubber sandal and wire. It was made in Jakarta and collected from a street pedlar. Without the handle it is $11'' \times 9\frac{3}{8}''$ (28×24 cm).

70 *Opposite* Toba Batak *hasapi* (lute). L $28\frac{3}{4}''$ (73 cm). The Toba Batak *ulos ragidup* (pattern of life) cloth behind is used for a variety of ceremonial purposes, and at weddings it is draped over the bride's mother by the father of the groom to symbolize the joining of the families.

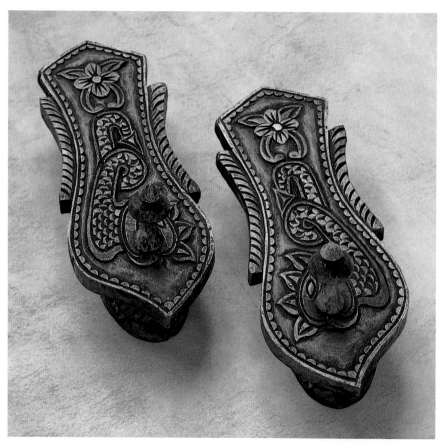

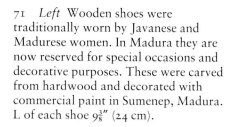

71 *Left* Wooden shoes were traditionally worn by Javanese and Madurese women. In Madura they are now reserved for special occasions and decorative purposes. These were carved from hardwood and decorated with commercial paint in Sumenep, Madura. L of each shoe $9\frac{3}{8}''$ (24 cm).

72 *Below left* West Lombok tobacco boxes carved from hardwood and decorated with commercial paint. H of frog lid box $7\frac{1}{2}''$ (19 cm).

73 *Opposite* One of a pair of Balinese lion figures from the Tantra workshop in Mas, carved from *udu* wood and decorated with acrylic paint. Most traditional Balinese carving was for architectural decoration, and the two lions are intended to be placed on either side of a doorway. H $17\frac{1}{4}''$ (44 cm).

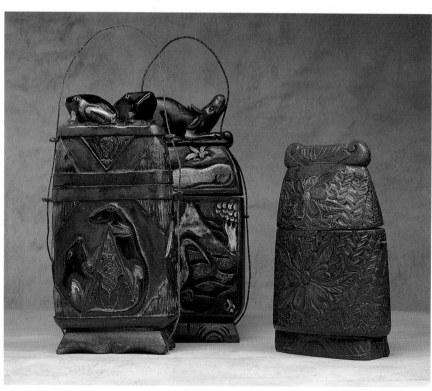

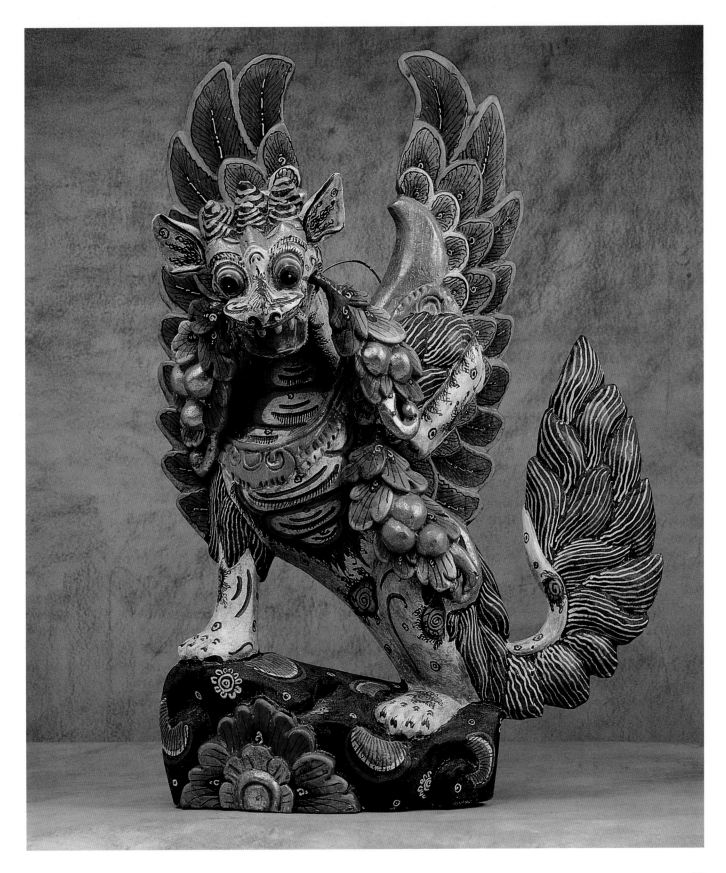

74 *Left* This painting presents images of ordinary village life: collecting water at the river, fishing, a man working in the terraced rice fields and an ornamental gateway and shrines. Peasant Painters' (Young Artists') School, unsigned, Penestanen, Bali. Acrylic paint, 26″ × 34¾″ (66 × 88.5 cm).

75 *Below* Village football game. Painted by I Wayan Arnawa, Campuan, Penestanen, Bali. Peasant Painters' (Young Artists') School. Acrylic paint, 25¼″ × 33½″ (64 × 85 cm).

76 *Opposite, above* Contemporary Batuan style painting. The painting shows the diversity of modern Balinese life: village activities, cars, bicycles, tourists and a cremation procession with the high tower being taken to be incinerated. Painted by I Wayan Bendi. Batuan, Bali. 11″ × 17¼″ (28 × 44 cm).

77 *Opposite, below left* Village and paddy fields. Painted by Karsa. Ubud, Bali. Acrylic paint, 10¾″ × 14¼″ (27 × 36 cm).

78 *Opposite, below right* Batuan style painting of the exorcistic *calon arang* dance, with the protective lion-like *barong* to the left and the widow-witch on the right. Painted by I Made Sudana. Batuan, Bali. Watercolour, 4¾″ × 6¾″ (12 × 17 cm).

79 *Left* Wood-carving of a sleeping boy. *Panggal buaya* (crocodile teeth) wood. Mas, Bali. H 12⅝″ (32 cm).

80 *Below left* Wood-carving of a sleeping figure. *Panggal buaya* wood. Mas, Bali. H 9¾″ (24 cm).

81 *Below right* Wood-carving of a family of flautists. *Panggal buaya* wood. Mas, Bali. H 11¾″ (29 cm).

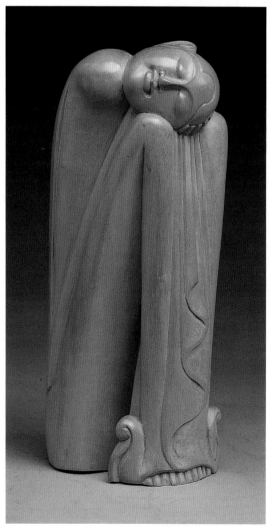

82 *Left* Leopard-shaped seat made with softwood and cream and gold acrylic paint. Pujung, Bali. 11″ × 21¾″ (28 × 55 cm).

83 *Below* This rhinoceros stool was carved in one piece from a *bentawas* log and decorated with acrylic paint. Bali Art workshop, Celuk, Bali. H 17¼″ (44 cm).

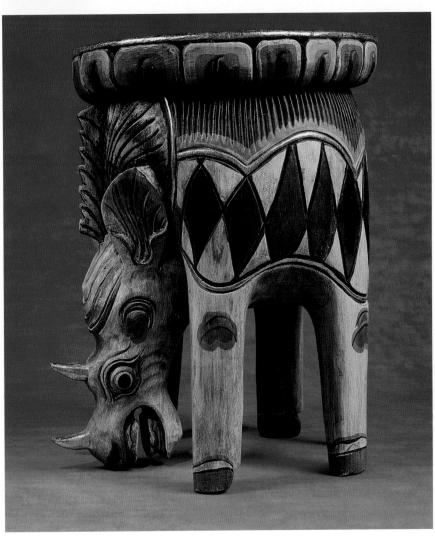

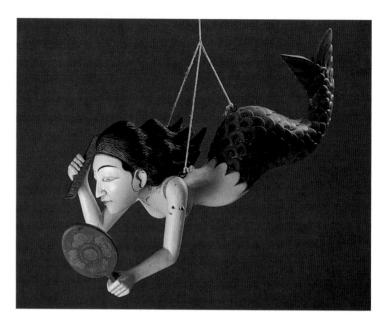

84 *Right* Painted wood-carving of a mermaid. *Bentawas* wood, acrylic paint. Gianyar district, Bali. L $14\frac{1}{4}''$ (36 cm).

85 *Below* Painted wood-carving of a winged goddess. *Udu* wood, acrylic paint. Ubud, Bali, wing span $34\frac{1}{4}''$ (87 cm), L $31\frac{1}{2}''$ (80 cm).

86 *Opposite* Painted wood-carvings of ducks. *Bentawas* wood, acrylic paint. Banjar Juga, Mas, Bali. Each duck is approx. $5\frac{7}{8}'' \times 13\frac{3}{4}''$ (15 × 35 cm).

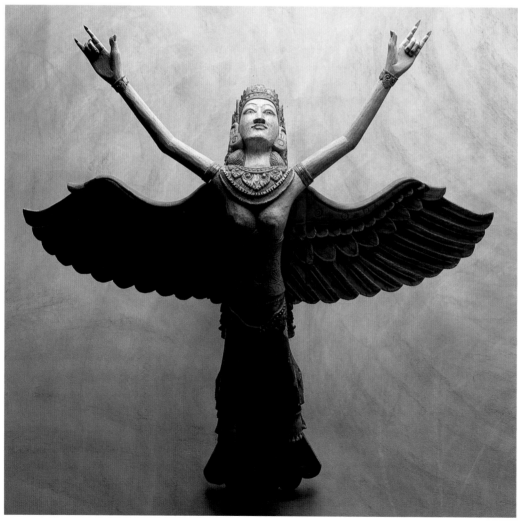

87 *Above left* Non-traditional cat mask plaque. *Bentawas* wood, acrylic paint. Peliatan, Bali. $11\frac{3}{4}'' \times 9\frac{3}{8}''$ (30 × 24 cm).

88 *Above* A set of leaf dishes with banana and *jambu* fruit, carved from *bentawas* wood and painted with acrylics. Gianyar district, Bali. The largest dish is $17\frac{1}{4}'' \times 9\frac{3}{4}''$ (44 × 25 cm).

89 *Left* Cactus and *antik* (antique) car. *Bentawas* wood, acrylic paint. Gianyar district, Bali. Cactus $17\frac{1}{4}'' \times 12\frac{5}{8}''$ (44 × 32 cm).

90 *Left* Painted wood-carving of a frog with a taro leaf umbrella. *Bentawas* wood and acrylic paint. Gianyar district, Bali. H $16\frac{7}{8}''$ (43 cm).

91 *Below* Painted wood-carvings of a frog flying an aeroplane and another driving a Volkswagen. *Bentawas* wood, acrylic paint. Gianyar district, Bali. Frog driving a Volkswagen. $4\frac{1}{4}'' \times 11''$ (11 × 28 cm).

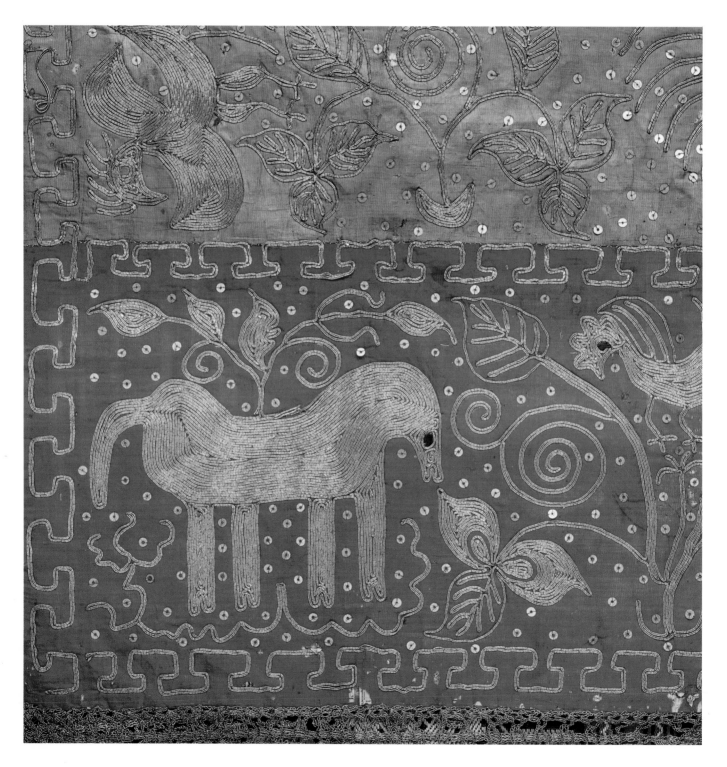

TEXTILES AND BEADING

Prince Panji wore a full billowing sarong of silk stamped with flowers of gold; his trousers were of green chindi ornamented with golden lace round the bottom and studded with golden ornaments in the shape of the firefly; his ear ornaments were of golden flowers studded with diamonds. On the third finger of each hand he wore two diamond rings. His waistband was a painted cloth of the pattern gringsing sang'u-pati; his kris of the kaprabon; his jamang, or head ornament, of gold set with diamonds and scented with all kinds of sweet-scented oils. He appeared more beautiful than a deity descended from heaven, all looking upon him with delight and astonishment.

In *The History of Java* (1817), Sir Thomas Stamford Raffles, in commenting on the Javanese literary taste for extraordinarily lengthy, detailed and luxuriant descriptions of costume, remarked: 'The extravagant genius of eastern poetry may perhaps be best employed in pourtraying such fantastic images, or celebrating such extraordinary tastes.'

Fantastic images and extraordinary tastes leap out from early twentieth-century and even contemporary photographs which record the full glory of pre-industrial clothing in Indonesia. Dress communicates ordinary information about ethnic identity, social status and gender, but more importantly it expresses the relationship of the wearer to supernatural and cosmic forces. Textiles have a sacred and magical significance over and above their use for covering the body.

The most widely used traditional garments for men and women in daily use throughout Indonesia are the unstructured sarong and *kain*. The sarong is a broad band of cloth sewn into a tube that usually falls from the waist; however, in the eastern islands of Nusa Tenggara, women fold much longer tubes above the breasts and gather them at the waist with sashes. The non-tubular strip form, the *kain*, is secured at the waist by folding and can extend in length from about seven and a quarter feet (*c.* two and a quarter metres) for ordinary wear, to twenty-three feet (*c.* seven metres) of fine gathered cotton for Central Javanese court costume or classical dance. Large rectangular woven cloths are also worn over the shoulders as mantles in Nusa Tenggara and in North Sumatra. A woman's shawl, or *selendang*, ideally matches the *kain* and can be draped and knotted to carry a small child or shopping. The *kebaya*, a light jacket, is worn as an upper-garment by women in Java, Bali, parts of Nusa Tenggara and those coastal Islamic trading communities in which women do not wear long loose blouses instead. The *kebaya* is usually made of embroidered voile or organdie, lace yardage, brocade or velvet and may be tailored to fit the body with a front panel

92 Minangkabau silk hanging for a marriage bed, embroidered with metallic thread and embellished with sequins and handmade lace. Collected in Bukittinggi, West Sumatra. Similar motifs, embroidery materials and techniques are used by other Sumatran Islamic communities. The panel measures $70\frac{1}{8}'' \times 27\frac{5}{8}''$ (178 × 70 cm). Detail.

to hide the breasts, or loosely cut and bound with a sash or secured with a pure gold safety pin or a set of brooches. Today most embroidered *kebaya* are stitched by machine; however, some women add further embellishment to the cuffs and collar by hand.

The wearing of regional dress is becoming so rare anywhere that it is a great pleasure to see Javanese women dressed in brilliant batik walking along palm-lined lanes, or Timorese horsemen swathed in brightly striped cloths crossing the dry, stony hills on their way to the district market.

Batik is generally thought of as the most quintessentially Indonesian textile. Motifs of flowers, twining plants, leaves, buds, flowers, birds, butterflies, fish, insects and geometric forms are rich in symbolic association and variety; there are about three thousand recorded batik patterns.

The patterns to be dyed into the cloth are drawn with a *canting*, a wooden 'pen' fitted with a reservoir for hot, liquid wax. In batik workshops, circles of women sit working at cloths draped over frames, and periodically replenish their supply of wax by dipping their *canting* into a central vat. Some draw directly on the cloth from memory; others wax over faint charcoal lines. This method of drawing patterns in wax on fine machine-woven cotton was practised as a form of meditation by the female courtiers of Central Java; traditionally, batik *tulis* (*tulis* means 'write' in Indonesian) is produced only by women. In the nineteenth century, the application of waxed patterns with a large copper stamp or *cap* saved the batik industry from competition with cheap printed European cloth. The semi-industrial nature of *cap* work allows it to be performed by men.

The number of colours desired will determine the number of dye baths in which the cloth must be submerged. The first dipping will colour only those parts of the cloth with no protective wax coating. In preparation for the second colour, the wax must be scraped away to expose new areas to the next dye. Areas already dyed are re-waxed to prevent discolouration.

In villages, drawing in wax on handwoven cloth has been practised for centuries and continues to co-exist with the comparatively recent production of refined batik on smooth, manufactured cotton. In Kerek, near Tuban in East Java, locally grown cotton is spun and woven into coarse cloth by women not engaged in planting or harvesting rice. Natural dyes are prepared in earthenware pots and supplemented in some cases with synthetics. Colours are used to express the poetry of different stages of a woman's life cycle: bright reds for the maiden, rich blues for the matron and dark hues for the older woman.

The culture of Central Java is suffused with a mixture of Islamic, Hindu-Buddhist and Javanese mystical traditions. The inland royal court cities of Yogyakarta and Surakarta, in Central Java, are the twin epicentres of this culture, and it is here that naturally dyed batik with the characteristic colours of *soga* brown and indigo blue is produced. In Surakarta, rich creams and browns are juxtaposed with tinges of yellowish gold. White, undyed cloth is left to contrast with the sombre opulence of brown and blue dyes in Yogyakarta. Batik motifs recall characters from the Hindu epics, plants, animals, sea creatures and gamelan melodies. Their names express a variety of characteristically Javanese moods and images: being shot with the flowered arrow of love; being intoxicated with love like a butterfly; experiencing the aloneness in a crowd of the water bee among companions or the melancholic longing for an absent lover as the bee

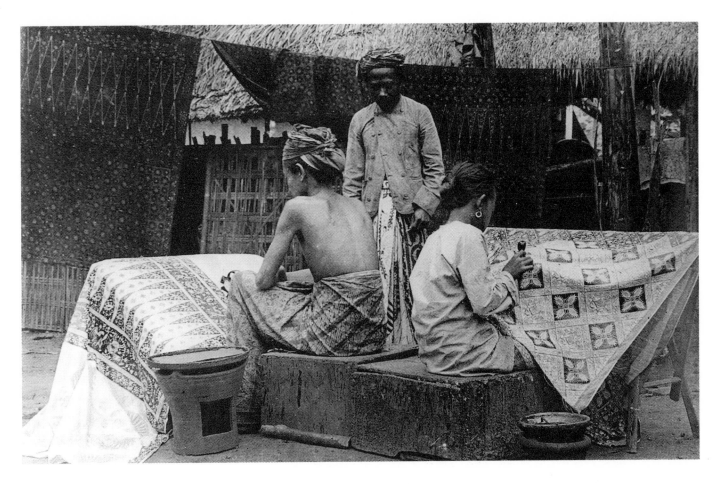

Batik-making in Java in the 1900s. The man on the left is printing patterns with a copper stamp while the woman draws wax patterns freely with a *canting*.

longs for nectar; the frisky happiness of a fish; the mournfulness of a certain bird; the whisper of dragons; the calm of smooth waters; or sad rain.

The bolder, freer designs and bright palette of the north coast were influenced by lively maritime trade and the textile traditions of the Chinese and Arab mercantile communities living in ports and coastal towns. Batiks with bold, red and blue swirling rocks and clouds, winged dragons and formal pleasure gardens are produced in the white-washed village of Trusmi, near Cirebon. The Massina workshop is renowned for its revival of local court designs.

Earlier this century, the ateliers in Pekalongan were operated by *Indische* women of mixed Dutch, Chinese and Javanese descent. Art Nouveau and Chinese influences contributed to the extraordinary delicacy of bird, butterfly, chrysanthemum and peony motifs. Refinements of the dyeing process permitted the use of exquisite pale and bright pinks, blues, greens and lilac colours. The workshop of Oey Soe Tjoen at Kedungwuni, outside Pekalongan, continues to produce very fine hand-drawn Pekalongan style cloths which can take several months to complete. Traditional Javanese batik centres also produce modern batik for clothing and home furnishings.

In the 1960s, Soelardjo, Soemihardjo, Bambang Oetoro and other Yogyak-artan batik designers began to experiment with bold abstracts, energetic figurative forms, landscapes and unusual colour combinations. Batik paintings are produced with sprays, brushes, rags and airbrushes in numerous small

studios and workshops around the city's old Water Castle. Balinese artists have also experimented with batik techniques.

Traditionally, Balinese painting on cloth has been restricted to two forms. *Perada* is plain coloured cloth painted or stamped with patterns in gold that is used for ceremonial clothing, umbrellas and draperies. Traditional illustrations of myths, folk tales and historical themes are painted on cotton ceremonial flags, calendars, curtains and wall hangings at Kamasan.

There is constant, even frenetic, innovation in the non-traditional batik and the screen-printed, hand-blocked and painted designs on rayon, viscose and cotton produced for clothing and yard goods. Western fashions and traditional floral, animal and geometric motifs are joined in inventive and even startling combinations. A long heritage of outstanding skill in dyeing textiles, the contribution of local and expatriate entrepreneurs and designers, and the unceasing flow of international visitors combine to provide the necessary conditions for a flourishing industry in Bali.

The oldest textiles in terms of technique, and perhaps the finest of all traditional Indonesian cloths, are the ikats. The word 'ikat' in Indonesian means 'to tie' or 'to bundle', and intricate patterns are produced by tie-dyeing patterns into the threads prior to weaving. Ikat cloths are produced by inland or mountain-dwelling societies, such as the Batak in North Sumatra, the Iban Dyak in Kalimantan and the Toraja in Sulawesi, and in the outer-island communities of Sumba, Flores and Timor, in Nusa Tenggara and Tanimbar in Maluku.

Traditional ikat cloths are woven only by women and are considered to be female in essence. They are extraordinarily rich cultural documents; stylized reptiles, birds, animals and ancestral figures communicate complex political, religious and aesthetic concepts. Design elements are also derived from the geometrical patterns and flower forms on the Indian cloths traded for spices, sandalwood and slaves in the past. In addition, Chinese floral and European heraldic motifs have been absorbed, but transformed in symbolic significance.

Before weaving, the warp or longitudinal threads are spread out evenly on a rectangular wooden frame. Motifs are tied tightly into the threads with leaves or plastic tape so that they will not be tinted when immersed in the first dye bath. Bindings are later removed to expose some motifs to the second dye. The process is similar in principle to that used in batik, and the number of tying, re-tying and dyeing steps will depend on the number of colours required. In the past, dyes were obtained from concoctions of leaves, bark, wood, roots and berries, and although these are still used, chemical dyes are frequently employed as well. Cotton fibres absorb synthetic dyes very rapidly; it can take months, or even years to complete the dyeing process using some natural substances.

When the process of dyeing the patterns into the warp threads is complete, they are mounted in a continuous loop on the loom beams and separated into upper and lower layers. During weaving, these layers are alternately opened and closed over the cross-running weft threads which are thus enmeshed. Women work at home weaving warp ikats with simple backstrap looms. The furthest beam is tied onto stakes driven into the ground or attached to wooden house pillars. The weaver unrolls her loom, sits on the ground and adjusts the wooden or woven strap behind her to fit the small of her back. She leans back to create tension in the warp threads and lays in the plain weft threads with a shuttle held in

This nineteenth-century engraving shows a Batak woman of North Sumatra tying the patterns to be dyed into threads before weaving ikat cloth commences.

her hand. Sarongs and mantles are constructed by sewing two or more matching narrow cloths together lengthwise.

In a weft ikat cloth, the warp threads are plain and the patterns are dyed into the wefts which are wound on shuttles and hidden from sight; the pattern can be seen gradually emerging on the loom as the weaving proceeds.

Only the weavers in Tenganan in east Bali, produce *geringsing* cloth, a double ikat with patterns dyed into both warp and weft threads. *Geringsing* cloths have powerful protective and curative properties. The people of this village do not marry other Balinese and they maintain distinctive ritual practices, so the wearing of *geringsing* indicates membership of an exclusive group. The cloths are also worn at stages of critical transition in the life of individuals and at elaborate communal festivals of dance and music.

Weft ikat cloth is most frequently woven on large, wooden framed shaft looms, and is generally produced in inner Indonesian communities. The weaver sits at a bench. Layers of warp threads are opened and closed by foot-controlled treadles. Weft threads are laid in manually with a hand-held shuttle. A loom with a flying shuttle (called A.T.B.M. in Indonesia) which mechanically shoots the wefts through the warps is also used in conjunction with treadles. Wider cloths can be woven quickly because this mechanism overcomes the limited reach and power of the human arm. Unlike the backstrap loom, which is only used by women, the shaft loom is sometimes operated by men.

In Sampalan, near Klungkung, at Sidemen, near Amlapura, and at Gianyar, in Bali, modern weft ikat cloth is woven on shaft looms in silk and cotton for sarongs, yard goods and furnishing fabrics. Locations for the various production stages (dyeing, tying patterns, weaving and so forth) are organized in terms of Balinese concepts of sacred and profane space.

In Surakarta, in Central Java, the narrow streets near the ikat workshops are lined with racks of brilliantly coloured hanks of thread drying in the sun, while the nearby canals run with magenta, emerald or scarlet waste water. Men and women work at the shaft looms, and the workshops resonate with the clack of shuttles.

Nearby, scarves and sashes of rainbow cloth are dyed and painted with spots, squares and circles in bright colours. Scattered patches on a white cloth are bunched and tightly sewn and tied to resist the penetration of background colour. Cluttered dye pots are interspersed with women busily removing stitches and decorating undyed areas with bright blobs, lines and dots. The green, crimson and purple rainbow shawls of Palembang, in South Sumatra, have large paisley and flower motifs formed by tying off sections of cloth.

Silk weaving has historically been confined to those coastal trading areas strongly influenced by Indian court culture and by the aesthetic traditions of the Middle East. The Buginese, Macassan and Mandarese women of South Sulawesi weave silk in brilliant plaids, checks, stripes and weft-ikat zigzag patterns which conform to Islamic tastes and proscriptions against representations of animals or the human body. In the Watansoppeng (Soppeng), Sinkang and Mandar districts, women can be seen weaving on backstrap looms in the shade under stilted houses. Black, blood red, acid green, cerise, yellow and deep purple silks are woven into vivid sarongs. Silk textiles are also produced in town workshops. The mulberry trees and silkworms north of Soppeng provide thread which is sold

undyed in other parts of Indonesia. At weddings and other important social and ritual occasions, women dress in bright gauze blouses and silks and wear golden flowers in their hair.

These Islamic communities dispersed to form coastal enclaves beyond South Sulawesi. In Samarinda, East Kalimantan, the weaving co-operatives produce colourful silks in designs adapted from those of South Sulawesi, the nearby kingdom of Tenggarong and Dyak communities from the interior. Silk thread is dyed in the bright sunlight in tiny pockets of garden or on the networks of board walks high above the river and is woven in the houses on shaft looms.

In the small town of Gelgel, the ancient capital of Bali, silks are woven on backstrap looms set up in the pavilions in leafy household courtyards. These are produced in the jewel colours of ruby pink, amethyst, garnet or sapphire and are extensively ornamented with additional gleaming gold or silver thread weft patterns. The term *songket* is applied to textiles of this type. Setting a *songket* pattern of peacocks, lotus flowers and formalized leaves takes two or more days of concentrated skilled work. This is performed by a specialist patterner, who is usually an upper-caste woman with a lifetime of experience in what was originally an art restricted to the courts.

In the Minangkabau mountain village of Pandai Sikat, near Bukittinggi in West Sumatra, members of the women's weaving co-operative use shaft looms for intricate gold and silvery *songket* cloths with shimmering surfaces which leave little of the red and black background visible. *Songket* cloth is woven for waistbands, shawls and the spectacular horned turbans worn by Minangkabau women, which suggest the lines of the sweeping buffalo-horn roofs of the traditional houses. In Palembang, South Sumatra, richly coloured silk ikats are ornamented with gold borders and flower motifs.

The type of backstrap loom used for the production of *songket* and silk textiles and also for weft ikats is different from that generally used for cotton warp ikats. The warp threads are not mounted to form a continuous loop but rather a rectangular or square piece. As the weaver lays in the wefts, the warps are held in precise position with a broad comb or reed; this maintains the separation of the threads and helps prevent the tangling which tends to occur with delicate fibres.

Embroidered textiles are especially admired in the trading and Islamic communities of Sumatra. The influence of Mogul, Ottoman and Chinese tastes is more pronounced, and religious practice has traditionally been more orthodox. Gold embroidery, beads, sequins and mirrors embellish cushions, fans, food covers and the draperies and hanging decorations that adorn splendid Sumatran bridal beds, alcoves and reception rooms used to celebrate weddings and circumcisions. At the Minangkabau village of Kota Gadang, in West Sumatra, delicately twining gold threads encircle colourfully embroidered leaves and flowers on satin shawls, cushion covers and ceremonial hangings; these are finished with handwoven silk fringes or lace made of cotton or metallic thread. At Menggala, Pisang Island, near Krui, and Bandar Lampung, in Lampung province, south Sumatra, striped cotton is woven on backstrap looms and ornamented with patterns in flashing gold embroidery. Luminous discs, geometric bands, stylized human figures, animals, plants and ships are the most common motifs on these cloths, which are called *tapis*.

A nineteenth-century regent of Kudus, Central Java. The batik *kain*, head-cloth and European-influenced jacket form the basis of traditional and formal costume today.

Sumatran needle-workers use the couching technique. A piece of cloth is stretched on a frame. The gold thread is laid out in lines and coils and tacked down onto the surface of the cloth with fine cotton. The stitches may be relatively unobtrusive or may be deliberately emphasized to form a counter pattern over the glittering motifs.

In the past, barkcloth clothing was more common in some communities than it is today. Festive garments are often appliquéd or embroidered with traditional motifs instead. Kenyah, Tunjung and Bahau Dyak women embroider plant, animal and bird forms in bold curling designs on narrow skirts and mats, and on Nias island, garments are embellished with geometric appliquéd patterns.

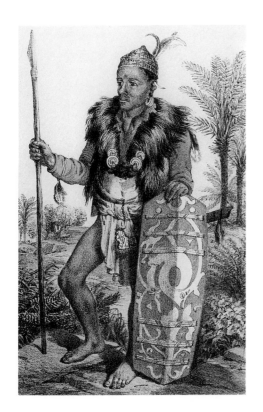

Beads, shells and feathers contribute to the splendour of nineteenth-century Modang Dyak ceremonial costume in Kalimantan.

The colourful beads with magical properties that are used in necklaces and to embellish ritual objects and clothing have been traded among inland and riverine Dyak communities for centuries. Some beads are thought to have been introduced from Venice by Portuguese and Dutch traders, and individual heirloom beads are the subject of clan and family myth. New beads are imported from Europe and Japan and used to decorate modern purses. The Kenyah and Kayan people, as well as the Ahoeng and Maloh, thread tiny seed beads into diamond-shaped nets and rows. These are sewn all over clothing or rattan caps in geometric and whirling tentacle patterns representing the powerful and protective *asoq* (dog-dragon) goddess. In a single image, the *asoq* links ideas about the underworld, fertility and animal potency with ancestral authority. Nets of beads are used by the Kenyah and Kayan to decorate rattan baby-carriers with protective designs that also indicate differences in social status. Patterns with curling stylized human figures, *asoq* masks and tigers indicate a noble lineage; less figurative motifs are used by commoners. Baby-carriers are also decorated with bear and tiger teeth, shells, strings of larger beads, old coins, bells and other magical talismans. These protect the body and soul of the new child and warn the mother of danger. Beading itself provides a hard, protective surface which fends off spiritual harm.

In most Indonesian societies, beads have been associated with agricultural fertility and femininity, and, with the exception of the Toraja people, beadwork is done by women. Traditional songs describe beaded panels as resembling rows of children, grains of rice and vistas of productive fields. In Nusa Tenggara, gifts are exchanged ritually between the families of the bride and groom. Beads are classified as female goods and given by the bride's party. The elaborate skirts included among the dowry cloths brought by Sumban brides are tufted with ornamental threads and decorated with split shells and glass and ceramic beads. Stylized female and male human figures, reptiles and sea creatures symbolize fertility and renewal.

In Timor, seed beads are particularly favoured for decorating pouches for betel ingredients and lime containers; lime is an essential chemical additive to the betel nuts, leaves and spices included in chewing plugs. Some Timorese beading is worked in the powerful colour combination of red, white and blue-black or black. These are of magical significance in the textiles and beading of many Indonesian societies; black represents the female; red the male; together with the white beads they represent the unity of the cosmos. Betel ingredients are thought

of as gendered and are associated in language and ceremony with courtship and marriage. Among the Angkola Batak in the southern Batak lands of North Sumatra, red, black and white beading decorates the purses used to announce forthcoming lifecycle celebrations such as weddings, as well as ceremonial betel servers and containers. Shafts of light sparkle through the beads from gold cigarette-paper backing.

In the villages around Rantepao, in South Sulawesi, Torajan women wear fillets across their foreheads and necklaces and bracelets on festive occasions. These are composed of orange, red, black and coral beads and shiny hollow cylinders and tablets which are ornamented with twisted gold wire and made by local blacksmiths. A simple string of small orange beads is worn as part of everyday attire. Beaded girdles and long funnel-shaped neck pieces (*kandaure*) are worn by women at dances and ceremonies associated with agricultural fertility. The spiral, hook, lozenge, and key and triangle designs of Torajan beading are also found on the Bronze Age drums discovered in several parts of Indonesia and on textiles and beading from Sumatra to Kalimantan and Nusa Tenggara.

The beaders of Bali, whose labours were traditionally confined to decorating food covers with rows of buttons and white beads, have extended their repertoire. Torrents of satin boxer shorts, skirts, belts and bustiers are beaded and spangled in crazy stripes, whorls and flowers; bead necklaces composed of tiny dolls of Dewi Sri, the rice goddess, are the only link to tradition.

93 A scene from a painting of the *Ramayana* in which Hanoman (the monkey god), Laksamana (on the left) and Rama discuss the rescue of Sita, Rama's abducted wife. Ink, ochre and pigments in a glue base on sized cotton cloth. Kamasan, Bali. Painting $14\frac{1}{2}'' \times 51\frac{1}{4}''$ (37×130 cm). Detail.

94 *Above* Hand-drawn (*tulis*), signed batik sarong from Pekalongan, on the central north coast of Java. The brilliant artificial colours and more informal Chinese- and European-inspired motifs are typical of the cosmopolitan styles of the north. The sarong is red with the green panel (*kepala*) displayed at the front. $75\frac{3}{4}'' \times 41\frac{7}{8}''$ (192 × 106 cm) sewn in a tube.

95 *Above right* Stamped batik (*cap*) *kain* in a sword pattern from Surakarta. Artificial colours have been used to dye the patterns into the cotton.

96 *Right* Batik *tulis kain* from Surakarta, Central Java, also drawn in a sword pattern (*parang*) and dyed with plant extracts. In the eighteenth century, the sultans of Yogyakarta and Surakarta in Central Java restricted the wearing of certain batik patterns to the royal courts. *Parang* designs, which suggest valour and power, were among those forbidden to commoners.

97 *Opposite* Hand-drawn (*tulis*) batik *kain* from Yogyakarta, Central Java, dyed with natural and artificial dyes. Copper stamp (*cap*) for waxing batik patterns. Wood, brass and copper pens (*canting*) for drawing wax patterns by hand. The stamp measures $7\frac{1}{8}'' \times 6\frac{3}{4}''$ (18 × 17 cm).

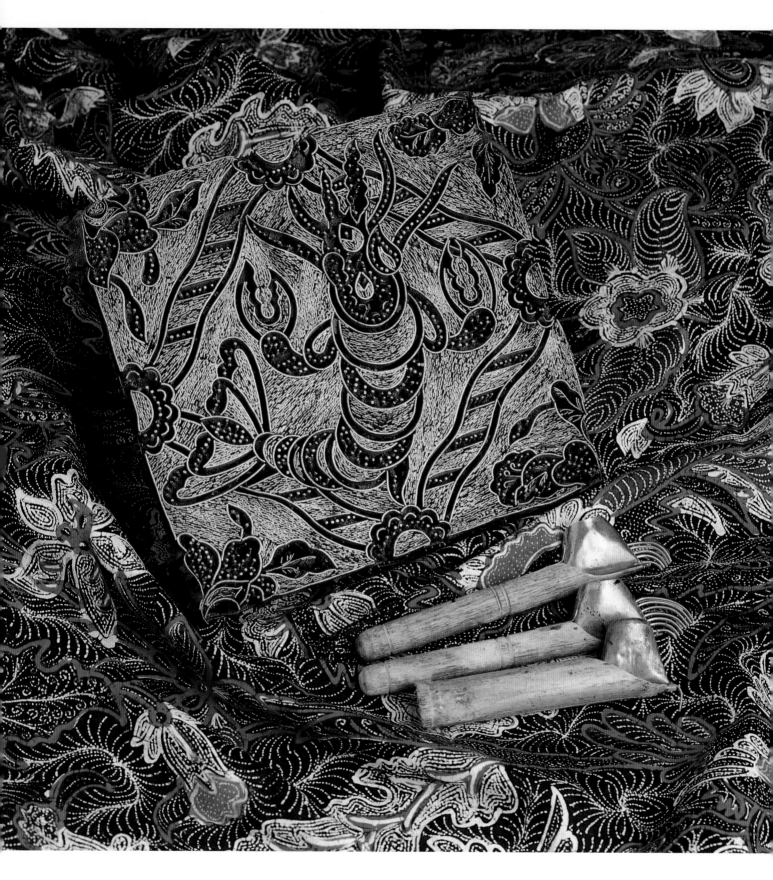

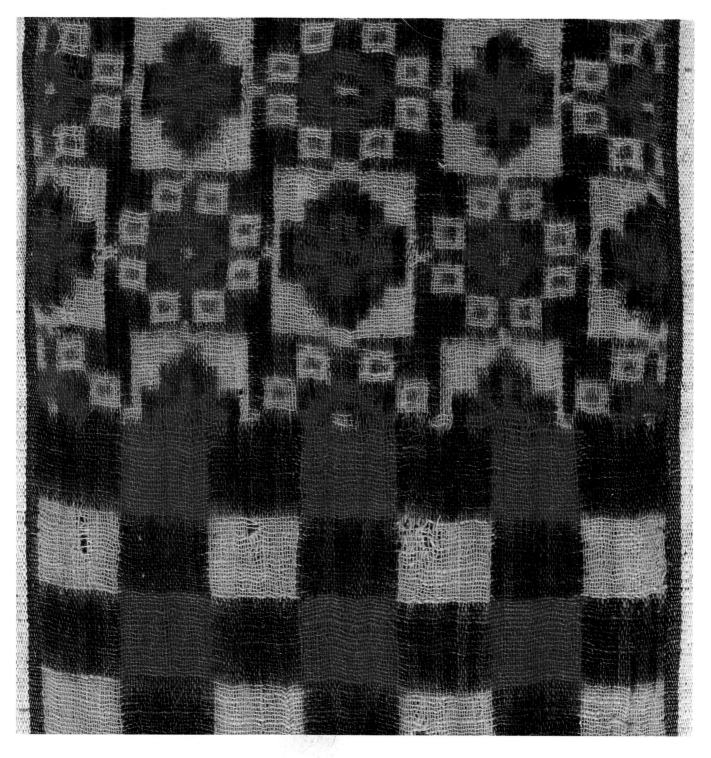

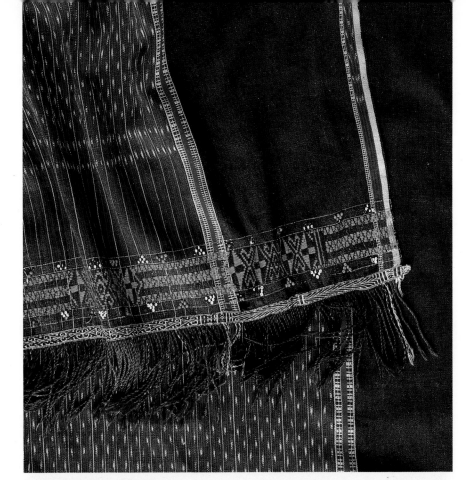

98 *Opposite* This *kamben geringsing* is a double ikat cotton ceremonial cloth, woven exclusively at Tenganen village in east Bali. The patterns in both warp and weft cotton threads are dyed before weaving commences; it can take several years to produce some red hues and the dyeing process can weaken the cotton fibres. The red dye (*mengkudu* or *kombu*) is obtained from *Morinda citrifolia*, and the purple-brown is the result of overdyeing indigo with red. *Geringsing* cloths protect the wearer from harm and are essential items of costume at ritual celebrations. *Kamben geringsing* $90\frac{1}{4}'' \times 9\frac{3}{8}''$ (229 × 24 cm). Detail.

99 *Above right* Ulos ragi hotang, a type of ceremonial mantle with stippled motifs representing rattan bark dyed into the cotton warp threads. The border of floating (supplementary weft) decoration and the glass beads were added during the weaving on a backstrap loom. *Ulos ragi hotang* are worn to announce the birth of a boy. They are also used at weddings: the groom's father drapes the cloth over the shoulders of the bride and groom and wishes them happiness and a large family. Toba Batak. Porsea, Lake Toba, North Sumatra. Mantle $74\frac{1}{8}'' \times 47\frac{1}{4}''$ (188 × 120 cm). Detail.

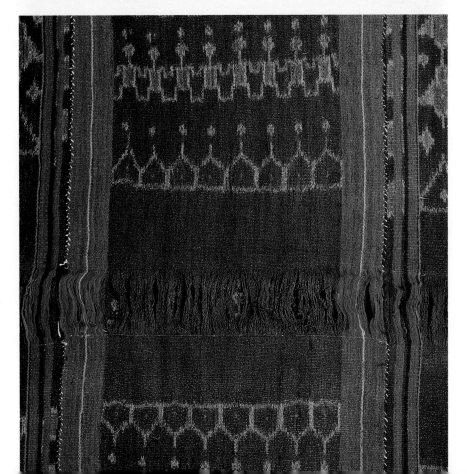

100 *Below right* Bridewealth sarong (*kewatek nai telo*) from Atadei, Lembata, Nusa Tenggara. Three pieces were sewn together into a narrow tube $74'' \times 51\frac{7}{8}''$ (188 × 132 cm). The loop of threads has been left uncut to symbolize continuity and the bonds of kinship and to indicate that the garment has a ritual purpose and is not for ordinary wear. Motifs of manta rays, ships, ancestral figures and houses are naturally dyed into hand-spun cotton yarn woven on a backstrap loom. Detail.

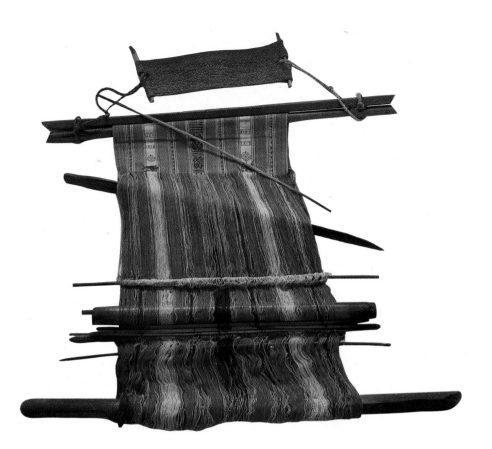

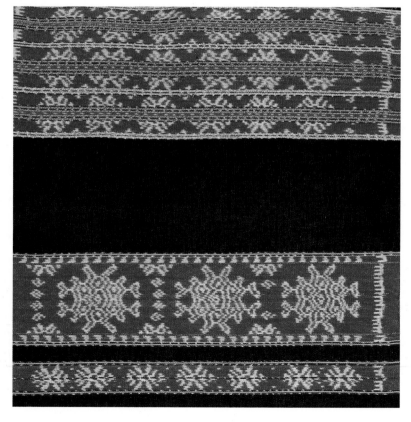

101 *Above* Timorese backstrap loom. The harness at the top runs behind the weaver's back. The loop of warp threads is strung between the breast beam closest to her body and the warp beam, which is normally tied to a stake in the ground or to the house timbers. The swordstick creates an opening between the layers of warp thread, so the long thin shuttle stick can be inserted. This cloth is decorated with supplementary warp and weft patterns. Bamboo, wood, palm leaf, cotton. Collected in Soe, central West Timor. L (breast to warp beam) approx. 30″ (76 cm).

102 *Right* Woman's sarong. This pattern indicates membership of the Greater Blossom ceremonial group that is determined by female lineage. The flower motifs are derived from the *patola* patterns on Indian trade cloths. Woven on a backstrap loom with hand-spun and naturally dyed cotton. 63¾″ × 44⅞″ (162 × 114 cm). This was sewn into a long tube that is worn folded above the breasts and gathered up and secured at the waist. Savu, Nusa Tenggara. Detail.

103 *Right* Timorese Atoni ikat mantle (*selimut*). The striped borders are woven with commercially spun and dyed cotton yarn. The central design is woven with hand-spun cotton and dyed with natural and artificial colours. Reptiles symbolize the lower world of fertility, and birds of various species represent the upper world of powerful and protective ancestors. Niki Niki, West Timor. The mantle is 39″ × 100¾″ (99 × 256 cm). Detail.

104 *Below right* Timorese Atoni cotton warp ikat mantle (*selimut*) with patterns of stylized cocks and ancestral figures woven on a backstrap loom. Collected at Kefamenanu, West Timor. The mantle is 70⅛″ × 38¾″ (178 × 98.5 cm). Detail.

105 *Below* Sumbanese sash. The parrots symbolize deliberation. Below them, the stylized skulls of beheaded captives represent renewed spiritual power for the community and victory for the male warrior. The mitre-shaped motifs at the sides are items of traditional jewelry (*mamuli*), based on formalized female genitalia. Thick light-coloured supplementary warp threads are stained to obtain variety of colour. Waingapu district, East Sumba. The sash is 69¾″ × 16⅛″ (177 × 41 cm). Detail.

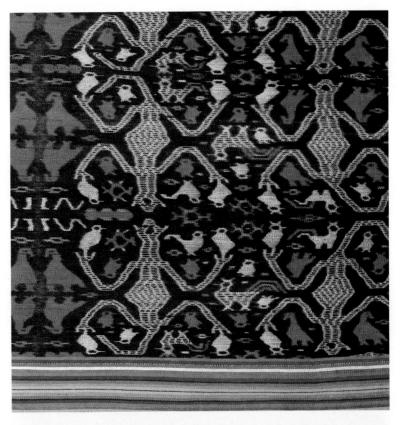

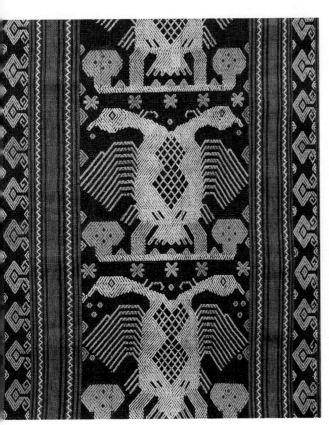

106 *Left* Silk *selendang* with weft ikat striping and additional silk and metal thread supplementary weft decoration. Singaraja, north Bali. $84\frac{1}{4}'' \times 15\frac{1}{8}''$ (214×38.5 cm). Detail.

107 *Below left* Tie-dyed rainbow cloth (*pelangi* and *tritik*) sashes or scarves. Those of red silk and purple rayon are from Surakarta, Central Java. The motifs on the green rayon scarf are in the Palembang style of South Sumatra. The red silk sash is $14\frac{1}{8}'' \times 78''$ (36×198 cm). Detail.

108 *Opposite* Gauze blouse, copper-alloy necklace and a pink plaid silk sarong woven in Sinkang, South Sulawesi. The red and the purple silk was woven at Samarinda in East Kalimantan by families originating in South Sulawesi. The silk cloths are approx. $75\frac{5}{8}'' \times 43\frac{3}{4}''$ (192×111 cm) and are sewn into tubes which fall from the waist.

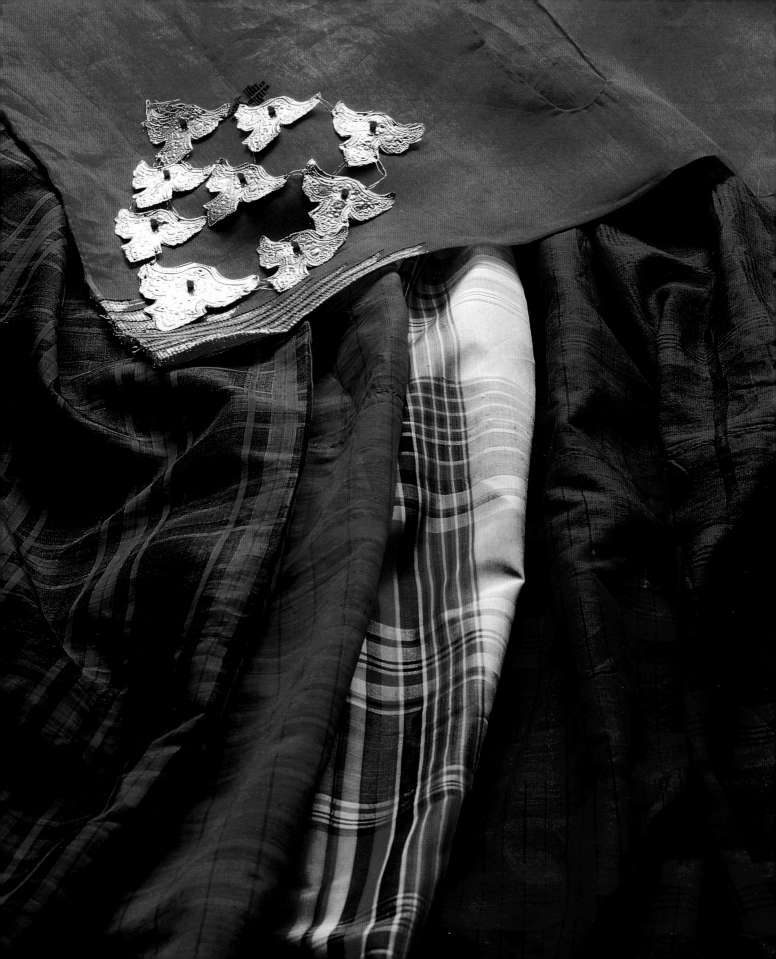

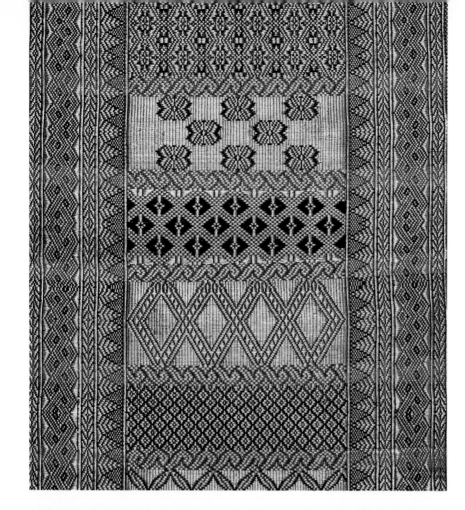

109 *Left* Minangkabau *songket* shawl, woven in silk and artificial gold thread on a shaft loom in Pandai Sikat, West Sumatra. The shawl measures $11\frac{3}{4}'' \times 77\frac{5}{8}''$ (30 × 197 cm). Detail.

110 *Below Songket* hip- or chest-cloth of artificially dyed silk and artificial gold thread woven on a backstrap loom in Gelgel, Bali. The cloth is worn over a longer cotton or silk weft ikat waist-cloth. $23\frac{3}{4}'' \times 46\frac{1}{8}''$ (60.5 × 117 cm).

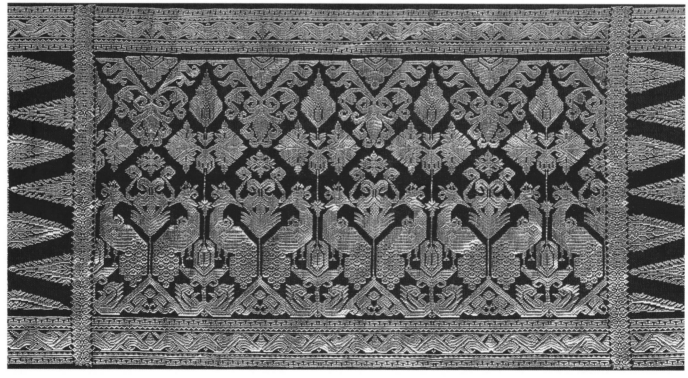

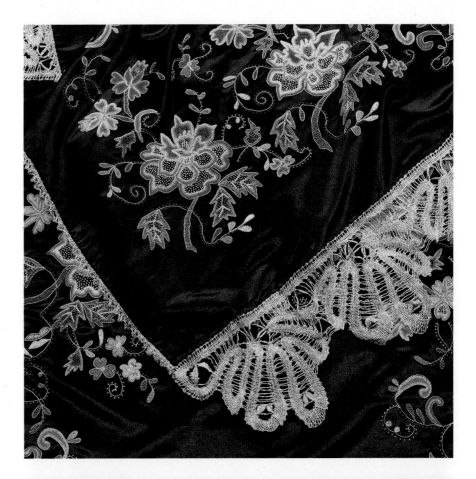

111 *Right* Minangkabau woman's shawl of polyester silk embroidered with artificially dyed silk, metallic couchwork embroidery and handmade lace. Kota Gadang, West Sumatra. The shawl measures 78″ × 16⅞″ (198 × 43 cm). Detail.

112 *Below* Modern *tapis* sarong of artificially dyed cotton woven on a backstrap loom and embroidered with gold couchwork at Manggala, Lampung, South Sumatra. *Tapis* cloths are worn by women at weddings and festive occasions. The cloth is 57½″ × 41¼″ (146 × 105 cm). Detail.

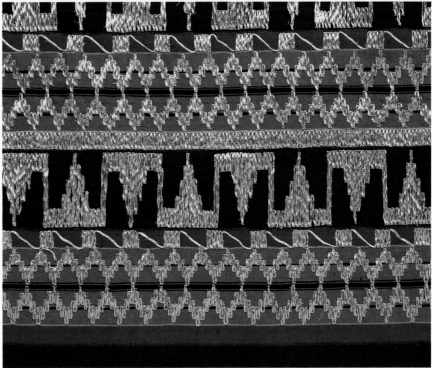

113 *Left* Jackets for women (*kebaya*) made from cotton voile with machine and hand embroidery and cutwork. Kudus, Central Java. The *kebaya* on the left is 30¼″ (77 cm) long and 50″ (127 cm) from cuff to cuff.

114 *Left, below* Hand-embroidered *kebaya* made from cotton voile with a machine-stitched and hand-embroidered cotton bodice with shell buttons. Bodices of this type have largely been replaced by the modern brassiere; however, they are still worn in some country districts. Collected in Surakarta, Central Java. The *kebaya* is 27¼″ (69 cm) long and 42⅞″ (109 cm) from cuff to cuff.

115 *Below (inset)* Detail.

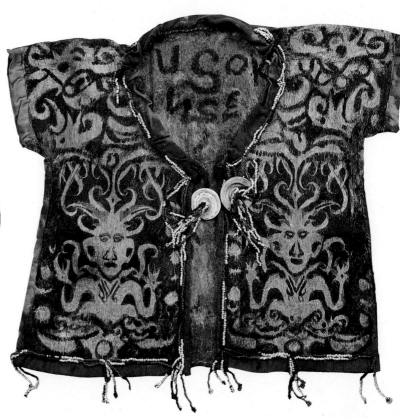

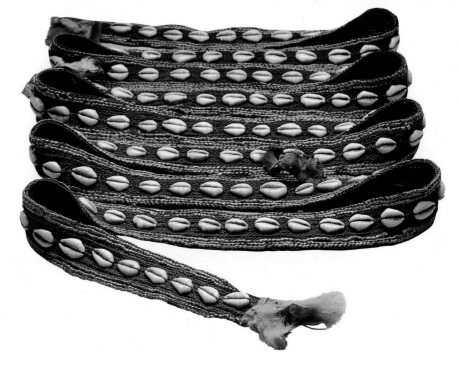

116 *Above* Kenyah Dyak beaded baby-carrier from the Middle Mahakam River district, East Kalimantan. The motifs are of the protective dragon goddess and a godly face. Glass beads on woven rattan, wooden base. H 11¾″ (30 cm).

117 *Above right* Kenyah Dyak ceremonial stained barkcloth jacket, embellished with beads and shell ornament. The curling figurative motifs are images of the *asoq*, the protective dog-dragon goddess, and other godly beings. Apo Kayan, East Kalimantan. L 20½″ (52 cm).

118 *Right* Jarrack (band) used to drape over the heads of newborn babies and on the dead and also to bind valuable green *je* stones given in marriage exchanges. *Jarrack* are also used to measure the pigs given by men as part of the bride price. Bark fibre, yellow orchid fibre, cowrie shells and cuscus fur. Dani people, Wamena, Baliem valley, Irian Jaya. 92⅛″ × 1⅝″ (234 × 4 cm).

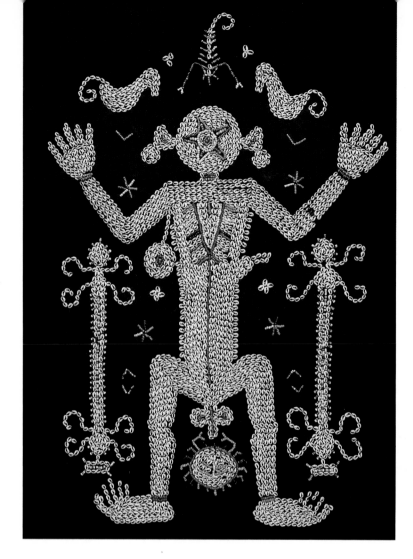

119 *Left* East Sumban woman's skirt (*lau hada*) beaded with *nassa* shells and ceramic beads. $51\frac{1}{8}'' \times 23\frac{3}{8}''$ (130×59 cm). Detail.

120 *Below left* Beaded Balinese food cover, made from teak-dyed pandanus leaves stitched to a rattan frame. D $10\frac{5}{8}''$ (27 cm).

121 *Below right* This handwoven Atoni beaded cotton bag for betel ingredients has a twined strap. The beaded lime container is bamboo. Collected at Soe, West Timor. The bag measures $5\frac{5}{8}'' \times 5\frac{5}{8}''$ (14.5×14.5 cm).

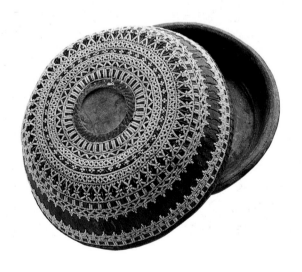

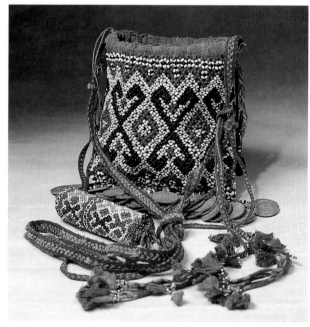

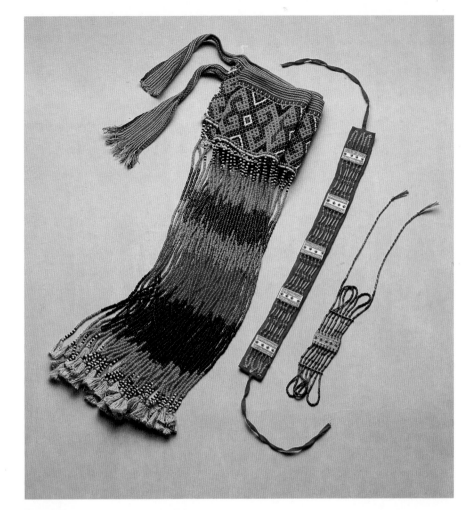

122 *Right* Torajan woman's beaded girdle, fillet and bracelet made at Londa, near Rantepao, South Sulawesi. Girdle $43\frac{3}{4}'' \times 19\frac{3}{4}''$ (111×50 cm).

123 *Below right* Padded decorations for hanging on a ceremonial wedding bed or alcove. Satin, beads, sequins and gold couchwork embroidery. Banda Aceh, Aceh, North Sumatra. The cock measures $9\frac{3}{4}'' \times 6\frac{1}{4}''$ (25×16 cm) including the dangling beads.

124 *Below* Beaded box for betel nut ingredients and cylindrical lime container. Both are from the Soe district of West Timor. The box is $5\frac{7}{8}'' \times 3\frac{7}{8}''$ (15×10 cm).

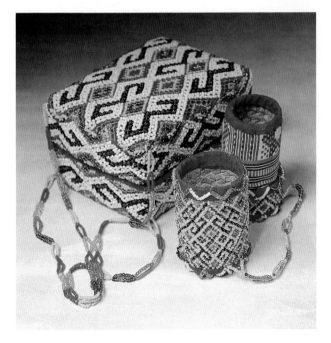

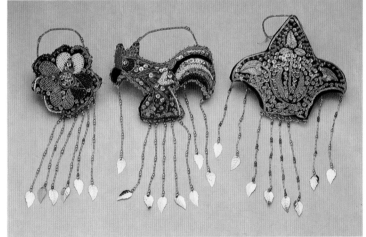

EPHEMERA FROM PARADISE

The blind Dutch naturalist Rumphius (1628–1702) who first classified Indonesia's extraordinarily diverse plant life called the archipelago the Water Indies; others have described it as a Garden of Eden with elegant palms, handsome trees and shrubs dropping all manner of edible delights into the outstretched hand. In the vivid green volcanic islands west of the Wallacian regions of mixed tropical and Australasian vegetation, Indonesia is a permanent hothouse. Year-round heat and humidity create an atmosphere in which lush ferns, vines, orchids and grasses flourish with such enthusiasm that it seems as if new shoots thrust up, and buds open, before the eyes. In the paddy fields, rice stalks grow perceptibly from day to day.

People living in rural areas have an inexhaustible supply of useful plant products derived from sugar palms, coconut palms, palmyra palms, rattan palm vines, pandanus (screw pines), breadfruit trees, reeds, grasses and fruit cases. Baskets come in every shape and size from the backpack funnels of Maluku to Javanese barrels for trapping ducks, cones for steaming rice and the triangular containers used in Bali to carry fighting cocks so their tail feathers will not be damaged. Spherical rattan baskets are used for *takraw*, the extremely fast form of football played in Indonesia and mainland Southeast Asia. An abundance of rice bags, seed baskets, storage containers and ceremonial, sitting and sleeping mats are made from a variety of plant fibres.

Coconuts are used to store water and foodstuffs, halved into scoops, cut into spoons or attached to handles to form ladles. Versatile gourds are used for a variety of purposes, which range from storing the flyers for Dyak blowpipe darts to the golden-yellow penis sheaths worn in the Dani, Moni, Jale and Ekari communities in the highlands of Irian Jaya.

Bamboo, which is possibly the most useful plant of all, is a type of grass. It is light, hollow and extraordinarily strong and thrives in a wide range of growing conditions. Thick bamboos serve as house posts and roofing structures and are lashed together to form rafts and items of furniture. The nodes that block the tubes intermittently can be perforated to form pipes to carry water from one rice paddy to another or from a mountain lake to the plains below.

If bamboo stalks are split they become very flexible and can be bent, twisted and woven. Sheets of matting or rows of stems are fixed into wooden frames and used as walls, ceiling linings or furniture panels. Stilted houses are floored with smooth, split bamboos; the narrow gaps between the stalks allow cool air to be sucked up from under the house, while the hot air rises into the roof. Broad stalks are split in half to make smooth, water-resistant roofing tiles.

125 This fine Torajan hat was collected in Rantepao, South Sulawesi, and is one of a variety of styles worn in the surrounding villages. The materials used include rattan, palm leaves, cotton cloth and cotton yarn for the pom-poms. D 21¼" (54 cm). The small warp ikat cloth is of traditional Torajan design (but not size) and is intended for decorative purposes. It was collected at Sa'dan, near Rantepao, South Sulawesi.

The moisture in fresh stalks allows them to be used for boiling water, and many traditional dishes are cooked and served in bamboo. Indonesia has a venerable fast food tradition, and the snacks sold in the markets and by street pedlars are packaged in leaves and bamboo cylinders. The expatriate Mexican artist Miguel Covarrubias reported in *The Island of Bali* (1937), 'The use of dishes and cutlery is to the Balinese an unclean and repulsive foreign habit. Balinese who use plates invariably place a square of banana leaf over them.'

In Minangkabau thought, the hollows in bamboo are dwelling places for the spirits. Jointed bamboo is included in household charms because the walls of the bamboo stalk are magically analogous to those of the home. An effective charm will leave a thief marooned at the scene of the proposed crime, unable to turn around or move forward, just as if he were trapped inside a bamboo stalk. He can only be released from the spell by the home owner and will be most eager to beg forgiveness and depart.

Minangkabau music of unearthly beauty can be played on a magical flute made from a rare species of bamboo which is only to be found in remote or secret places. Mouth and nose flutes, whistles, buzzers, Jew's harps and drums are played all over the archipelago. In West Java, *anklung* composed of bamboo tubes suspended in a frame are rattled to provide musical accompaniment to dances, and the watery melodies tinkled on Balinese bamboo xylophones or *garantang* serve the same purpose.

In South Sulawesi, the Toraja use rattan and bamboo for every conceivable purpose: green bamboo canes carry milky palm wine or *tuak* to and from the markets; decorative containers and flutes are ornamented with incisions and poker-work designs burned in geometrical bands and rubbed with red and black pigments. Bamboo tobacco containers are bound with rattan twines. Woven rattan containers and palm leaf, bamboo and rattan hats are exceptionally fine.

Available plant forms and fibres and similarities in the material culture of diverse communities in Indonesia result in utilitarian and sometimes decorative or even ritual items that display an obvious likeness. This is particularly evident in the way bamboo containers are used and decorated. They are ideal for holding lime or other powdery substances such as gunpowder and medicines. If the nodes are left in place, they seal the bottom of a container; a neatly fitting lid can be made from another piece.

West Timorese lime containers are decorated with the geometric Bronze Age lozenge patterns found throughout the archipelago in other art and craft forms. The delicate incisions are emphasized with soot and pink and green dyes. North Sumatran Batak containers have finely scratched curvilinear motifs like those painted and carved on the majestic ship-like traditional houses. Laments, letters and calendars for determining auspicious days were also inscribed on bamboo. Utilitarian containers for water, jewelry and a variety of odds and ends may be plain, but are often incised with a little decoration and topped with simply carved lids. Those with very elaborate wooden stoppers are modelled on the medicine containers used by the shamans of the past to hold the powerful magical substance *pupuk*. The conversion of Batak communities to Christianity has meant great changes to the role and nature of the rituals performed by shamans, and, although traditional healers are still consulted, these containers are now essentially decorative.

A nineteenth-century Karo Batak girl in North Sumatra using broad bamboos for carrying water. Bamboo tubes are still preferred to plastic buckets in some communities.

Traditional Indonesian household items made with bamboo, rattan, palm leaf and wood. Similar food covers, rice baskets and steamers, sieves and containers are sold in markets today.

Some simpler, curling Batak patterns are not unlike the bolder, dynamic swirling *asoq* designs carved into bamboo on Dyak pipes, lice crushers, containers and quivers for blowpipe darts. Dyak song celebrates the vigorous bamboo as embodying the life force and calls on the spirit inhabiting the green canes to grant vitality to the new born and to young couples. In many parts of Indonesia, the umbilical cord is severed with a knife of bamboo, whose prodigious growth and strength are an apt symbol of life and energy. Bands of triangles representing stylized bamboo shoots and their inherent qualities are a common motif in textiles, wood-carving and metalwork throughout Indonesia.

The tall *lontar* or palmyra palm, with a hairy black trunk and fan leaves at the very top, can also grow in very poor and mountainous conditions. It is of great economic importance in the more arid parts of Madura and on the eastern islands of Nusa Tenggara in the dry Wallacian regions.

The juice of the palm is tapped to make delicious palm sugar, which nourishes domestic animals as well as people, and is distilled into toddy or even gin. Folded leaf buckets are suspended from the tree to catch the fluid exuded from the crushed buds. In the streets and markets, itinerant palm wine vendors offer drinks by the cup from leaf containers dangling on either side of a yoke. The tree provides all the necessities of life. A large leaf can form a rain cape to cover the entire body, or be split and woven into boxes and baskets. The pliancy and strength of *lontar* leaves enable them to be woven in the curling textured patterns that cannot be achieved with less flexible fibres which must be arranged in horizontal or vertical designs. The leaves have a finely striated, almost waxily smooth surface, which, if left undyed, is a pale or slightly deeper yellow.

In Timor, plain *lontar* leaves are woven into a variety of practical boxes and baskets, but the most imagination goes into those intended for serving betel, which is still very much enjoyed throughout Nusa Tenggara. In the market stalls, *lontar* baskets are filled with nuts and leaves; green piles of neatly folded plugs ready for chewing are arranged on trays. For betel serving baskets, intricate

patterns are woven in black, pink and green to contrast with the plain leaf. On smaller boxes, borders of bright commercial cloth and panels of handwoven tapestry contribute to the gaiety. Folded and dyed double-headed horse figures, pink, green and red leaf streamers, and fine patterning decorate the large serving boxes used for guests and at weddings.

A similar taste for bright colour is expressed in the bright basketry of Dili in East Timor. Baskets, trays and small slipcases are dyed in deep purple, bright pink, green and bright yellow. Although the motifs of flowers, leaves and birds are common in the arts and crafts of Nusa Tenggara, in Dili, some influence from Portugal and the style of European peasant embroidery is perhaps evident.

On the nearby island of Roti, men wear several types of curving *lontar* leaf hat, shaped rather like those worn by cowboys; it is thought that the design might be based on the helmets of the swashbuckling sixteenth-century Portuguese sandalwood traders who established outposts on Solor, Flores and Timor. However, the Rotinese decorate their hats with unicorn-like horns, feathers and other elaborate additions which indicate the wearer's participation in particular social or everyday activities.

The *sasando*, a Rotinese stringed instrument, has between twelve and forty wires strung onto a central bamboo cylinder; a large *lontar* leaf is curved around it to form a hemispherical sound box. The *sasando* rests on the lap or a table, and the musician's hands reach in to pluck the strings and produce a sound similar to that of a mandolin.

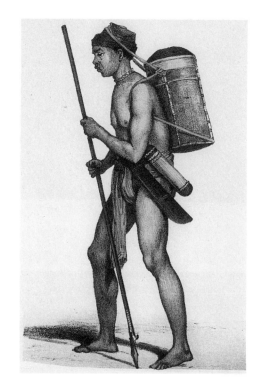

For centuries *lontar* leaves have been used as a material for writing. Hindu and Buddhist scriptures, histories and literature were scratched on narrow palm blades with a sharp stylus; these were rubbed with carbon or black *kemiri* nut oil to make the letters stand out, and the durable *lontar* pages were strung together into a stack with two wooden boards forming a cover at the top and bottom. The Gedong Kirtya library of *lontar* manuscripts at Singaraja, in North Bali, holds shelves of stacked boxes containing old *lontar* manuscripts on traditional architecture, law, poetry and dynastic and clan histories; many of these are beautifully illustrated. In the conservative village of Tenganen, in east Bali, visitors may watch scribes at work incising the words and illustrations of the *Ramayana* epic. In many Balinese villages, literary clubs gather around *lontar* manuscripts of traditional literature and, while loosening their flow of thought with palm wine, members take it in turns to elaborate on sections of the text.

The plaiters of Bona, apart from weaving hats, mats, baskets, toys and food covers from pandanus and other fibres, now make some of the palm leaf decorations used in Balinese religious festivals in long-lasting *lontar*. The pale green coconut palm leaves, which are more common in Bali, quickly wither and turn brown. The *lontar* leaves are left plain or are dyed in vivid pinks, greens and yellows and are exported as floral decorations.

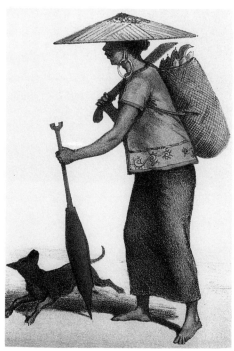

Rattan bags, baskets, bamboo containers and sunhats like those shown in this nineteenth-century engraving are still in common use today on the Mahakam river in East Kalimantan.

Balinese palm leaf decorations are of such complexity and artistry that one marvels at the astonishing speed and skill with which the most intricate forms are twisted and folded. For local temple festivals and village celebrations, little girls and women sit in circles and chat while preparing mountains of twirling rosettes, windmills, fans, streamers, flowers, leaves, ears of rice and dolls of Dewi Sri, the goddess of fertility. Tall bamboo poles or *penjor*, which are associated with the goddess and the beneficent underworld dragon, are weighted at the bottom to

form gracefully curving banners to line roads and gateways on festive occasions and to join heaven and earth and the gods and men. Tiny palm leaf baskets or *canang* are woven and filled with food offerings, blossoms and a stick of incense to honour the gods. These are placed in shrines and in locations potentially exposed to the danger of wandering demons such as gateways and on the dashboards of cars. At Javanese weddings, a pair of elaborate palm leaf decorations symbolizing the cosmos are prominently displayed; these are considered to be the gift of Dewi Sri.

Everywhere children fly homemade paper kites with bamboo or rattan frames, but in Sanur and on Turtle Island in South Bali, kite flying is a serious affair. Competitions are staged between teams from village associations, and it takes several men to launch the huge kites that are as long as a bus. Small bat and hawk kites of blue and electric pink and green with papier mâché heads, beaks, tiny teeth and wire claws are sold on the beach. Traditional toy-makers from Lombok and villages around Surabaya and Mount Bromo, in East Java, come by ferry to Bali to sell their brightly painted toy beetles, dragons, spiders and monsters that are constructed of papier mâché, bamboo, rattan and scrap materials. For tourists these handmade toys are much more of a novelty than they are for Javanese children, who in fact increasingly prefer those that are made of plastic.

Rattan or *rotan* is a wild palm in the form of a vine which snakes through the jungles of Kalimantan, but world demand has led to the recent establishment of plantations. Its shiny skin is peeled in thin strips from the core to be woven into baskets and mats of extraordinary flexibility and durability. The strength of rattan is such that chair seats laced with rattan netting last for decades. The solid core of larger vines, which is usually referred to as cane, is very strong and can be used with or without its outer coat to form the structural members of furniture and baskets.

Dyak communities have always used rattan for baskets, protective armour, hats and mats, and cultivated the plant near villages and longhouses. The Iban, Kenyah, Ngaju and Aoheng are renowned for the quality of their plaiting; the work of the semi-nomadic Punan of the interior is so fine that their mats are insect- and waterproof.

Although men help prepare rattan, almost all baskets and mats are woven by women. Making beautiful rattan baskets and mats is an essential, almost definitive, female accomplishment. In Dyak poetry, plaited motifs are described as being like ferns that grow in the flatlands, flames of burning fire and coloured clouds. In a Kenyah romance, a young man awakes and sleepily observes the patterns on his mat: interlocking human faces, the long design of an endless snake and motifs that shift and change like the shapes of clouds in the sky. The beauty of the timber-floored longhouse spread with many intricately patterned mats is also celebrated in song.

Dyak basketry and matting is patterned with vigorous geometric designs and stylized leaves, flowers, triangular bamboo shoots, serpents and dragons. Human figures and the munificent tree of life motif appear on ritual mats. Rattan fibres are left natural or stained black with soot, earth or indigo decoctions; red, dragon's blood dye is derived from boiled rattan seeds.

Weaving or plaiting a mat proceeds by working on the diagonal. Bundles of prepared rattan are spread out in readiness; the weaver starts by interlacing a few to form a first corner section; the strands branch out from there to the right and left. She interweaves additional strands of rattan to complete the bottom edge of the mat and then forms a second edge at right angles. The fabric is built up by adding strands which run up and across it. The ends are tucked in and woven back into the mat.

The aesthetic and technical refinement of Dyak plaiting is so admired that rattan panels are integrated into Indonesian leather goods. Subtly patterned rattan, textiles woven from *doyo* leaves from Kalimantan and ikats from Nusa Tenggara are used to enhance the briefcases, purses, belts and handbags which were first designed and sold by Yamin Makawaru in Yogyakarta. These are also marketed in Jakarta and Bali, and are exported.

In Kalimantan itself, baskets and mats are bartered in the inland and along the Mahakam, Kedang Kepala and Kayan rivers and their tributaries that form the main transport routes. At settlements and riverside shacks, baskets and mats are sold along with fish traps, canoe paddles, petrol, confectionery and sunhats. Delight in colour is the main feature of these conical palm leaf hats, which are decorated with swirling sequins or patches of colourful commercial cloth. Bamboo strands sprout from the crown and are tied with bright cloth strips. They are looped together to form a colourful flopping tail or left loose to bob and sway like flowers in a breeze or a cloud of butterflies above the wearer's head.

Rattan baskets are also made by coiling up lengths of the cane into the shape of the basket and looping or sewing them together in position with long thin strips of the outer coating. In Lombok, cane is coiled to make rounded and spherical baskets with lids. The thicker cane coils are set off by a counter pattern of delicate loops. More refined baskets and small boxes for jewelry are also made with finer, shinier strands of tough grass. Lizards and frogs are carved in wood to form lid handles.

The basket-makers of Lombok are very skilled in their use of a wide variety of plant products to make unusually varied containers; many of these either stack inside each other or can be arranged to form towers or sets of matching boxes of different sizes. Bamboo, sticks, rattan, sheets of bark and *lontar* leaves are stained with blacks, browns or rich purples, deep reds and soft dark greens. Patterns of white *nassa* shells set off the colours and contrasting textures of the plant fibres. In some villages, like Loyok and Kota Raja and Suradadi, in east Lombok, and Beleka village and Jangkok Rungkang, in Cakranegara in central Lombok, basketry provides an important source of income. Some work is sold in the big markets at Sweta and Cakranegara, but much of it is sent to Bali to fetch higher prices.

Bark is also used to make circular boxes similar to those made by the Batak in North Sumatra and by Dyak communities in central Kalimantan. Subtly stained boxes with shell ornament are also made in Alor, further east in Nusa Tenggara, and *nassa* shell decoration is also occasionally used on Dyak basketry.

In Lombok, sets of colourful palm leaf, bark and rattan boxes were used to carry wedding clothes. Bright bamboo boxes are filled with festive cakes.

Colourful and plain basketry is woven in Bukittinggi and nearby Payakum-buh, in West Sumatra. Pandanus leaves and reeds, which readily absorb bright

Batak symbols and charms of the type inscribed on bone, bamboo cylinders and in bast books.

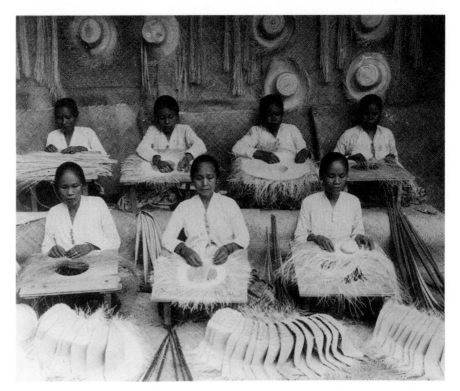

Women demonstrating the plaiting of hats at a craft fair in the 1900s.

aniline dyes, are woven into a variety of baskets in bright pink, red, purple and green plaid and checked patterns. Strong, plain baskets are constructed from pandanus, rattan and bamboo.

Pandanus, also known as *pandan* or screw pine, grows along the seashore or in estuarine swamps and on river banks. Tufts of strappy leaves sprout from the ends of grey branches. Aerial roots dangle down to meet the clustering stilt roots rising from the soil to support the trunk. Pandanus leaves are armed with lacerating hooks which must be sliced off before they can be woven.

Green and red checked mats are sold in the markets of Palembang, in South Sumatra, and in the city's lacquer workshops, rattan baskets are sealed with red and black lacquer and decorated with gold paint. Shiny dried scales from the fish in the Musi river are painted with bright colours and stitched to conical palm leaf food covers.

In Aceh, in North Sumatra, the Gayo women of the highlands weave large reed mats in deep rose, green, black, red and yellow to provide rich linings for walls and floors in rooms used for weddings and important celebrations. Small bags for tobacco and betel ingredients are made with finer reeds and decorative openwork panels. Pandanus mats for daily use are embroidered in bright wools and thick cotton with similar geometric and star patterns.

The Bugis and Macassan love of brilliance in silk is also expressed in brightly coloured basketry. In Watampone (Bone), in South Sulawesi, seat of earlier Bugis kingdoms, men's fez-like hats or *songkok*, which are worn to the mosque or to formal festivities, are woven in white, cream and black, or patterned with bright colours and ornamented with bands of golden thread. Circular mats and baskets like ziggurats are coiled and bound with orchid or palm fibres, which are dyed deep purple, green, bright pink and canary yellow.

Fine bark from breadfruit, wild fig or paper mulberry trees is fermented, softened and then felted by beating it with paddles. Barkcloth garments are worn in several Indonesian societies. In the last century, and during wartime shortages of commercial cloth this century, women of Central Sulawesi made very fine barkcloth garments for ceremonial and everyday wear. These were painted with plant dyes in browns, rust, black and pink in geometrical and curling designs of buffalo horns. Barkcloth is still produced in villages in the highlands of Central Sulawesi, and patches of barkcloth are sewn onto plain black cotton garments. In South Kalimantan, breadfruit tree barkcloth is used for plain mourning garments. Kenyah clothing made from barkcloth is decorated with powerful symbols and only worn on ceremonial occasions. The Dani, in Irian Jaya, and the reclusive and conservative Badui, in West Java, shred bark and roll it into fine filaments to make weaving material for woven string bags and other items. Dani tribesmen make subtly coloured, shining orchid and fern fibre skirts for their women.

Many people make practical items from plant products for their own use, and women with a special talent for plaiting, basketry or bamboo work take their wares to local markets. However, in some villages manufacturing these products has become a cottage and export industry.

Modern furniture is made with massive golden canes up to eight inches (twenty centimetres) in diameter at the village of Belaga in Bali. Black bamboo is also used for the chairs, tables, settees and beds seen in daily use all over the island. Cirebon, Jakarta and Bandung, in Java, are well known for their furniture and basketry. At Rajapolah, near Tasikmalaya in West Java, the main street is lined with stalls selling colourful modern bamboo and rattan goods: furniture, lidded and unlidded checked baskets of every size, lampshades, gaily painted and grand double-layered umbrellas and toys. High-quality items are sold in Jakarta and beyond Indonesia.

126 The fruit basket on the left, which is constructed from bamboo, wood and rattan and decorated with oil paint, is from Sumenep, Madura. $6\frac{1}{8}'' \times 11''$ (15.5 × 28 cm). The taller rice basket is made from wood and painted rattan. It was collected in Yogyakarta, Central Java. The small fruit basket is of lacquered rattan and was made in Palembang, South Sumatra. The serving spoons were carved in softwood and painted with commercial paint in Sumenep, Madura. L of the larger spoon $9\frac{1}{8}''$ (23 cm).

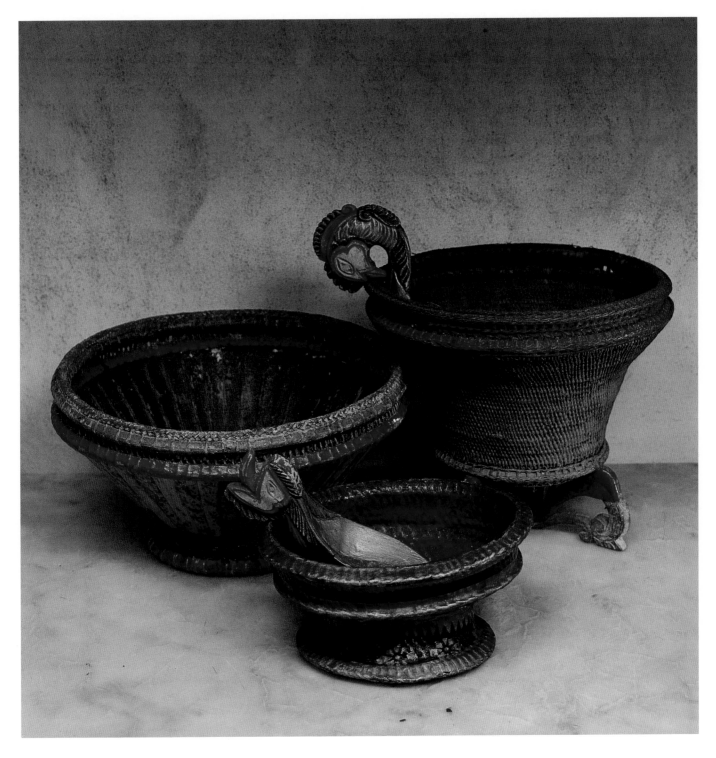

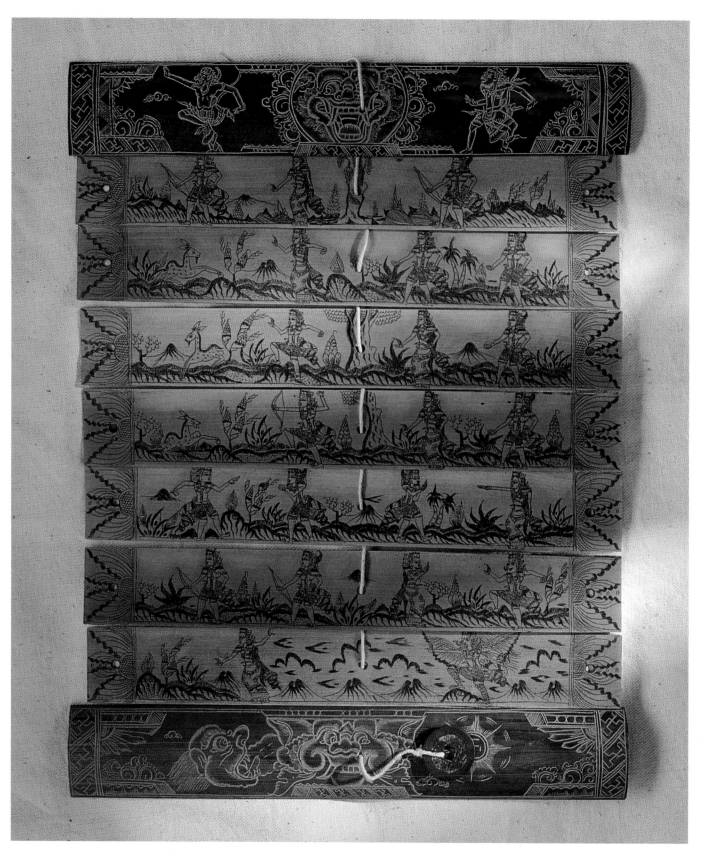

127 *Opposite* Illustrated manuscript of the *Ramayana* made in Tenganen, Bali. Etched and stained *lontar* palm leaves, bamboo, cotton string and an old Chinese coin. $10\frac{1}{8}'' \times 11\frac{3}{8}''$ (26 × 29 cm).

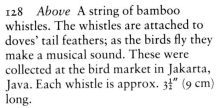

128 *Above* A string of bamboo whistles. The whistles are attached to doves' tail feathers; as the birds fly they make a musical sound. These were collected at the bird market in Jakarta, Java. Each whistle is approx. $3\frac{1}{2}''$ (9 cm) long.

129 *Above right* Rotinese *sasando*. This musical instrument is made from split *lontar* leaves, bamboo, wire and screws. *Sasando* are also made with a single uncut leaf that is curved to form the sound box. The sound produced by the *sasando* depends on its size and on the number of strings. This *sasando* sounds like a mandolin. $21\frac{3}{4}'' \times 16\frac{7}{8}''$ (54 × 43 cm).

130 *Right Gerantang* or *tingklik* (bamboo xylophone) from Pengosekan, Bali. This type of instrument produces a fluid, tinkling sound and is traditionally used to accompany the *joged bungbung*, a flirting dance performed by girls, who invite male spectators to dance by tapping them with a fan. L $22\frac{3}{4}''$ (58 cm).

131 *Right* The etched bamboo lime containers on the left are from the Soe district of West Timor, Nusa Tenggara. The others are the work of Batak craftsmen in the Lake Toba district of North Sumatra. Containers of this type are used for holding lime, medicine, trinkets and cotton reels and also for decoration. The stoppers are carved with the motifs of a rider astride a *singa* (lion) and a double *singa*-like head. The tall water container is etched with a Batak calendar that is used to determine auspicious days. H 17¼" (44 cm).

132 *Below* Container for medicine or for decorative purposes with etched bamboo and a carved wooden stopper and side in the form of *singa*. Toba Batak people, Lake Toba, North Sumatra. L 8⅞" (22.5 cm).

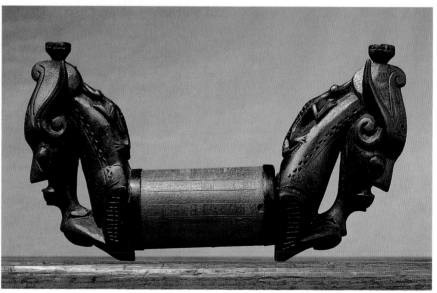

133 *Right* This decoratively incised gourd from central Lombok, Nusa Tenggara, is a container for spices or trinkets. H (including the stopper) $8\frac{1}{4}''$ (21 cm).

134 *Below* Utilitarian container made from a coconut, with a wooden lid and a curved horn hook, to form part of a Madurese fisherman's kit. It is worn attached to a belt with a knife in a carved wooden scabbard. Collected in Surabaya, East Java. D $5\frac{7}{8}''$ (15 cm).

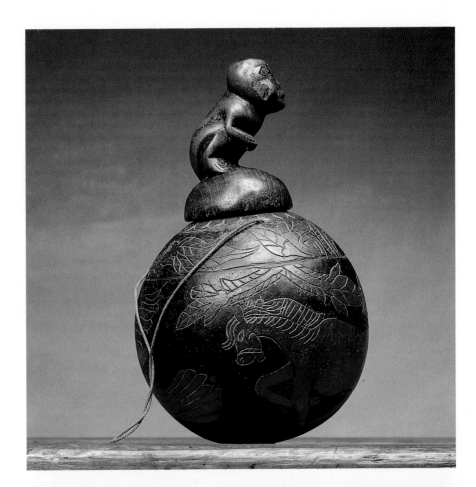

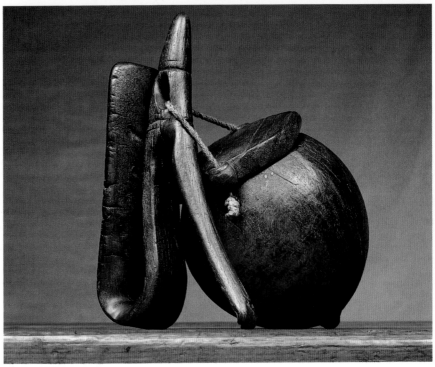

135 *Below* Kenyah Dyak baskets for carrying personal belongings collected at Melak, East Kalimantan. The motifs represent extremely stylized images of the *asoq* (dog-dragon), leaves, bamboo shoots, stars and serpents. Approx. $19\frac{3}{4}'' \times 10\frac{5}{8}''$ (50 × 27 cm).

136 *Right* Small palm leaf slipcases or purses. Those with checked patterns are from Bukittinggi, West Sumatra. The others are from Dili in East Timor. The large slipcase is $6\frac{3}{4}'' \times 4\frac{1}{2}''$ (17 × 11.5 cm).

137 *Centre right* These small baskets for betel ingredients were woven from dyed and undyed *lontar* palm leaf in central Timor, Nusa Tenggara, and are bordered with machine-woven cloth. The mat behind is from the same materials and location. The larger basket was made with split bamboo and sealed with industrial paint. It was collected in Palembang, South Sumatra, and is used for storing cosmetics, medicines, trinkets and occasionally magical charms. H $8\frac{5}{8}''$ (22 cm).

138 *Bottom right* Coiled rattan basket for clothing from central Lombok, Nusa Tenggara. Fine strips of the shiny outer coating of the rattan palm-vine are looped over the peeled core. H $10\frac{1}{4}''$ (26 cm).

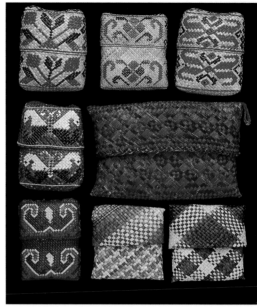

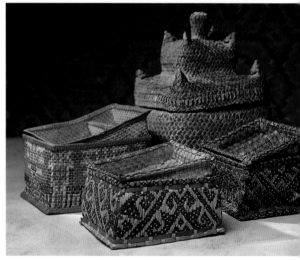

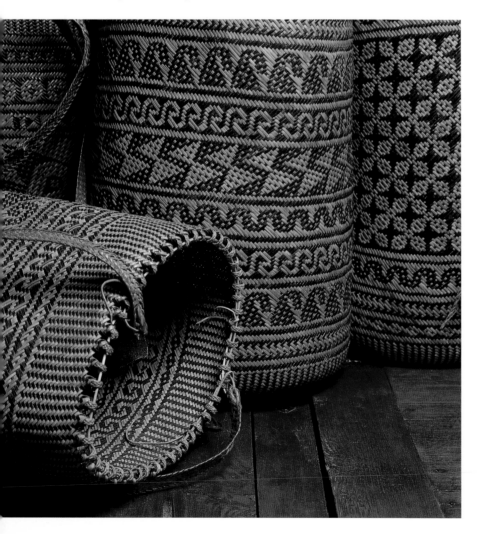

139, 140 Boxes of stained
split bamboo and bark from
central Lombok, Nusa
Tenggara. These can be fitted
inside one another to make a
box measuring $13\frac{1}{4}'' \times 13\frac{1}{4}''$
(33.5×33.5 cm), used as
separate boxes, or stacked to
form a tower (*right*) H $25\frac{1}{4}''$
(64 cm).

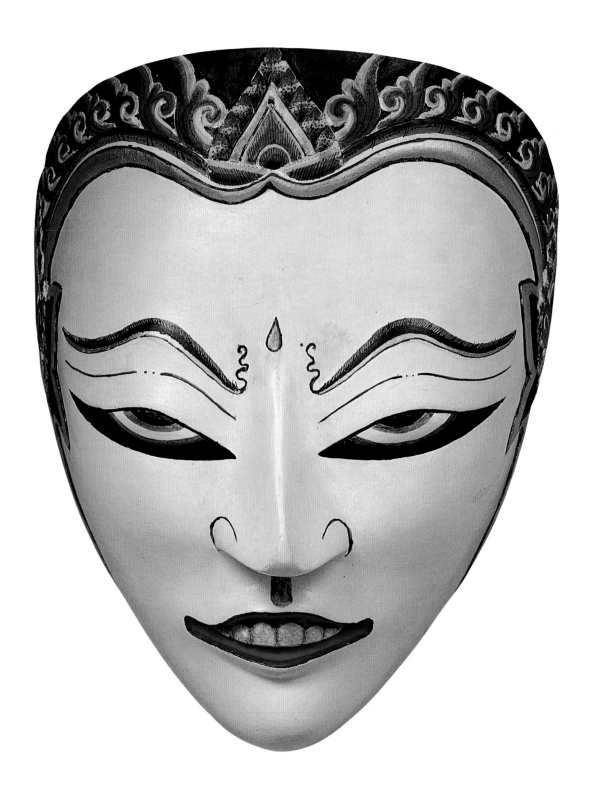

MASKS AND PUPPETS

The origins of Indonesian drama lie deep in prehistoric culture. Sacred performances invoked the guidance and blessing of ancestors, drove away danger and disease and placated the recently dead. Bountiful harvests, and thus the survival of whole communities, depended on the generosity of vegetation deities. Javanese and Balinese shadow and doll puppet plays and dance dramas are still performed for planting and harvest celebrations and at times of transition in the lives of individuals and communities.

In Asmat villages in Irian Jaya, relatives of the dead impersonate the departed for a day. They wear string masks with ochre and feathers and appear as spirits at the edge of the jungle or across the river to join the world of the living to feast and dance; then the spirits return satisfied to the land of the dead.

The large, fully clothed *si gale-gale* puppets of the Toba Batak in North Sumatra were used as artificially weeping mourners for those who had died without children. The Karo and Toba Batak dead were accompanied on their journey to the grave by dancing companions wearing male, female, horse or hornbill masks. In many parts of Indonesia, the use of masks for fertility and funerary rites has declined as a result of conversion to Christianity. The masks and wooden hands carved and sold at Prapat and on Samosir are symbols of ethnic identity but no longer have a central role in communal ritual.

It is thought that the Hindu, Islamic and historical tales that form the basis of most drama and puppet theatre in Java and Bali have been superimposed on ancient rituals that are still clearly recognizable in trance and cult drama and in Dyak agricultural ceremonies in East and Central Kalimantan.

In the Apo Kayan, Mahakam and Teleng river districts, it is believed that the gods descend from the mountains and enter men to bring the beneficent rice spirits and seeds that will ensure the fertility of crops. The godliness of the men is disguised by their deer, pig, dragon, tiger and human masks (*hudoq*) that are painted red, black and white. The masked gods dance down the long public galleries of longhouses as a prelude to the banquets held at critical times of rice planting and harvesting. Men and women exchange roles, and there is a great deal of jesting which draws parallels between human and agricultural fertility. Young men wear frightening masks to inspire delicious terror in the girls who live temporarily in huts to watch over the fields. In Lombok, the masked dance dramas (*teater kyak*) of the Islamic Sasak communities are traditionally performed to exorcize epidemics or intractable illnesses.

On the misty Dieng plateau and in Javanese towns and villages, a variety of trance dances are performed with demon and animal masks and costumes.

141 Mask of the wife of Prince Panji, the quintessential Javanese hero. Despite endless frustrations and separations, she is always his great love; she represents the moon and he the sun. She is extraordinarily beautiful, and her hand is sought in marriage by several kings; however, the Panji narrative cycles involve various different locations and versions of her character as well as a number of variations on Panji himself. This is the mask of Dewi Sekartaji or Raden Chandra Kirana, the princess of Kediri, who is often simply known as 'the maiden'. The mask was made by Pak Warnowiskito at Krantil, near Yogyakarta, Central Java.
Wood, pigmented glue-based paint.
$7\frac{1}{2}'' \times 6\frac{7}{8}''$ (19 × 17.5 cm).

Exorcistic *barongan* (lion or tiger) and hobbyhorse dances are performed under regional names. Wild steer, water buffalo, elephant, pig and tiger masks are used to entertain and to drive away misfortune. Fire summons an animal spirit to enter a mask while it is held over a brazier. The dancer may be brought to the mask again and again until he is willing or able to fall under its power. Musical accompaniment is provided by bamboo rattles and hypnotic, rhythmic banging on gongs.

In the *kuda kepang* dance, hobbyhorse riders astride their woven bamboo mounts begin to rear and prance; in animal mask dances, bulls lower their heads and paw the ground. The players are controlled or perhaps stimulated by long curling whips that induce a state in which some become so beside themselves that they run blindly away into the fields from which they must be rescued by a traditional doctor. Papier mâché animal masks for both adults and children are sold in the streets for carnivals and parades celebrating the birthday of Muhammad, which is a favourite occasion for the performance of a variety of folk theatrical events.

In Central Java, highly formalized court dance lacks the primordial urgency that flourishes among travelling players and folk performers. Drama and dance were, and still are, an important part of the state ritual of the Central Javanese courts. Rulers were themselves great dancers and choreographers, and they mounted magnificent theatrical festivals which lasted for days and involved vast numbers of performers drawn from the ranks of their families, friends and retainers as well as from the permanent corps of dancers and musicians living at the court.

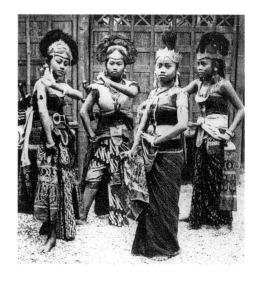

Wayang wong unmasked dance in Java at the turn of the century.

Most Javanese masked dance drama or *topeng* is reserved for history plays celebrating the lives of the Javanese kings. Many of these centre on the adventurous Panji, the quintessential Javanese hero and a prince of the utmost sweetness and refinement. Core narrative elements recur in all plays. Inevitably, and against great odds, Panji regains a position of power and rescues his abducted or lost princess. Folk versions of the Panji and other historical tales and stories based on the Hindu epics are performed with masks in the Javanese countryside.

The performance masks made by the elderly Pak Warnowiskato of Krantil village, out across the rice fields from Yogyakarta, are a tour de force of three-dimensional design. Like Bambang Suwarno at Sangkro, in Surakarta, he not only makes very fine masks but puppets as well.

There is a constant procession of major and minor festivals in Bali, and dance and puppet performances are offerings to the gods as well as sacred entertainment. Village associations own gamelan orchestras, dance costumes and sets of masks. In the evenings, music floats across the rice fields. Little girls are painstakingly trained to dance by older sisters who stand behind them gently twisting their fingers into position. Old men patiently correct tiny boys who, with flashing eyes, strut out the martial movements of the Baris warrior dance. Children at play flutter and twirl their fingers or absent-mindedly adopt dance postures.

Bali is famed for its elaborate masked dances and ceremonial dramas which include the exorcistic *barong* and *calon arang* (see pls 77 and 147) in which the widow (*rangda*), the queen of witches, is temporarily defeated by the *barong*, a

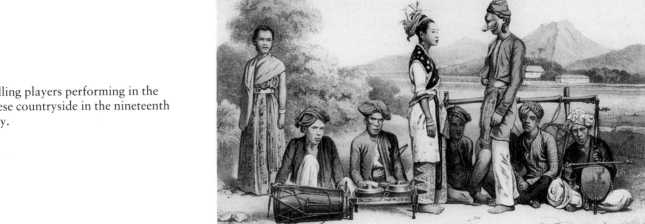

Travelling players performing in the Javanese countryside in the nineteenth century.

positive underworld creature that neutralizes chthonian evil and usually resembles the lions of Chinese processional dance. Other Balinese masked dances are more courtly and are based on historical tales. The holy *topeng pajegan* performance requires a series of character masks that are sequentially donned by one dancer. The more informal *topeng panca* is danced by five masked men. Some Balinese dramas require masks for minor and comical characters, and these can be interpreted with creative freedom by the maker. In the *jauk* dance, which derives from the Hindu epics, the character of a demonic masked king dances menacingly.

Sacred masks are usually made by high-caste families with a hereditary specialization in the craft, whose members are familiar with the appropriate rituals and the mask-makers' code of practice (*dharmaning sangging*). For a powerful mask, permission to cut into the living wood is sought from a *pule* or a *kepuh* tree growing in a place imbued with spiritual power – a graveyard or temple courtyard. Some trees are thought to grow masks on purpose by producing appropriately shaped swellings which are cut away when they reach a suitable size. An especially fine mask may receive dozens of coats of pigment in a gelatin base. Teeth are usually carved and painted, but pigs' teeth or seashell may be used instead. Human hair, horsehair or the coarse black fibres of the sugar palm are used for the less refined and thus hirsute characters. The curls of refined characters are painted on. As in Java, the facial features of main characters are firmly established by convention. Balinese masks are comparatively rounded and naturalistic; the lips are full and the chins less receding than those of the sharp delicate masks of Central Java, the flat moon-like faces of Cirebon, in West Java, and the heavily carved masks of East Java and Madura. Balinese sacred masks are kept wrapped in cloth and stored in a high place at the village *Pura Dalem*, the temple of the underworld.

There are several talented mask-makers working in and around the village of Mas, in South Bali. Much of their work is intended for sale to collectors and tourists, but an ordinary mask that is used and appropriately cared for may acquire spiritual power. Sacred performance masks are also made at Singapadu by I Wayan Tangguh and his family. Some Balinese dramas require masks for

minor and comical characters, and these can be interpreted with creative freedom by the maker. Many traditional masks are accomplished in their study of character and are eagerly sought by collectors. Other non-performance masks carved in and around Mas are sculptural works in their own right and are equally highly prized.

In Java, shadow plays are performed in villages and towns on public holidays, religious festivals, weddings, birth celebrations and circumcisions. In Bali, they are also staged at cremations. After dark, men, women and children gather around the white cloth screen. Shadows are made by incandescent gas or electric lighting positioned behind the puppets and the screen.

The *dalang* or puppeteer lifts the puppets up to take their place in the heavenly world of shadows. They move with graceful dignity, mincing fastidiousness, hearty striding motions or lugubrious waddles. Maidens fiddle with their clothing; ogres clamber about boisterously and wave clubs. Shadows shiver and blur with the unpredictability of living things, and are precise and dainty or threatening and swollen with distortion. The *dalang* manipulates the puppets, sings and taps out signals to the orchestra. He also speaks the parts for all the characters; he must be able to render the shy sweetness in the voice of a princess, the spiteful whine of a lackey and the righteous but controlled anger of a noble hero.

The most frequently performed narratives derive from the Hindu epics. The *Arjuna Sasra Bahu* and *Ramayana* cycles concern the affairs of the noble Rama himself and his ancestors. Favourite stories concern Rama's marriage to Sinta; their banishment to the forest together with his brother Laksmana; Sinta's abduction by the monster king Rahwana; and her subsequent rescue, with the aid of the monkey king and after numerous battles, from the kingdom of Sri Lanka. The *Ramayana* contains many episodes from the lives of these characters which are emphasized in varying degrees to form separate plays in their own right.

The *Mahabharata* tells of the conflict between the superior Pandewa brothers (Judistra, Bima, Arjuna, Nakula and Sadewa) and their hundred jealous and mendacious cousins, the Kurewas, who drive them away from their home at the court of Astina, to wander in the wild. In the forest the Pandewas build the lovely and idealized kingdom of Amarta where the majority of the plays are set. The heroic quests, battles with vile ogres and scenes of romantic love are made all the more poignant by the knowledge that the glory and beauty are fleeting. Events are presented as taking place in Java rather than India, and the heroic Pandewas, descendants of Vishnu, are the ancestors of the Javanese kings. Many episodes have simply been invented by puppeteers over generations.

The court scenes also allow scope for the comic misadventures and intrigue of the Pandewas' clown servants, the Punakawans: Semar the wise, whose identity is thought to have evolved from that of the pre-Hindu Javanese god Ismaya and his sons. The inane and melancholic Gareng, with his round drooping nose, is the butt of jokes and tricks played by the sharp Petruk. Philosophical and mystical speculations made by the refined characters provide an intellectual and spiritual dimension for members of the audience with a taste for high seriousness.

The moral world of *wayang* is complex and subtle, so that while each of the five Pandewa brothers provides a study of positive character traits, none of them

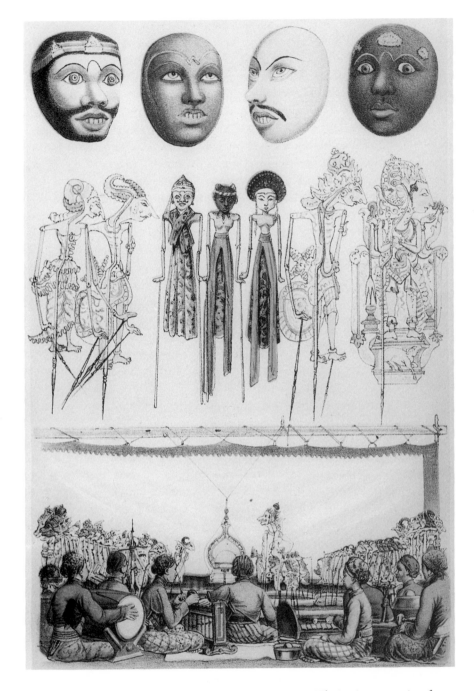

Javanese masks, shadow puppets, rod puppets and a performance of a shadow play against a cotton screen with an orchestral accompaniment.

implies a perfection remote from human experience. Their virtues spring from the same source as their vices, so that whereas Arjuna is refined in emotion and intellect, he is also cool and lacking in empathy. Bima is bold and forthright, but without humility. The characters provide a range of fully achieved personality types which reflect important and influential cultural ideals; boys may wonder whether they are more like Bima than Arjuna, and growing girls try to emulate the graciousness of Sinta. Pedlars laden with cardboard *wayang* puppets and papier mâché dance masks sell their wares as playthings to children in towns and villages.

There are at least one hundred puppets in a very basic *wayang kulit* set, although the palace collections in Yogyakarta and Surakarta contain up to five hundred in each. The puppets are made by initially sketching the lacy patterns onto buffalo or goat hide. After the form has been cut out, it is placed on a flat wooden anvil, and the work of creating the tiny holes begins; these are formed by precise blows with a wooden mallet to a chisel or punch. Sacred colour symbolism conveys essential information. The face of Vishnu is painted black, whereas Shiva's is gold, but a character may appear in a different colour to indicate alterations in circumstances or emotional state. Red is used to suggest a fiery or impetuous nature; white implies innocence or youth.

Puppet body types can be identified across a spectrum which ranges from *alus* (extremely refined) to *kasar* (extremely rough and crude). Refined, virtuous characters have small dainty bodies, slitted oval eyes with pupils shaped like rice grains, pointed noses and a modest downward gaze towards narrow, delicate feet. Vigorous or turbulent characters have a more direct and confrontational stare. As the personality of the puppet becomes less refined, there is an increase in size; the nose becomes heavier and blunter; eyes and pupils become larger and rounder and the gaze more aggressive; teeth and gums may be exposed in a snarl or a foolish sneer. The more refined middle-sized puppets may represent courageous but impetuous kings and heroes; the coarser ones suggest an uncontrolled or evil nature. The largest puppets are used for those whose greatest attribute is physical strength; they are bold, graceless and large footed, but need not be lacking in honesty and virtue. The *raksesa* or ogres are lumpish monsters and unlike the other characters have only one arm.

The making of *wayang kulit* puppets is usually a family concern. Knowledge of the vast number of characters and their attributes is handed on through generations. Smaller children are encouraged to help with the job of inking in the fine lines, painting and gilding, because this familiarizes them with the physical features and costumes of the characters. Later, they learn the more unforgiving skill of accurately cutting and punching. Moveable leather arms are hinged at the shoulders and elbows; these are attached to thin buffalo horn sticks which are manipulated by the *dalang* to provide movement and expression. The completed puppet is fitted with a long, polished buffalo-horn handle.

The Sagio workshop in Gendeng, near Yogyakarta, is well known for fine puppets, and orders are received from collectors throughout Java. Puppet-making can also be observed at Surakarta's palace workshops, where royal patronage of traditional artisans continues. At Manyaran, south of Surakarta, members of the village co-operative make puppets of unusually high quality.

Wayang kulit is also performed in Bali and Lombok. Balinese puppets differ from the Javanese in that they are much simpler and more naturalistic. There has been some speculation that the delicacy and distortion of Javanese puppets arises from Islamic proscriptions against the making of images of the human body, and that Balinese puppets are more original. Family workshops in the village of Puaya, near Sukawati, specialize in producing leather shadow puppets as well as performance masks and costumes. Fine puppets are also made in Peliatan. In Lombok, the Sasak leather puppet plays concern Islamic themes.

Wayang klitik puppets of flat painted wood are rarely used in the performance of the East Javanese historical romances about the Majapahit

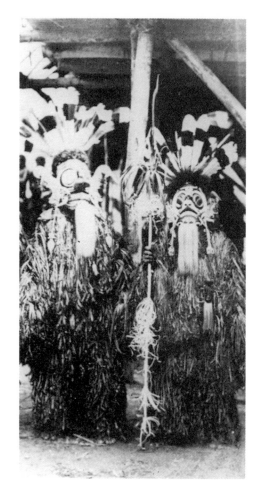

Kenyah or Bahau dancers wearing *hudoq* animal masks, hornbill feathers and leaf capes in a performance to ensure a bountiful rice crop.

empire, the *Damar Wulan* cycle. *Wayang klitik* puppets of characters from the Hindu epics are also made as souvenirs. *Wayang klitik* makers around Yogyakarta work in Driyo, Sewan, Pendowarharjo and Bantul.

The relationship between the shadow theatre and dance drama is clear in Sumenep, in Madura, and in Gegesik, near Cirebon in north West Java, where performers and mask-makers live and work. Dancers mimic the puppet movements, and costumes and facial features are based on those of the puppets. In Cirebon, stories from the Hindu epics are Islamicized and narrated by a *dalang*, who speaks for the living puppets who dance wordlessly. Short masked dances which express the personality of a single character from the epics, often that of the demon king Rahwana, are also popular in the district of Cirebon.

Like Chinese and Indian puppets, *wayang golek* (doll or rod puppets) are fully three dimensional, carved in wood and dressed in cloth costumes and tiny items of metal jewelry set with glass stones.

There are regional differences in the style of rod puppets and preferred narrative cycles. In West Java, where *wayang golek* is most popular, the stories are based on the *Ramayana* and the *Mahabharata*; identity and character are expressed by physical attributes similar to those used for leather puppets, and faces are the most conventionalized. A slim, but wide-shouldered, bronze body with a velvet breast cloth is used for refined male characters. Goddesses, queens and ladies are bare-shouldered, their small breasts hidden by a close-fitting bodice. Coarse male characters may have stout torsos partly obscured by a sash, and grosser demons wear only a sarong. Male and female servants and officials are dressed in sarongs and long-sleeved jackets. Puppets appearing in the *wayang cepak* or doll puppet history and Islamic plays of Cirebon have flat, precise, triangular faces and full lips.

In Central Java, an Islamic cycle of stories (Menak) is the most popular. These concern the stirring exploits in love and war of Muhammad's uncle, Amir Hamza, and his friends and family in Mecca and Medina. Most stories are set in far away and exotic lands and involve intrigues and trials of spiritual and physical strength against dangerous *jinns* and the bearded, wide-eyed kings of Greece, Rome, Germany and Yemen. Many seek help from Amir Hamza; even the Queen of the Fairies entreats him to save her realm. He promotes good against evil and protects the weak from the strong; his moral and spiritual example serves as a spur in converting others to Islam.

Since the stories portray historical and human rather than divine affairs, the puppets, like those used for history plays, are always fully clothed in Central Javanese traditional dress with batik sarongs and splendid velvet or braided cotton jackets. Their liveliness and colour are reminiscent of illustrations to the tales of the *Arabian Nights*, some of which may be of Indonesian and not Middle Eastern origin.

West Javanese puppets can be purchased at the Cupu Manik and Ruhiyat workshops in Bandung and in Bogor and surrounding villages. Local markets and roadside stalls on the Puncak Pass offer a diverse range of puppets, including unusual clown puppets with bobbing heads that are operated by a string.

Central Javanese puppets are sold in the markets and shops in the cities of Yogyakarta and Surakarta. Excellent examples are made by the family of the respected mask-maker Pak Warnowiskato at Krantil, but delightful puppets are

also produced in the workshops in Kalibondal village in the district of Sentolo to the south.

Like so many other crafts in Indonesia, making *wayang golek* is also a skill handed down through families. The master puppet-maker usually makes the head because it expresses the personality of the puppet. Ceremonies are performed before commencing a deity or a demon. A piece of light, local softwood, which is easy to carve and not too heavy to hold up during a performance, is sawed or chopped down to the right size, and the main features are roughly chiselled. After sanding, fine decorations such as the parts of a crown are carved in with more care and sanded. The smooth surface receives a coat of glue-based paint, which will enable subsequent coats to adhere well. Lips, flowers and some bits of jewelry are painted red, as are the irises of angry characters. Blue is also used for eyes and sapphire jewelry. Fine black lines are painted for eyes, eyebrows, moustaches and wisps of hair.

Bodies are often made by younger members of the family, and arms are attached at the elbow and shoulders with string so that they move easily. The shapes of hands also express character and role; those of nobles stretch out gracefully, but servants and commoners have large open palms. A rod passes from a hole in the base of the puppet's head and down through the body to form a handle. Costumes are usually made by wives.

The tourist market creates a high demand, and in some areas, the process of puppet-making has become a cottage industry. Heads may be carved in one village and sent to another, where they are attached to bodies, painted and arrayed in their costumes.

Decorative puppets, which are not necessarily made to be used in performance, are often works of such artistry that few *dalang* could afford them. Some puppet-makers in West Java are mainly occupied with producing exquisite puppets for collectors within Indonesia. The cast of characters offers an array of archetypal personalities, and fine puppets are treasured by those who have been familiar with *wayang* since childhood and have developed an attachment to particular characters and legends.

Decorative and performance puppets are the subject of increasing innovation. Some refined characters are not as inhumanly ethereal as they have traditionally been. The red-faced clown, Cepot, now bristles with knives and raffishly dangles a cigarette from his mouth. Young puppeteers experiment with foam-rubber faced puppets which vomit and bleed. A new shadow puppet may struggle with escalating absurdity to kick-start his motorcycle. Amid shrieks of laughter from the audience, he finally succeeds in starting the engine by urinating into the fuel tank, and then zooms away, up and down imaginary mountains in pursuit of his quest. In abandoning courtly fantasy for comic realism, there is some loss of the distancing which frees the imagination and is, for some, one of the great satisfactions of *wayang*. Nevertheless, novelty and humour should not be suppressed in the interests of preserving a deadly orthodoxy of good taste. It is the mixture of courtly, mystical and popular elements that allows traditional theatre to be so loved by so many people.

142 A collection of masks of characters in *Mahabharata* and historical cycles. These display the deep carving, facial expressions and styles of crown typical of those from East Java and Madura. The lower masks are approx. $7\frac{1}{2}" \times 6\frac{3}{4}"$ (19 × 17 cm) and were collected in Sumenep, Madura.

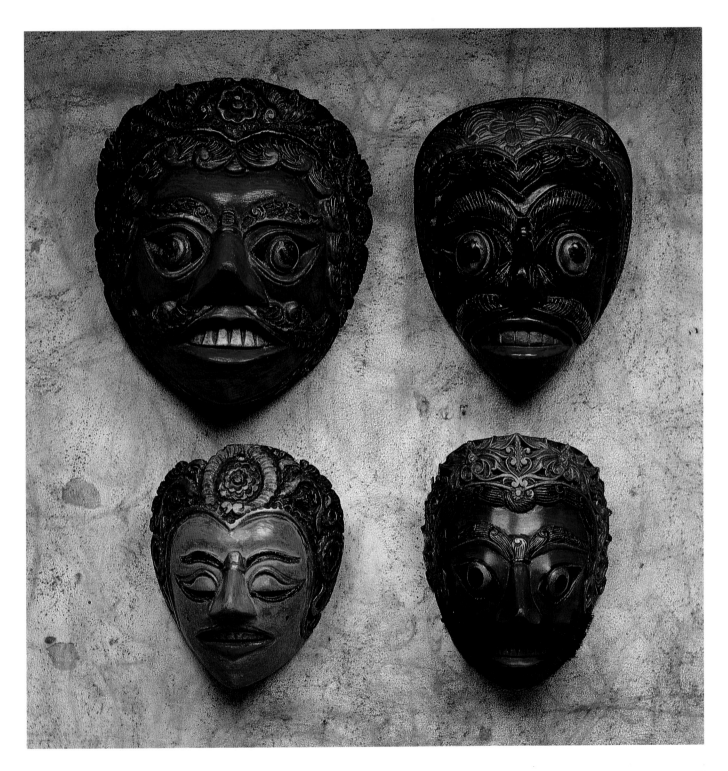

143 *Right* Balinese masks from the *topeng* history plays. The white mask of the king reflects his refined nature. A more active personality is expressed in the warm colour and thick moustache of the mask of his prime minister (below). The mask of an old man is that of an elderly advisor. The mask of Sidha Karya, lord of innocence and childhood, which combines comic and demonic qualities, is both amusing and frightening to children who run away from the dancer. One child is always caught and quickly released with some coins or sweets. The masks are worn with elaborate gilt leather headdresses and rich costumes. The masks of the king and the old man were made at Singapadu and the others at Mas with softwood (*pule*), commercial paint and pigmented glues, horsehair and goatskin. Seashell was used for the teeth of the king's mask which measures $7\frac{1}{2}'' \times 5\frac{1}{2}''$ (19 × 14 cm).

144 *Below* Papier mâché toy mask decorated with commercial paint and collected from a street pedlar in Jakarta, Java. $7\frac{1}{2}'' \times 5\frac{1}{8}''$ (19 × 13 cm).

145 *Below right* Festive animal masks made with papier mâché and commercial paint. Collected from a pedlar in Jakarta, Java. H of the larger masks approx. $15\frac{3}{4}''$ (40 cm). The bird cage was collected in the Jakarta bird market.

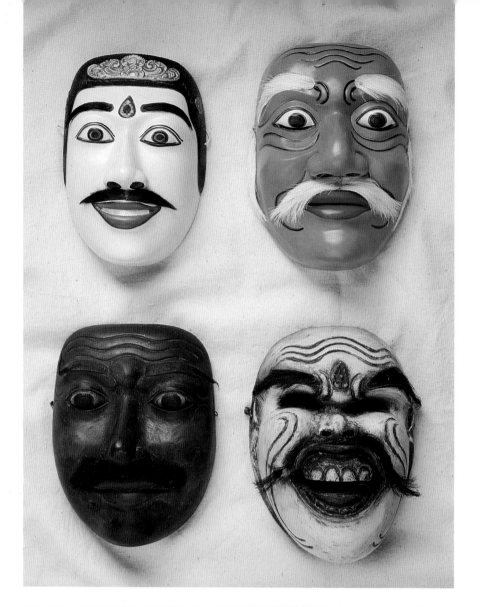

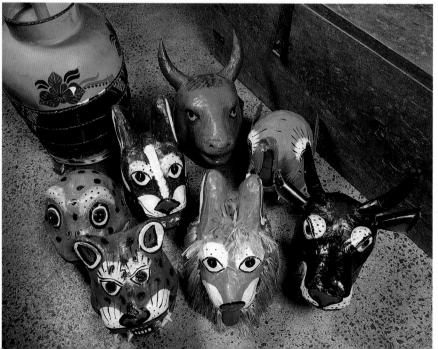

146 *Above right* Demon mask used in the interrelated Javanese trance dramas which include the *singa barong*, *reyog* and *kuda kepang*. This mask could also be used for the solitary dance of the demon king Rahwana from the *Ramayana*. In folk performances of historical romances, which are not connected to the Hindu epic, the character of Rahwana may also be included. Coconut wood, black sugar palm fibre, industrial paint and rubber bicycle tyre. Collected in Yogyakarta, Central Java. $11\frac{3}{8}'' \times 6\frac{7}{8}''$ (29 × 17.5 cm).

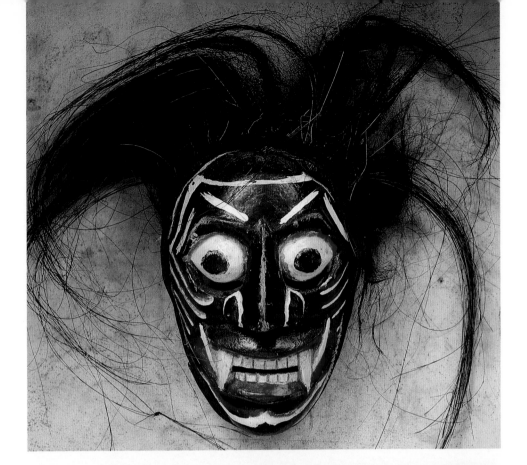

147 *Below right* The *calon arang* exorcistic dances are performed either in the street or in the grounds of the village temple of the dead and the underworld (*pura dalem*) and its adjacent cemetery. The plays dramatize the temporary defeats of the widow (Rangda), the vengeful queen of witches. This witch mask can be worn by one of her cohorts (or company) and was made by Ida Bagus Sutarja of Mas, Bali. Softwood (*pule*), leather, pigmented glue and horsehair. $11\frac{3}{8}'' \times 10\frac{1}{4}''$ (29 × 26 cm).

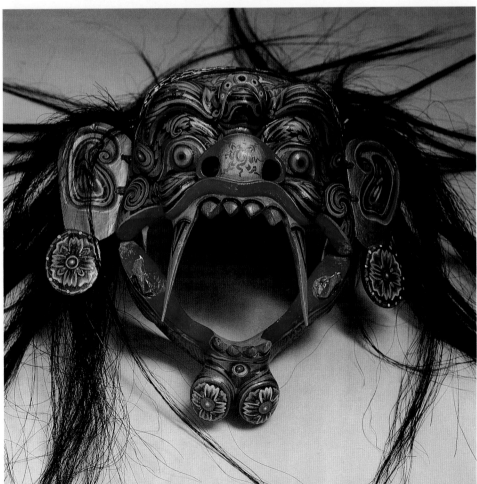

148 *Below* Shadow puppets from the *Ramayana*. Sinta, the lovely and virtuous wife of Rama, who was abducted by the wicked Rahwana and taken to Sri Lanka, is rescued with the aid of Hanoman, the energetic monkey god. The puppets were made at the Sagio workshop in Gendeng, near Yogyakarta, Central Java, with painted and gilded leather and buffalo horn. Sinta is $16\frac{7}{8}''$ (43 cm) high.

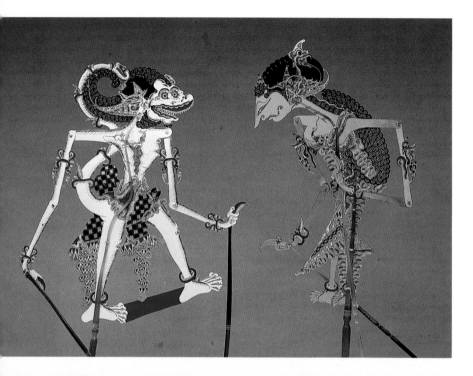

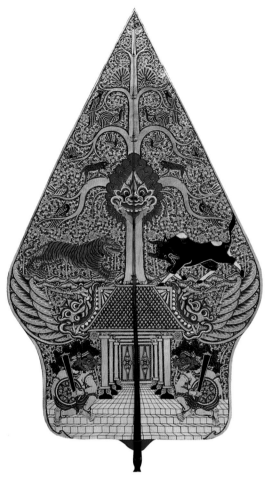

149 *Above* The painted leather *kayon* (forest) – also called the *gunungan* (mountain) – shadow puppet is used during the preliminary ceremonies at leather and rod puppet plays to bring the puppets to life. It can also represent a change of scenery during the play. Flames and a demonic face are painted on the back and the *kayon* may be fluttered during a performance to indicate the intervention of natural forces, such as wind and fire. Surakarta, Central Java. $39\frac{3}{8}'' \times 18\frac{7}{8}''$ (100 × 48 cm).

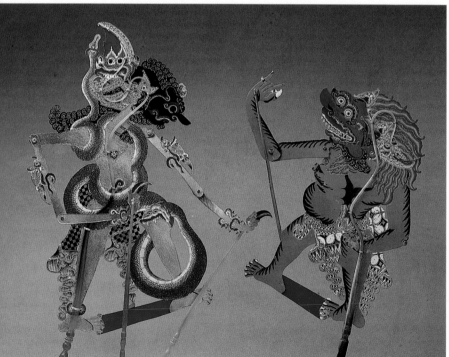

150 *Left* Bima, the heroic and forthright Pandewa brother from *Mahabharata* cycles, and a *raksasa*, a wild and evil-tempered creature. *Raksasa* and *buta* (giants and demons) appear in many story cycles. They emerge from their lairs, accost the heroes and lose the battle. These puppets were also made in the Sagio workshop. H of Bima $18\frac{7}{8}''$ (48 cm).

151 Rod puppets from East, West and Central Java that appear in the Hindu epics, Javanese history plays and the Islamic Menak cycles. On the left is the wise and earthy clown-servant Semar. His inane and melancholic son, Gareng, is next to the lively and comical female servant in the foreground. Behind them are a variety of gods, nobles, servants, heroes, advisers and fools. At the rear is Bouraq, the winged steed of Muhammad.

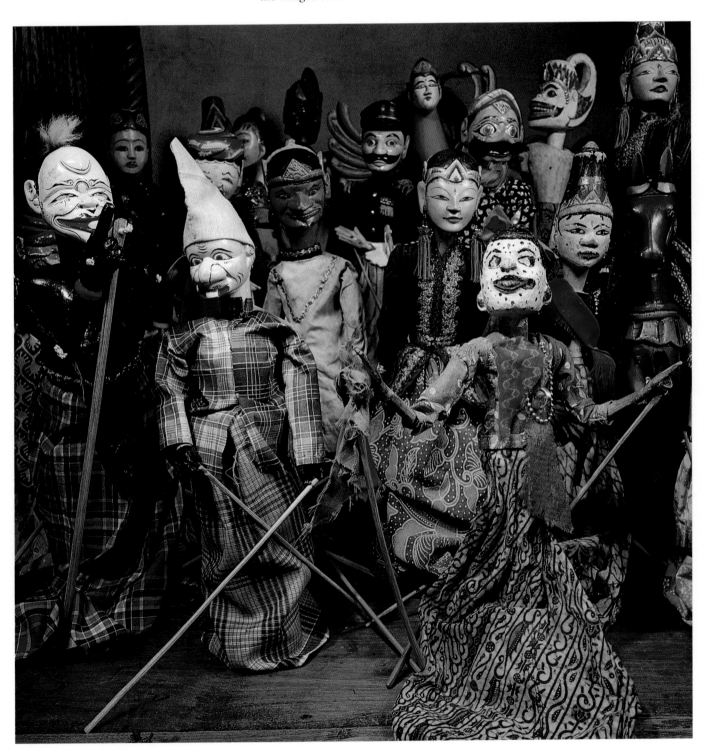

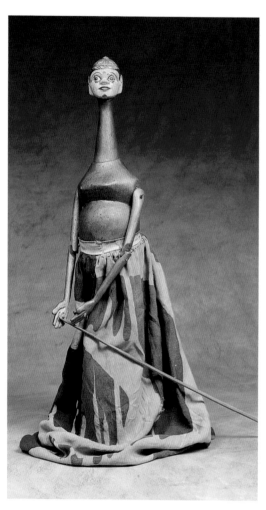

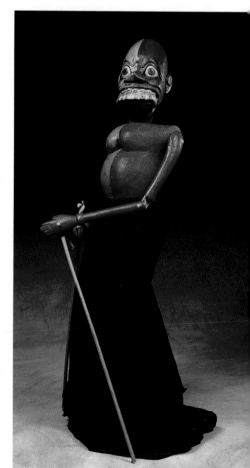

154 *Below* The martial second Pandewa brother, Bima, married the giantess Arimbi. This giant puppet could play the role of her brother Prabakesa, Bima's mentor. In other narratives, the puppet could express an unusually aggressive and irascible personality, since the striping suggests a combination of qualities from more than one nasty character. H 12$\frac{1}{4}$" (31 cm).

152 *Above* The refined Dewi Muniggar, wife of the hero Wong Agung Jayagrana from Menak Islamic cycles. Like many of the romantic heroines of traditional drama, she is also the subject of a saga of abduction and rescue. She has the flat triangular face and full lips typical of puppets from Cirebon in north West Java. H (head to hip) 7$\frac{7}{8}$" (20 cm).

153 *Above right* This West Javanese puppet, Sekar Pandan, fell in love with his sister Sutiragen, the wife of Semar, the wise clown-servant. Many puppets of this type and also grotesque and comical masks display symptoms of identifiable illnesses and genetic and congenital defects. The puppet has other names, including Catik Danaloka, an exceptionally ugly pupil of a holy hermit, who pretends to be the husband of Arjuna's beautiful daughters. Both characters are notable for the inappropriateness of their amorous behavior. H 11$\frac{3}{4}$" (30 cm).

155 West Javanese *wayang golek* (rod puppets). The red-faced puppet is the vicious Rahwana. He is highly intelligent, articulate and dangerous and appears in the *Arjuna Sasra Bahu* stories and in the *Ramayana*. H (head to hip) $12\frac{7}{8}''$ (33 cm). The blue-faced puppet is Gatot Kaca, from *Mahabharata* cycles. He can fly up in the clouds and break the necks of his opponents. He is fearless, virtuous and well mannered, but not particularly clever.

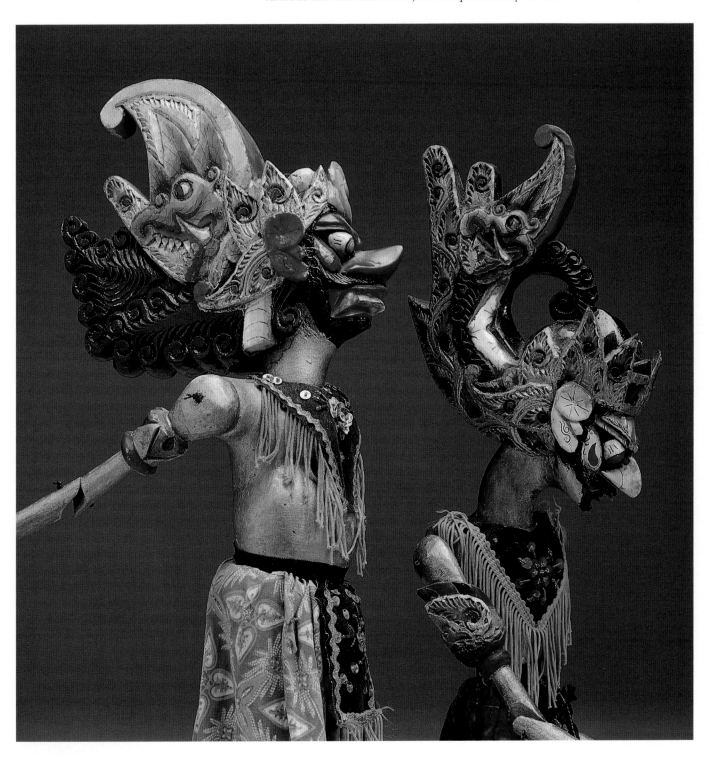

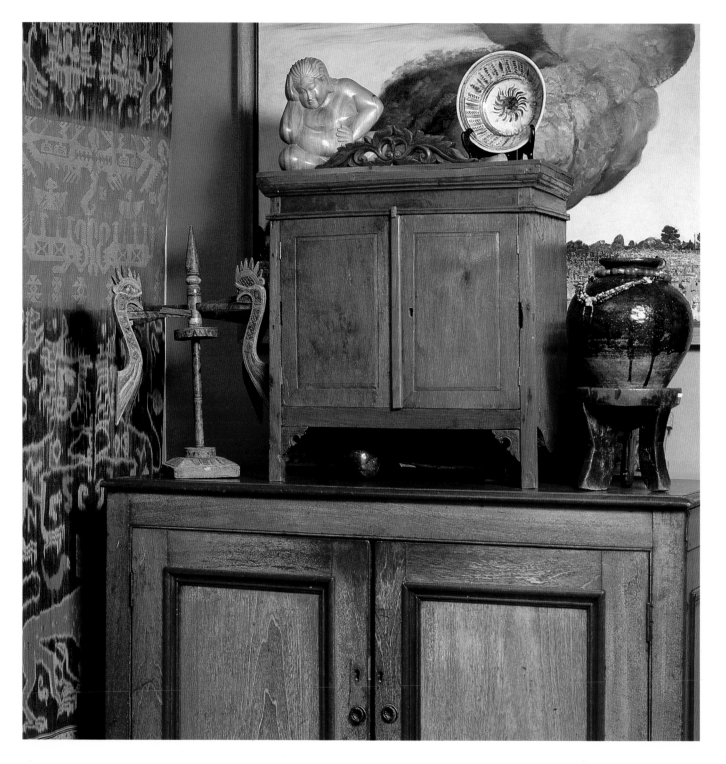

COLLECTING INDONESIAN ARTS AND CRAFTS

The collection of Indonesian arts and crafts may be approached in various ways. With so many islands and ethnic groups, the diversity can seem overwhelming. One could spend a lifetime assembling only a fine collection of batiks, without even contemplating ikats, puppets or masks. The variety of beautifully woven bamboo and palm leaf hats worn in the different parts of the archipelago would make a rewarding study in itself. The possibilities are endless.

Arts and crafts objects can be divided into two main categories. The first comprises those produced with domestic and international tourists in mind, with little or an indirect relationship to traditional culture. Most of these are either made or sent to be sold in Bali, and are often attractive, well made and sometimes of original and even arresting design. Although not strictly collectable, they are sold profitably as decorative items outside Indonesia.

The quality of Balinese workmanship in silver jewelry and wood-carving is generally superior to that available in other international resorts. Beaded garments, interesting textiles for household use, clothing made from handwoven cloth and distinctive leather goods are all very popular. There is a continuing search for fresh ideas, but repetition can hardly be avoided, and it is easy to tire of hundreds of carved and painted ducks or mermaids combing their hair, however charming they might appear on their own. A few months, or perhaps only weeks, later the new fashion will be bats, tigers or flying pigs. One could purchase a sheaf of carved and gilded wooden lilies, endless mirror frames or a host of ornamental boxes. A small, but life-sized, rambutan tree, with each irregularity of leaf, bark and spiny red fruit case perfectly carved and painted with such care that it is easy to confuse with the real thing, is clearly a technical tour de force. These products delight holiday-makers and interior decorators. No effort is required to collect these non-traditional art and craft items, and it takes a conscious decision to avoid the temptations of the numerous art markets, galleries and shops that overflow with inexpensive and ever changing stock designed to amuse and distract. In Jakarta, the renowned designer Iwan Tirta adapts the styles of the traditional decorative arts and textiles to the particular demands of contemporary high fashion.

The second category consists of the traditional arts and crafts of regional Indonesian societies. Collecting these is ultimately more rewarding and requires more discrimination.

The sheer size and geographical and cultural complexity of the archipelago means that most collectors find it best to begin with the arts and crafts of one or two regions. The majority of masks and puppets, for instance, are to be found in

156 A Sumbanese ikat hangs on the wall beside a small Madurese cupboard topped by a modern Balinese wood-carving in the style of Ida Bagus Nyana. On the left is a Balinese weaver's carved and painted thread winder. An old Chinese pot imported into Indonesia centuries ago is strung with beads. Beneath the cupboard is a Timorese coconut shell ladle.

Java and Bali; warp ikats are woven in North Sumatra, Kalimantan, Sulawesi, southern Maluku and Nusa Tenggara. One can learn about local culture, watch things being made and used and observe religious ceremonies and cultural events. Travel can be planned around the collector's personal interests.

It is important to research the region to be visited and its arts and crafts in advance. There are several museums outside Indonesia with fine collections of artefacts, and some excellent books on Indonesian textiles and other art forms have been published recently.

Within Indonesia, the National Museum, the Textile Museum, the Wayang Museum and the Taman Mini Indonesia park, all in Jakarta, have major collections. These museums display sculpture, architecture, jewelry, costumes, ceramics, domestic utensils, weapons, musical instruments, puppets, fishing equipment, sailing craft and agricultural tools from all over the archipelago. Provincial capitals also have fascinating museums displaying the arts and crafts of their region. Museum staff and local government tourist offices can also be helpful in providing information about local art and craft centres.

If visitors show that they are acquainted with the culture of the region, vendors and producers will be appreciative and may offer finer or more unusual items for sale. Ill-prepared tourists may take the trouble to travel to remote parts of Indonesia, only to pay exorbitant prices for imported carvings of Balinese fishermen, instead of selecting from among a host of inexpensive local items of fine, and even museum, quality.

Markets dealing primarily or exclusively in local arts and crafts are uncommon in Indonesia, unless they are close to tourist resorts. The markets in Denpasar, Kuta, Ubud and Sukawati, in Bali, offer an enormous range of local handicrafts. In Java, the Jalan Surabaya flea market, in Jakarta, and the Truwindi market, in Surakarta, offer a profusion of old and new items of varying quality. The Ancol art market in Jakarta offers some interesting art and craft work from Java and elsewhere and provides the opportunity for visitors to observe some items being made. The Bukittinggi market, in West Sumatra, is noted for the range of handicrafts offered for sale on major market days. The largest textile market in Indonesia is Pasar Klewer in Surakarta. Markets in large towns usually have a few stalls selling local arts and crafts.

The wares offered for sale in village markets, away from tourist areas, are made for local people. These include earthenware pots, locally forged weapons and tools, baskets, cages, mats, canoe paddles, cooking equipment, coconut shell ladles and handmade cloth. Such utilitarian items are inexpensive and are of no great value outside Indonesia. In the countryside, a water pot, or a palm leaf sunhat is unlikely to cost more than one or two United States dollars, but for people living in industrialized countries, where so many things are manufactured by machine, using such simple handmade objects can give great pleasure. It is, however, these utilitarian items that are most under threat from factory-made and imported substitutes. Village markets also provide the opportunity to find out what is available in the district and to discover the location of the villages where the hand-crafted items are made.

If they have special requirements, many Indonesians directly commission items that are not generally available in local markets; these include especially fine textiles for weddings, traditional jewelry in precious metal and furniture.

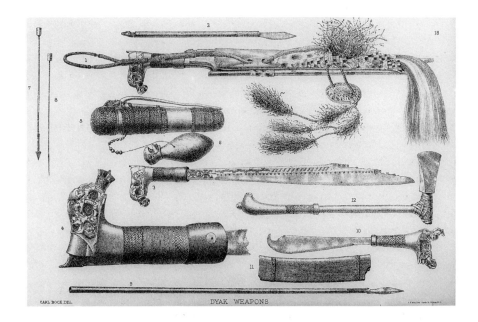

These Dyak blow-pipes, darts and their containers, as well as the swords and knives with fine blades and well carved handles, display exceptional craftsmanship.

Puppeteers, dance troupes and Indonesian collectors of masks or musical instruments order them from master craftsmen.

Collectors too may buy from art and craft workers by visiting villages and workshops and either purchasing available stock or ordering particular items. However, some objects may take a long time to produce, and it may not be practical to wait months for a particularly fine textile, for example, to be completed. Respectable dress and small gifts for children create good will. Visitors will be graciously plied with bananas and glasses of tea, and endless questions will be asked about their families and country of origin. Artisans will also be delighted to explain and demonstrate their skills.

In villages close to tourist resorts, some residents are likely to speak English. In more remote areas, and in villages unused to visitors, it is desirable to be able to communicate in Indonesian and to introduce oneself to the village headman. However, people working around hotels or local tourist offices who speak English will happily interpret for a modest fee. Although Indonesian (Malay) can be used in a very sophisticated and subtle way, its history as a traders' lingua franca gives it the great advantage of being easy to use at a simple level. A phrase book and special vocabulary relevant to the collector's interest is enough for basic communication, and a great deal can be conveyed without words. Even moderately well motivated travellers become proficient in 'survival' Indonesian. In remote areas, local languages may be in general use rather than Indonesian, and it is useful to travel with a guide who can interpret.

Collectors may be asked to pay as much, if not more, for an item purchased from the producer in the village as in the market or the shops in the nearest town. The visit may, quite rightfully, be regarded as an opportunity to ask the best price rather than an occasion for desperate discounting. However, it is also important to check for quality, because inferior work may be sent to market, and the finer, costlier pieces kept for sale or display to discriminating Indonesian buyers who prefer to deal directly.

Public transport in Indonesia is efficient and inexpensive. If a driver or guide brings a visitor to a village, a workshop or even a shop, a secret commission, which can be as high as thirty per cent, may be paid to him by the producer or vendor; naturally, the additional cost will be passed on. It is best to make it clear, first to the driver or guide, and then to the producer or vendor, that one already knows the price of the item in the market, and has already heard or read about the village or workshop. The driver should wait in the car; his help is not necessary, and his presence will most certainly undermine negotiations. It is also wise to explain that the intention of the visit is to make comparisons of price, quality and range and not necessarily to buy. All this information can be conveyed in a pleasant manner as a part of normal conversation. If a driver is unusually helpful and informative and provides a genuine service, then he is entitled to an additional reward.

As a general rule, Indonesian craft workers and vendors actively enjoy bargaining. A buyer who is overbearing, or who attempts to reduce what should be a sociable and mutually interesting transaction to a brisk impersonal exchange, is likely to be silently scorned as an oaf or, even worse, a bore; and so, except in Balinese resorts where vendors are fully accustomed to the mannerisms of foreigners, a blustering business-like style will usually be counter-productive. However, no self-respecting market vendor or craft worker will accept the same amount from an international traveller as he or she would from a neighbouring villager with a comparatively tiny income. Profit margins are flexible and will depend on the circumstances of the day, and on who is buying. These rules apply to Indonesian purchasers as well as to foreigners.

If one enjoys bargaining and has formed an idea of what an item is worth, it may be possible to negotiate a significant reduction in price. If one is unsuccessful, pride or irritation should not prevent the acquisition of something of exceptional interest. There is no guarantee that the same thing can be found for less elsewhere, if at all. If the price appears high at the time it is unlikely to seem so in retrospect.

It is also important to understand the skill and time it takes to produce a particular item. When exposed to hundreds of beautifully crafted and inexpensive pieces of filigree or granulated silver jewelry, it is easy to forget the expertise required to produce such accomplished work. A young Balinese or Javanese silversmith may work quickly and apparently effortlessly, but many college graduates in silver- and goldsmithery would find the same results difficult to achieve. Apart from the extraordinary skill required to create a *songket* pattern, it takes an expert craftswoman a full day to produce a few centimetres of cloth. It may take months to collect suitable dyestuffs and to tie and dye the intricate patterns into the threads of an ikat cloth before weaving even begins. Fine work requires patience and a great deal of experience.

The prices offered for work of high quality should be generous in relation to local expenses and aspirations. Collectors can help to sustain the prestige, and even the very existence, of skills that may be lost if not sufficiently rewarded. We would all be the poorer for this.

Many visitors to Indonesia purchase batik or ikat cloths, and it is important to be able to judge the quality and type of workmanship if purchases are to be made at markets. At the Batik Research Centre in Yogyakarta, visitors can

An Irian Jayan man's jewelry composed of feathers, bones and tusks.

Javanese *topeng* (masked) dancers at the turn of the century. The richness of Javanese and Balinese traditions of masked dance and drama provides an enormous variety of character masks of interest to the collector.

observe batik being made and commercial workshops and studios are also very welcoming. The distinctions between hand-drawn and stamped batik should be reflected by a significant difference in price. If a section of regular, repetitive patterning on a hand-drawn and stamped piece are compared, the hand-drawn piece will not only reveal minor irregularities, but will also be unmistakably alive, in a way that the stamped cloth is not. In hand-drawn work, the amount of fine detail, its clarity on both sides of the cloth and the absence of actual errors in dyeing and drawing determines value. In Central Javanese batik, the use of natural indigo and *soga* dyes also adds to cost. Both of these types of batik are genuine in that colours are dyed right through and not printed on the surface. Cheap cloth, which is printed or silk screened with batik patterns, has a right and a wrong side.

The major batik producers – Batik Keris, Danar Hardi and Batik Semar – have shops in several large cities. In these and in the Sarinah department store in Jakarta, which has an entire floor devoted to batik, cloths are graded and displayed according to quality, with fixed prices to match. The experience of handling, inspecting and comparing a wide variety of batiks is educational.

Copies of Sumban warp ikats are woven on shaft looms in Java, and some ikat patterns may be printed on coarse cotton cloth. The differences between these and genuine hand-dyed and backstrap-loom woven cloths are obvious if a comparison is made by either visiting a shop specializing in high-quality ikat or actually observing the ikat dyeing and weaving process. Hand-spun cotton threads have variations in thickness and are generally coarser than machine-spun

yarns. It should also be remembered that a piece of cloth that is much wider than the body cannot be woven in comfort on a backstrap loom.

Ikats are prized for rich colours and detailed patterns, in which a considerable amount of effort has gone into tying the motifs. Crisp outlines suggest tight tying and also mean that not too many layers of threads were tied at once. However, the subtle shifts in colour caused by looser tying are one of the main attractions of ikat. It is a matter of degree. Chemical dyes can be mixed to imitate natural dyes very successfully, and may be used for some colours, if not all, because they are so much faster and easier to use. Naturally dyed colours tend to be subtler, but comparing cloths is the only way of educating one's judgment. Indigo dye is still frequently used in Nusa Tenggara. Some cloths are unashamedly woven with bright factory-dyed yarns in colours that are obviously artificial.

It is important to care for textiles in an appropriate way. Airing a cloth is as effective as rinsing it in water as a means of providing overall freshness. Only genuinely soiled spots should be subjected to more active and potentially damaging processes. The wax residue in batik provides protection from dirt and stains; if this is chemically broken down with detergent and washed away, the cloth will be more exposed to further soiling. Batik should be wiped clean and aired; if necessary, it can be very gently washed if dyed with chemicals, or rinsed in cold water or cold weak tea if dyed naturally. Few vegetable dyes are really colourfast and ikat cloths should not be washed. Some chemical dyes may be unaffected by rinsing in cold water, but testing a small section before immersing the whole cloth is essential. Woven silks, like those made in South Sulawesi and East Kalimantan, can be rinsed briefly in cold, vinegared water, preferably in bright sunlight. *Songket* cloths should not be washed and must be rolled and never folded, because the metal threads break along the creases. Carvings made of green wood and bamboo items can be waxed or sealed; otherwise they may split or deteriorate if left for long in a very dry or cold atmosphere.

Travel to parts of Indonesia that are not on the tourist track can be a profoundly rewarding experience. A collector can wander for weeks, or even months, among the islands of the archipelago gathering unusual textiles, beading, pottery or metalwork in places where traditional life is almost unchanged and visitors are rare. One of the difficulties of travelling and collecting for any length of time is that it can become increasingly difficult to transport the beautiful, but bulky, textiles or carvings that one has purchased. Smaller articles can be sent by surface or airmail from the post offices of major towns along the way. Larger items, which fit into a cheap suitcase purchased at a market, can be sent home as unaccompanied luggage from airports with a customs clearing facility. This is considerably more economical and convenient than paying an excess baggage fee at the end of the journey, and consignments arrive very quickly.

Some collectors have neither the time nor the inclination to brave the adventure and the occasional difficulties of travel in remote areas. Excellent examples of many arts and crafts can be bought in Jakarta and Bali, where there are numerous shops selling decorative wares from all over the archipelago. Some of these may offer unusual or particularly fine items which might not be found easily at their place of origin; however, the shops do not stock everything. Village

Intricately beaded and feathered caps similar to this nineteenth-century example are worn at Dyak festivities today.

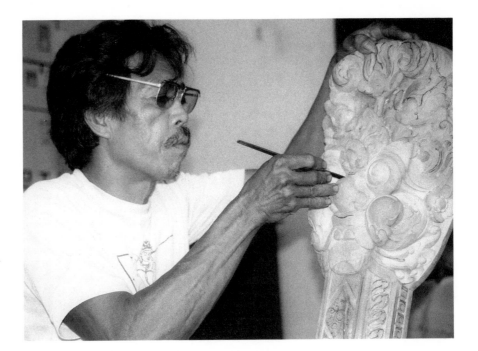

A wood-carver in Mas, Bali, works on the frame for a gamelan instrument that will be fitted with bronze keys and embellished with red and gold paint.

pottery, naive toys and utilitarian items, such as ordinary baskets or fish traps, are rarely thought of as being worthy of interest and must be purchased from markets or from their makers.

Although many dealers are reputable, others are not. Many ethnographically styled wood-carvings, although decorative and quite well carved, are made in Bali and Jakarta, and not at their supposed place of origin. Some dealers are not very knowledgable about their stock. Items described as antique should generally be taken to be merely traditional in style.

Shops specializing in works from a particular region, like the Batak or Torajan areas or the islands of Nusa Tenggara, are often owned or staffed by people who originate from those places, and whose families collect locally and ship to the capital or to Bali. These dealers are usually well informed, and enquiries can also be made about their best stock, which is not always on display.

Art and craft shops in provincial towns and in Sumatra, Sulawesi, Kalimantan and Nusa Tenggara, which are less frequently visited by tourists, specialize in regional work. A local item purchased at a regional shop or market may be three or more times less expensive than in Bali or Jakarta.

A Timorese ikat blanket woven with artificially dyed and machine-spun thread might be relatively inexpensive at a local market, yet it could cost ten times as much in a gallery or shop outside Indonesia. Prices increase for finer, more complex, naturally dyed and hand-spun pieces, depending on size, detail, the richness and number of colours used and so forth. Older cloths of high quality are not always available, but may be offered by specialist dealers in Nusa Tenggara and will, obviously, be considerably more expensive. Particularly fine pieces may fetch thousands of dollars at international auctions.

Street and beach pedlars hover in the background at hotels, guest houses and restaurants. If asked, they will do their best to find a particular type or quality of item. They, and helpful hotel or restaurant staff, may lead to producers or local

dealers who do not have shops, and whose existence might not otherwise have been discovered.

Many provincial capitals have government-sponsored art and craft centres, where regional wares of good quality are offered for sale at fixed prices that are fair to producers and to purchasers. Demonstrations of carving, weaving or plaiting techniques are frequently given, and staff can also direct visitors to nearby villages producing the arts and crafts displayed.

International exhibitions and an enormous growth in the number of tourists have increased awareness of and enthusiasm for traditional Indonesian design. Since the 1970s this burgeoning interest has produced a massive escalation in the price of older, rarer pieces. Some valuable ritual artworks were produced by very small communities. Since there are a limited number of genuine pieces available, the sophisticated faking of artefacts illustrated in museum catalogues and art books has increased sharply. The Indonesian government does not prevent the sale of scarce and important cultural property, but its export is strictly prohibited.

It is, however, possible to buy or commission new works of considerable merit. In terms of the sheer technical skill required to produce it, modern Minangkabau *songket* cloth (pl. 109) easily bears comparison with fine textiles woven in the past, and with those from outside Indonesia. In traditional societies, in which workmanship and design is relatively unchanging, there is not necessarily any advantage to an object in being old, unless it is thought to have acquired unique or magical properties.

A collector's puppet is not a 'fake' *dalang*'s puppet. In Indonesia, it is appreciated as a deeply resonating expression of local culture in its own right, as is a fine mask not necessarily made for performance. The magnificence of a Sumban ikat cloth is not diminished because the woman who made it did not intend that it be used as a shroud for a member of her family.

In the recent 'Festival of Indonesia' group of special exhibitions, many items of major importance from Indonesian and international public and private collections were brought together for the first time. The public in the United States and in parts of Europe has been able to appreciate the splendour of Indonesian artistic achievement in a way that has not previously been possible.

There has always been significant trade in prestige goods between Indonesian societies and with the world beyond, and it makes good sense for collectors to conceive of themselves as consumers of these goods within a long and continuing tradition.

GUIDE TO FURTHER INFORMATION

MAP AND GLOSSARY
BIBLIOGRAPHY
ACKNOWLEDGMENTS
INDEX

MAP AND GLOSSARY

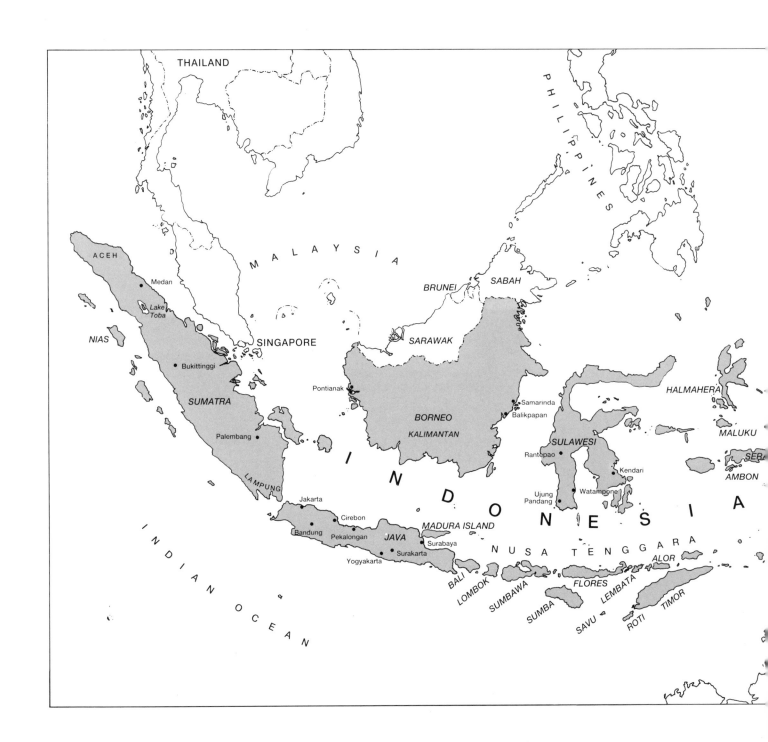

ACEH Region of far north Sumatra; orthodox Islamic piety. Traditional houses, like those of some other coastal Islamic peoples, are built on stilts with fretworked ornament. Crafts: *songket*, embroidery, fine metalwork, pottery. Produce: rubber, rice, pepper, gas, gold, cattle.

ALOR Island of Nusa Tenggara; animist, Christian. Crafts: weaving, pottery; bronze drums (*moko*) are ceremonial currency.

ASMAT Ethnic group; southern coastal swamplands of Irian Jaya (West New Guinea). Animist, Christian. Crafts: woodcarving, plaiting. Fishing, hunting and gathering; new logging industry in Asmat homelands.

ATONI Ethnic group; western Timor, Nusa Tenggara; Christian, animist. Crafts: basketry, pottery, beading, weaving; beehive-shaped palm thatched houses. Dry agriculture, cattle.

BADUI Ethnic group; West Java; reclusive, ascetic community practising Hindu-Buddhist and Javanese mystical beliefs.

BALI Island; Hindu-Buddhist; exceptional vitality of drama, music and textile and other craft traditions. Wet rice agriculture, coffee, orchards, tourism.

BATAK Related ethnic groups in Northern Sumatra: Toba, Karo, Simalungun, Angkola, Mandailing Batak. Houses on piles with carving, sculptures and massive roofs. Crafts: weaving, beadwork, fine metalwork, ironsmithing, plaiting, bamboo work and woodcarving. Market gardening, agriculture.

BETEL (*sirih*) A mildly stimulating recreational and ceremonial drug widely appreciated in the Pacific and Southeast Asia. The nuts of the Areca palm are crushed or sliced, mixed with shavings derived from the solidified juice of the Gambir tree and lime obtained from seashells. These are wrapped in a leaf of the Piper betel vine (*sirih*), forming an aromatic chewing plug that stains saliva red. Balls of tobacco or dried cloves may be chewed in addition to the plug. *Sirih* is thought to promote calmness and courage.

BRIDE PRICE Goods contributed to the family of the bride by the groom and his family. The quantity and type of goods are usually established by custom. The practice cements family loyalties and obligations.

BRIDEWEALTH Goods contributed by the bride's family to the groom's family.

BUGINESE Ethnic group; Watampone (Bone) central South Sulawesi; Islamic; fishing, farming, trading, boat-building, pottery and silk-weaving. Diasporan settlements are common in coastal Kalimantan and Nusa Tenggara.

CHASING Creating relief decoration on a metal object by working on the outside surface with carving and chiselling tools.

COUCHWORK Embroidery technique in which decorative threads are placed in the desired patterns on the surface of the cloth and then stitched into position.

DANI Ethnic group; inland mountains of Irian Jaya; men wear penis gourds; stone-age and modern tools; vegetable gardens, pig raising; animist and Christian. Plaiting.

DYAK Ethnic groups; inner Kalimantan; include Bahau, Bidayuh, Kayan, Kelabit, Kenyah, Iban, Maloh and Tunjung; longhouses divided into family apartments; nomadic Punan hunt with blowpipes; animist also Christian; wood-, bone- and horn-carving, beading, ironsmithing, plaiting, embroidery and weaving; dry agriculture.

GAYO Ethnic group; central mountains of Aceh, north Sumatra; Islamic; hand and machine embroidery, weaving, pottery; rice, coffee.

IKAT Technique of patterning cloth by tie-dyeing motifs into the threads before they are mounted on the loom to be woven.

JAVA Island; most densely populated (100 million of Indonesia's 180 million); Islamic; Javanese regarded as extremely refined by other Indonesians; residue of Hindu-Buddhist culture and mysticism is strongest in Central Java which is also notable for its batik, fine metal-work, bronze and brass ware, ironsmithing, pottery and dramatic and musical traditions; Sunda (West Java) has distinctive batik, drama and music and is more orthodox in Islamic practice.

KAIN Waist-cloth of varying length in a strip form that is wound around the body and secured by folding and tucking, or with a sash or belt. A short *kain* is tightly wrapped, but a longer one may be gathered in folds.

KAUER Ethnic group; west coast of Lampung, south Sumatra; textiles are noted for embroidery with mirrored ornament (*cermuk*).

LEMBATA Island; east of Flores, Nusa Tenggara; Christian and animist; annual bean festival; coastal communities hunt whales, manta rays, weave ikat; inland agriculture.

LIO Ethnic group; central Flores, Nusa Tenggara; Christian; complex ikat in figurative and geometrical designs in rich colours.

MADURESE Ethnic group; Madura island off East Java; resourceful, Islamic, fishing, farming, bull racing, boat-building, cabinet-making, batik.

MAKASSARESE Ethnic group; Ujung Pandang (formerly Makassar) southwestern South Sulawesi; Islamic, seafaring, farming, silk-weaving, pottery, fine metalwork.

MANDARESE Ethnic group; north-west South Sulawesi; Islamic, also belief in the spirits of the sea and flying fish; boat-building, fishing, farming, pottery, silk-weaving.

MANGGARAI Ethnic group; west Flores, Nusa Tenggara; Christian, also animist customs; masked whip fights; weaving with colourful supplementary weft patterns over dark indigo cotton; wet and dry rice and other agriculture.

MINANGKABAU Ethnic group; West Sumatra; descended from Alexander the Great; Islamic, matriarchal, intellectual, mercantile; clan houses carved and painted with massive roofs that suggest buffalo horns or ships; *songket* textiles, lace, embroidery, pottery, woodcarving, jewelry-making, ironsmithing and brasswork; rice, other agriculture, timber, rattan, cattle.

NAGE Ethnic group; central Flores, Nusa Tenggara; strong animist customs, also Christian; traditional boxing; sombre figurative ikat; agriculture.

NIAS Island west of Sumatra; Christian, but traditional and socially stratified; remarkable stone and wooden architecture; woodcarving and smithing; agriculture.

PAMINGGIR Ethnic group; Lampung, far south of Sumatra; Islamic, and strong traditional Javanese influences. Embroidery and woven textiles reflect social status. Motifs of ships on the *palepai* and *tampan* cloths of special ceremonial importance; rice, copra, coffee.

PATOLA Indian double-ikat silk cloths traded and treasured in Southeast Asia; influential in regional textile design; *jelamprang* (eight-petalled lotus) motif derived from *patola* cloths is common in Indonesian textiles.

PELANGI (rainbow) Cloth dyed with patterns produced by bunching and tying off small patches so that the dye will not penetrate.

REPOUSSÉ Relief decoration on the outer surface of a metal ornament or vessel made by beating and working the metal from the back or inside.

ROTI Island; off the west coast of Timor, Nusa Tenggara; strong educational and administrative traditions; Christian with some animist customs; red, black and yellow ikat, plaiting and pottery; lontar palms, rice.

SARONG (*sarung*) Cloth sewn into a tube to fall from the waist or above the breasts and secured in various ways – folding, tucking, sash or belt.

SASAK Major ethnic group; Lombok island, Nusa Tenggara; Islamic and Wektu Telu (Islam combined with Hindu-Buddhism); stave-fighting, distinctive drama, smithing, weaving, pottery and basketry; wet and dry agriculture.

SAVU Island; Nusa Tenggara; Christian, animist customs; lontar palm economy; floral ikats, ironsmithing, pottery.

SELENDANG Long, usually narrow shawl worn over one shoulder or diagonally across the chest; may be knotted to form a sling for carrying a child or shopping.

SELIMUT Blanket of cotton ikat. In Nusa Tenggara men wear one cloth around the waist and another similar or matching cloth draped over the shoulders as a mantle.

SONGKET Cloth extensively ornamented with supplementary weft patterns in contrasting coloured or metal thread.

SOUTH SUMATRA Cultural heartland of the Islamic and courtly Malay culture of coastal Sumatra; *songket* and silk ikat weaving, metallic embroidery, fine metalwork. Palembang, the capital, is also a centre for lacquerwork.

SUMBA Island of Nusa Tenggara; Christian, also conservative animist, megalithic; spectacular mock battles on horseback (*pasola*) are held when the seasonal *nyale* (sea worms) arrive; east Sumban men's cloths (*hinggi*) have bold designs of animals, human figures, birds, skulls; pottery, beading, bone- and woodcarving, plaiting, basketry; cattle, horses, dry agriculture.

SUPPLEMENTARY WARP Additional contrasting warp threads are introduced during weaving to provide decorative patterns on the surface of the cloth.

SUPPLEMENTARY WEFT In addition to the usual weft threads required to build up the fabric, some additional contrasting ones are introduced to form decorative borders or motifs.

TANIMBAR Islands of southeast Maluku; Christian but also animist customs; geometric ikats; a little fine metalwork; woodcarving on houses, boats and figurines; fishing, vegetable gardens; pearl diving.

TETUM (also Belu) Ethnic group; central Timor, Nusa Tenggara; Christian and animist; wood- and horn-carving, basketry, pottery, silverwork and textiles; architectural carving; like many houses in Nusa Tenggara, roofs are high and palm-thatched; dry agriculture.

TOPENG A mask or a masked dramatic performance.

TORAJA Ethnic communities; mountains of South Sulawesi; Christian and animist; lifelike effigies of the dead are placed on balconies in cliff faces; houses with carving, sculptures and massive roofs; smithing, woodcarving, plaiting, bamboo work, weaving.

TRITIK Technique of tightly sewing small bunches of plain cloth to produce a similar effect to tie-dyed or *pelangi* cloths. Tying and sewing may be combined.

ULOS Woven cloths worn by the Batak people of North Sumatra. A variety of special *ulos* are worn on ceremonial occasions.

WARP IKAT Patterns are dyed into the threads that run longitudinally before weaving commences.

WEFT IKAT Patterns are dyed into the horizontally running threads before weaving.

WIFE-GIVING FAMILIES Men traditionally choose wives from particular families in outer-Indonesian marital alliance systems. Wives are chosen from family A by men of family B; the males of family C choose wives from family B and the circle is completed with the males of family A choosing wives from family C. The patterns vary.

BIBLIOGRAPHY

Achjadi, Judi, *Indonesian Women's Costumes*, Jakarta, 1976

Adhyatman, S., *Kendi*, Jakarta, 1987

——*Modern Ceramics in Antique Style*, Jakarta, 1983

Aragon, Lorraine, 'Barkcloth Production in Central Sulawesi', *Expedition*, vol. 32, no. 1, pp. 33–48, 1990

Ashabranner, Brent and Martha, 'Loro Blonyo: Traditional Sculpture of Central Java', *Arts of Asia*, vol. 10, no. 3, pp. 112–19, 1980

Ave, Joop, and Judi Achjadi (eds), *The Crafts of Indonesia*, Singapore, 1988

Bandem, I Made, and Fredrik De Boer, *Kaja and Kelod: Balinese Dance in Transition*, Kuala Lumpur, 1981

Barbier, Jean Paul, and Douglas Newton (eds), *Islands and Ancestors: Indigenous Styles of Southeast Asia*, New York, 1988

——*Indonesian Primitive Art*, Dallas, 1984

Beekman, E. M., *The Poison Tree: Selected Writings of Rumphius on the Natural History of the Indies*, Amhurst, Mass., 1981

Brandon, J., *On Thrones of Gold: Three Javanese Shadow Plays*, Cambridge, Mass., 1970

Buurman, Peter, *Wayang Golek*, Singapore, 1988

Campbell, J., *Irian Jaya: The Timeless Domain*, Stenhouse, Thornhill, Dumfries, Scotland, 1991

Covarrubias, Miguel, *The Island of Bali*, Kuala Lumpur, 1972 (1937)

Crosier Missions, *Asmat Images*, Catalogue of the Asmat Museum of Culture and Progress, Minneapolis, n.d.

Cultural Media Project, Directorate General of Culture, Department of Education and Culture, Jakarta, Cultural Album Series: *Aceh*, n.d.; *Asmat*, n.d.; *Bali*, 1981–82; *Batak Simalungan dan Toba*, n.d.; *Benkulu*, 1982–83; *Daerah Istimewa Yogyakarta*, 1982–83; *Jambi*, 1981–82; *Jawa Barat*, 1983–84; *Jawa Timur*, n.d.; *Kalbar*, n.d.; *Kal Timur*, n.d.; *Kalimantan Selatan*, 1983–84; *Lampung*, 1982–83; *Maluku Tenggara*, n.d.; *Seni Patung Maluku*, n.d.; *Minangkabau*, n.d.; *Nusa Tenggara Timur*, 1981–82; *Rogam Hias Toraja*, n.d.; *Sulawesi Tenggara*, 1982–83; *Sulawesi Selatan*, n.d.; *Sumatra Selatan*, n.d.; *Sumatra Utara*, 1982–83; *Sumba*, n.d.

Djelantik, A., *Balinese Painting*, Singapore, 1986

Eiseman, F. and M., *Woodcarvings of Bali*, Berkeley, 1988

——*Bali: Sekala and Niskala*, vols 1–2, Berkeley, 1989

Ellen, R. F., and I. Glover, 'Pottery Manufacture and Trade in the Central Moluccas, Indonesia', *Man*, vol. 9, no. 3, pp. 353–79, 1974

Elliot, Inge M., *Batik: Fabled Cloth of Java*, London, 1985

Endicott, K., *An Analysis of Malay Magic*, Kuala Lumpur, 1981

Feldman, Jerome (ed.), *The Eloquent Dead: Ancestral Sculpture of Indonesia and Southeast Asia* (exhib. cat.), Los Angeles, 1985

Fontein, Jan, *The Sculpture of Indonesia*, New York, 1990

Forge, Anthony, *Balinese Traditional Paintings* (exhib. cat.), Sydney, 1978

Forman, Bedrich, *Indonesian Batiks and Ikats*, London, 1988

Fox, James, *Harvest of the Palm: Ecological Change in Eastern Indonesia*, Cambridge, Mass., 1977

Fraser-Lu, Sylvia, *Handwoven Textiles of South East Asia*, Singapore, 1988

——*Silverware of Southeast Asia*, Singapore, 1989

Frey, E., *The Kris: Mystic Weapon of the Malay World*, Singapore, 1988

Gasser, Stephen, *Das Topferhandwerk von Indonesien*, Basle, 1969

Gearheart, Phillip, 'Earthenware of Java', *Ceramics Monthly*, 33 (5): 23–8, 1985

Gillow, John, *Traditional Indonesian Textiles*, London, 1992

Gittinger, Mattiebelle, *Splendid Symbols: Textiles and Tradition in Indonesia*, Washington, D.C., 1979

——(ed.), *Indonesian Textiles: Irene Emery Round Table on Museum Textiles, 1979*, Washington, D.C., 1980

——(ed.), *To Speak with Cloth: Studies in Indonesian Textiles*, Los Angeles, 1989

Glover, Ian, 'Pottery making in Orolan Village, Portuguese East Timor', *Australian Natural History*, vol. 16, pp. 77–82, 1968

Graburn, Nelson H. H. (ed.), *Ethnic and Tourist Arts: Cultural Expressions from the Fourth World*, Berkeley, 1976

Guy, John, *Palm Leaf and Paper: Illustrated Manuscripts of India and Southeast Asia* (exhib. cat.), Melbourne, 1982

Hamzuri, Dr, *Keris*, Jakarta, 1984

——*Batik Klasik*, Jakarta, 1985

Hauser-Schnaublin, B., and U. Ramsayer, *Textiles in Bali*, Singapore, 1991

Heppell, Michael, *Masks of Kalimantan* (exhib. cat.) Melbourne, 1992

Herman, Dr V. J., *Topeng Tradisional Koleksi Museum Negeri Nusa Tenggara Barat* (exhib. cat.), Mataram, 1991–92

Hersey, Irwin, *Indonesian Primitive Art*, Singapore, 1991

Hitchcock, Michael, *Indonesian Textiles*, London, 1991

Hoogerbrugge, J., *The Art of Woodcarving in Irian Jaya*, Jakarta, 1977

Jasper, J. E., and Mas Pirngadie, *De Inlandsche Kunstnijverheid in Nederlandsch-Indie*, vol. 1, *Het Vlechtwerk*, 1912, vol. 4, *De Goud-en Zilversmeedkunst*, 1927, vol. 5. *De Bewerking van Niet-edele Metalen*, The Hague, 1930

Jessup, Helen, *Court Arts of Indonesia*, New York, 1990

Kartiwa, Dr Suwati, *Indonesian Ikats*, Jakarta, 1987

Kartomi, Margaret, J., *Musical Instruments of Indonesia: An Introductory Handbook* (exhib. cat.), Melbourne, 1985

Koojiman, S., *Ornamented Barkcloth in Indonesia*, Leiden, 1963

Leigh, Barbara, *Hands of Time: The Crafts of Aceh*, Jakarta, 1989

Lindsay, Jennifer, *Javanese Gamelan*, Singapore, 1985

Lubis, Mochtar, *Land under the Rainbow*, Singapore, 1990

Lucas, H., *Java-Masken: Der Tanz auf Einem Bein*, Kassel, 1973

Maxwell, Robin, *Textiles of Southeast Asia*, Melbourne, 1990

Muller, H. R., *Javanese Terracottas*, Lochem, the Netherlands, 1978

Munan, Heidi, *Sarawak Crafts*, Singapore, 1989

Newman, Thelma, *Contemporary Southeast Asian Arts and Crafts*, New York, 1977

Raffles, T. S., *The History of Java*, Kuala Lumpur, 1965 (1817)

Ramseyer, Urs, *The Art and Culture of Bali*, Singapore, 1977

Rodgers, Susan, *Power and Gold: Jewelry from Indonesia, Malaysia and the Philippines*, Geneva, 1985

Rubenstein, Carol, *The Honey Tree Song: Poems and Chants of Sarawak Dyaks*, Athens, Ohio, 1985

Schefold, R. (ed.), *Indonesia in Focus*, Mappel, the Netherlands, 1990

Sellato, Bernard, *Hornbill and Dragon*, Jakarta, 1989

Seltmann, F., and W. Gamper, *Stabpuppenspiel auf Java*, Zurich, 1980

Sheppard, Mubin, *A Royal Pleasure Ground: Malay Decorative Arts and Pastimes*, Singapore, 1986

Sibeth, Achim, *The Batak*, London, 1991

Slattum, Judy, *Masks of Bali*, San Francisco, 1992

Soedarsano, *Dances in Indonesia*, Jakarta, 1974

——*Wayang Wong, The State Ritual Dance Drama in the Court of Yogyakarta*, Yogyakarta, 1984

Solheim, W. G., and C. Arnold, 'Pottery Manufacture in Abar, Lake Sentani, Irian Jaya' and also Solheim, W. G., and J. Mansoben, 'Pottery Manufacture in Masinim, Manokwari', *Irian Bulletin of Irian Jaya Development*, vol. 6, no. 1, Feb. 1977

Spitzing, G., *Das Indonesische Schattenspiel: Bali, Java, Lombok*, Cologne, 1981

Stewart-Fox, D. H., *The Art of the Balinese Offering*, Jakarta, 1974

Suanda, E., *Topeng Cirebon* (MA thesis), Wesleyan University, Conn.; pub. Oakland, Ca., 1983

Sularto, B., *Topeng Madura*, Jakarta, 1970

Taylor, E., *Musical Instruments of Southeast Asia*, Singapore, 1989

Taylor, Paul M., and Lorraine Aragon, *Beyond the Java Sea: Art of Indonesia's Outer Islands*, New York, 1991

Therik, J., *Ikat in Eastern Archipelago*, Jakarta, 1989

Tillema, H. F., *A Journey among the Peoples of Borneo in Word and Picture*, Singapore, 1989 (1938)

Veenendaal, Jan, 'Seventeenth Century Furniture from V.O.C. Settlements in South Asia', *Arts of Asia*, vol. 17, no. 1, pp. 116–22, 1987

Vickers, Adrian, *Bali: A Paradise Created*, Ringwood, Victoria, 1989

Wallace, A. R., *The Malay Archipelago*, Singapore, 1989 (1869)

Ward, Philip, *Traditional Indonesian Poetry*, New York, Cambridge, 1975

Waterson, Roxana, *The Living House: An Anthropology of Architecture in Southeast Asia*, Singapore, 1990

Young, E., *Topeng in Bali* (Ph.D. thesis), University of California, San Diego, 1980

Yudoseputra, Wiyoso, *Album Keramik Tradisional*, Jakarta, 1983

Zoete, Beryl de, and Walter Spies, *Dance and Drama in Bali*, London, 1938

Zurbechen, Mary, *The Language of Balinese Shadow Theatre*, New Jersey, 1987

Guidebooks

Cummings, J., S. Forsyth, J. Noble, A. Samagalski, T. Wheeler, *Lonely Planet Travel Survival Kit to Indonesia*, Melbourne, 1990

Dalton, Bill, *The Indonesia Handbook*, Chico, Ca., 1989

Hickey, A., *The Complete Guide to Indonesia*, Singapore, 1991

Muller, K., *Indonesian Borneo, Kalimantan*, Singapore, 1990

——*East of Bali: From Lombok to Timor*, Singapore, 1991

——*Indonesian New Guinea: Irian Jaya*, Singapore, 1991

——*Spice Islands: The Moluccas*, Singapore, 1991

——*Sumatra*, Singapore, 1991

Oey, E., *Java*, Singapore, 1991

Volkman, T. and I. Caldwell, *Sulawesi*, Singapore, 1990

ACKNOWLEDGMENTS

I would like to thank the many craftworkers who graciously demonstrated their skills, museum staff in Indonesia who were most helpful and numerous people who were generous with advice and information. I am also indebted to many scholars and writers of the past and present whose books and articles provided me with data and insight that I could not have gained without their contributions.

Friends in Melbourne, Australia, kindly allowed us to photograph in their homes and borrow items from their collections. Numerals in the following list refer to plate numbers: Veronica and Christopher Hazzard of Balique Arts of Indonesia, 5, 6, 7, 8, 11, 22, 23, 32, 66, 94, 98, 106, 156; Karen Purcell of Rasa, 46, 47, 48, 50, 51, 52; Michael Sklovsky of Ishka, 82, 83, 87, 88, 89, 90, 91; Trish and Colin Boucher, 4, 39, 40, 41–3, 54, 68, 69, 128, 144, 145; John Faine, 15; Craig Haire, 151; Susan and Garry Hearst, 85; Roslyn and Louis Kusinsky, 61, 73, 76, 77, 79, 109, 137, 143, 152, 155; the Light family, 74, 78, 81, 93, 127, 138, 139, 140; Anne and Paul Marin, 57; Meredith and Michael Prideaux, 84, 89; Norman Sterling, 22; Andrew Trahair, 14; Gail and Paul Trahair, 33, 95, 130, 147. Items in the author's collection are shown in plates 1, 2, 3, 9, 10, 12, 13, 15, 16, 17, 18, 19, 20, 21, 22, 23, 24, 25, 26, 27, 28, 29, 30, 31, 33, 34, 35, 36, 37, 38, 44, 45, 49, 51, 53, 55, 56, 58, 59, 60, 61, 62, 63, 64, 65, 67, 70, 71, 72, 73, 75, 80, 86, 92, 96, 97, 99, 100, 101, 102, 103, 104, 105, 107, 108, 110, 111, 112, 113, 114, 115, 116, 117, 118, 119, 120, 121, 122, 123, 124, 125, 126, 129, 131, 132, 133, 134, 135, 136, 137, 141, 142, 143, 146, 148, 149, 150, 151, 153, 154. Rick Bennet, Bun Teo and Remi van der Weil gave much valued assistance. Cam Stuckley drafted the map of Indonesia.

I would also like to thank Monash University, Victoria, for access to their fine collection of rare and general books and pamphlets on Indonesian subjects. Old black and white photographs and illustrations were taken from the following sources: *Besuch bei den Kannibalen de Sumatra*, Joachim von Brenner, 1894; *Headhunters of Borneo*, Carl Bock, 1881; *Java*, D. M. Campbell, 1915; *Java: Facts and Fancies*, Augusta de Wit, 1905; *Java Tooneelen uit het Leven, Karakterschetsen en Kleederdragten van Java's Bewoners*, Lemercier, after Hardouin and W. L. Ritter, 1855; *Der Malayische Archipel*, H. von Rosenberg, 1878; *Nederlandsch Oost-Indie*, P. van der Lith, 1877; *Die Neerlands Indies*, H. Colijn, 1913, by courtesy of Elsevier, Amsterdam; *Vues de Java*, Woodbury and Page, 1865. Contemporary photographs were taken by the author. Indonesian literary extracts derive from the following works: p. 89 from *The History of Java*, by T. S. Raffles, Oxford University Press, Kuala Lumpur, 1965; pp. 14, 26 and 57 from *Traditional Indonesian Poetry*, translations by Philip Ward, Oleander Press, Cambridge, UK, 1975; p. 25 from *Pengap Gawai Batu*, collected and translated by Benedict Sandin, Borneo Literature Bureau, Kuching, 1968. Other Dyak poetic references were adapted from translations in *The Honey Tree Song* by Carol Rubenstein, Ohio University Press, Athens, Ohio, 1985, and the *Sarawak Museum, Kuching, Journal*, 1973 (special edition of Dyak poetry).

INDEX

Colour plate page references are given in bold type, black and white illustration pages in italic.

Aceh, north Sumatra, embroidery 94, 95, 111; metalwork 24, 29, 30, 34, 36; glossary; *see* Gayo
Alor, Nusa Tenggara 28, 49; glossary
appliqué 95
Arab traders, craftsmen 7, 13, 30, 91
aristocracies and aristocrats 13, 14, 25, 27, 27, 29, 58; *see also* royal courts
Art Nouveau 32, 58, 91
Asmat people, Irian Jaya 60, 71, 129; glossary
Austronesians 8, 41

Bali 7; bamboo 120, 123; baskets 22, 116; beading 96, 110; brass 32; carving, bone and ivory, wood, stone *frontispiece*, 19, 21, 51, 58, 62, 63, 64, 73, 79, 82, 83, 84, 85, 86, 87, 144, 145, 151; dance and drama 129, 130, 131, 134, 138, 139; fine metalwork 29, 29, 31, 32, 36, 37; iron-smithing 25, 26, 28, 34; literature 116; music 28, 114, 123, 130, 151; paintings, modern 22, 62, 63, 80, 81; paintings, traditional 62, 63, 92, 97; palm leaf manuscripts 14, 116, 122; and decorations 116, 117; pottery 42, 43, 43, 46, 48, 49, 52; textiles and costume 29, 89, 92, 94, 100, 104, 106; glossary
bark string 109, 120
barkcloth 9, 95, 109, 120
baskets 22, 23, 68, 113, 115, 116, 118, 119, 120, 121, 126, 127; and techniques 117, 118
Batak people, North Sumatra 8, 14; bamboo 114, 114, 115, 118, 124; beading 96; funerals 129; furniture 58; houses 57, 62, 114; jewelry 31, 32, 38, 39; literature 114, 118; music 61, 77; textiles 77, 92, 101; woodcarving 61, 62, 73, 77, 124; glossary
batik 9, 18, 27, 90, 91, 91, 92, 94, 98, 99, 148, 149; batik techniques 10, 15, 90, 91, 99, 149
beads and beading 9, 95, 95, 96, 101, 109, 110, 111, 150; beliefs and ceremonies 95, 96
betel (*sirih*) 21, 22, 27, 36, 58, 95, 96, 110, 111, 114, 115, 116, 124, 126; glossary
birth, babies 41, 109, 115; baby-carriers 61, 70, 95, 109
bone ornament 34, 62, 70, 75
Buddhism 7, 8, 28, 29, 30
Buginese people, Sulawesi and Kalimantan 41; plaiting 119; pottery 49; silk 93, 94, 105; glossary

ceramics, beliefs and ceremonies 41, 42; glazed 48, 49; sculptural 17, 22, 40, 42, 43, 44, 45, 46, 49, 53, 54, 55; techniques 45, 46, 47; utilitarian 42, 43, 44, 45, 46, 47, 49, 50, 51, 52
China, Chinese 7, 8, 10, 11, 13, 13, 135; motifs, influences: ceramics 47, 48; furniture 58, 59;

lacquerwork 58; metalwork 29; textile arts 8, 91, 92, 94
Christianity 8, 11, 14, 60, 61, 72, 114, 129
colour symbolism 90, 95, 134, 138
cosmological beliefs 9, 10, 11, 25, 44, 57
costume 89, 90; blankets and mantles (*selimut, hinggi*) 103, 144; blouses 89, 94, 105; feather ornament 95, 129, 134, 148, 150; hats 18, 27, 95, 112, 114, 116, 116, 118, 119, 119, 145, 150; headcloths 26, 27, 31, 44, 94; jackets 18, 26, 27, 94, 109; *kain* (waistcloth) 18, 27, 89, 94, 98, 99; *kebaya* 89, 90, 108; sarongs 89, 93, 94, 98, 101, 102, 105, 107; sashes 103; *selendang*, shawls, scarves 89, 104, 106; shoes 78; skirts 95, 110; *ulos* 77, 101; glossary
couchwork 95; glossary

dance drama 7, 11, 12, 12, 128, 129, 130, 130, 131, 131, 133, 135, 137, 138, 139, 149; Bali 131, 138; history plays, Java 19, 128, 130, 137; social dance 123; trance dance 19, 129, 130, 139; *see* Hinduism, Islam, masks
Dani people, Irian Jaya 109, 113, 120; glossary
death, funerals, tombs 8, 48, 58, 59, 109, 129
Dewi Sri, rice goddess 11, 17, 41, 42, 52, 56, 58, 67, 116, 117
Dong-Son bronze culture, motifs 8, 29, 46, 96, 114
Dutch people 8, 58, 62, 63, 91, 92
Dyak people, Kalimantan 8, 10, 11, 13, 14; architecture 57, 58, 59; bamboo 115, 116; barkcloth 109, 120; beading 95, 95, 96, 109, 150; blowpipes 113, 147; carving 16, 61, 61, 70, 95, 147; ceramics 48; costume, embroidery and textiles 11, 95, 95, 116, 118; literature 13, 25, 26, 115, 117; masks 129, 134; ironsmithing 25, 26, 27, 34, 116, 147; plaiting 116, 117, 118, 126; glossary
dyes, textile, natural 7, 10, 18, 90, 92, 98, 99, 100, 101, 102, 103, 148, 149; synthetic 91, 92, 93, 94, 149; plant fibres, natural 117; synthetic 116, 119

embroidery 18, 43, 88, 89, 90, 94, 95, 107, 108, 111; *see tapis* and couchwork
export crafts 48, 116, 120, 145

Flores, Nusa Tenggara 31, 36, 74, 116; glossary; *see* glossary Lio, Manggarai, Nage peoples
food preparation, cooking and serving 21, 34, 42, 47, 49, 50, 51, 61, 65, 72, 114, 115, 121
furniture and furniture-making 8, 14; bamboo 68, 113, 120; rattan 58, 117; wood 20, 27, 29, 49, 58, 59, 60, 61, 65, 66, 67, 69, 70, 83, 94, 144

Gayo people, Aceh 43, 51, 119; glossary

gender roles in art and craft 10, 27, 31, 41, 44, 46, 90, 92, 95, 117

head-hunting 10, 26, 34, 60, 103
Hinduism 7, 8, 11, 25, 28, 30; in drama 11, 129, 132, 133, 135, 137, 139, 140, 141, 142, 143; motifs, themes 29, 32, 35, 42, 43, 62, 97, 122
horn-carving 34, 61, 62, 72, 75, 125, 147
houses, bamboo 42, 113; wood 14, 19, 20, 43, 51, 57, 58, 59, 59, 60, 62, 79, 117

ikat 9, 74, 77, 92, 92, 93, 100, 101, 102, 103, 104, 112, 144, 146; double 93, 100; techniques 92, 92, 93, 150; warp 74, 77, 92, 101, 102, 103; weft 93, 104
illness and medicines 61, 73, 93, 100, 114, 124, 126, 129, 142
Indianization, traders 7, 8, 13, 30, 94, 135; *see also* Buddhism, Hinduism, Islam; glossary *patola*
Irian Jaya 16, 47, 113; *see also* Dani *and* Asmat
Islam 8, 11, 42, 89, 94, 119; circumcision 30, 62, 94; drama 19, 129, 134, 135, 141, 142; motifs 29, 30, 34, 59, 93; Muhammad 41, 44, 130
ivory 9, 62

Jakarta 15, 55, 76, 123, 139, 145, 146, 149, 150, 151
Java 7, 8, 11, 12, 146; bamboo and plaiting 113, 114, 117, 119, 120, 121; brass 29, 33, bronze 28, 35; dance drama 11, 12, 128, 129, 130, 130, 131, 131, 135, 137, 138, 139, 149; furniture and woodcarving 20, 49, 58, 59, 65, 66, 67, 68, 69, 144; ironsmithing 26, 34; jewelry and fine metalwork 27, 30, 31, 37; literature 13, 43, 89; music 12, 12, 28; pottery 17, 22, 40, 41-7, 49, 51, 53, 54, 55; puppets 19, 129, 132, 133, 134, 135, 136, 140, 141, 142, 143; textiles and costume 10, 27, 89, 90, 91, 91, 93, 94, 98, 99, 108; glossary; *see* Madura
jewelry 9, 24, 25, 29, 30, 31, 32, 36, 37, 38, 39; forms: anklets 29, 30; bracelets 6, 29, 30, 37, 39; belts and buckles 29, 30, 31, 36; crowns 6, 24, 29, 30, 32; earrings and studs 29, 30, 36, 37, 38; necklaces 6, 29, 30, 39; pendants 36, 37; gems and semi-precious stones 7, 26, 29, 32, 36, 37, 89; techniques 29, 30, 31; glossary

Kalimantan (Borneo) 7, 9, 13, 16, 146; Negara, South Kalimantan 29; *see* Dyak *and* Buginese
Kauer people, Lampung 75; glossary
Kayu Agung, South Sumatra 43, 50
Kris *see* weapons

lace 89, 94, 107, 108

lacquerwork 58, **73**, 119, **121**
Lampung, Sumatra, textiles 6, **22**, 75, **94**, **107**; glossary Paminggir
Lembata island, Nusa Tenggara **101**; glossary
lime *see* betel
Lombok, Nusa Tenggara, and Sasak people, carving 62, **65**, **69**, 75, **78**, **125**; drama **129**; ironsmithing **34**; plaiting and basketry **19**, **23**, 118, **126**, **127**; pottery 42, 44, 48, **49**, 51; puppetry **134**; glossary Sasak
looms and weaving *11*, 92, 93, 94, **102**; supplementary warp **103**; supplementary weft 77, **101**; glossary
loro blonyo 17, 42, 56, 67

Madura island, Java **115**; basketry **121**; batik *15*; carving **21**, **78**, **121**, **125**; drama 131, *135*, **137**; furniture 59, 60, **66**, **67**; glossary
Majapahit empire 8, 28, 43, 44, **134**
Makassar, Sulawesi, also Ujung Pandang, jewelry 30; pottery **49**; silk 93, **94**; glossary
Maluku 9, 16, **146**; baskets **113**; carving 60, **71**; jewelry **36**; pottery 41, 46, **47**; shellwork **62**; textiles **92**; *see* glossary Tanimbar
markets 27, 46, **146**
marriage 10, 30, 31; beds 58, 59, **67**, **88**; jewelry 14, 24, 30, 31, **36**, **37**, **39**; plaiting **109**, **117**, 118, **119**; pottery **41**; textiles, beading and costume 18, **30**, **31**, **88**, **94**, **95**, **101**, **110**, **111**
masks and mask making **19**, **86**, 128, **129**, 130, 131, *131*, *133*, 135, **137**, 138, *139*, *149*; beliefs and ceremonies 10, **131**; techniques **131**
matting and techniques 58, **116**, **117**, *118*, 119, **126**
Megalithic culture 8, 58
metals and metallurgy, beliefs and ceremonies 25, 31; brasswork 29, 32, **33**; bronze 28, **35**; coppersmithing *10*, 24, 31; gold and silversmithing 29, **30**, 31, 32, **148**; *see* jewelry; ironsmithing 25, 26, 27, **34**; lost-wax technique 28, 29, 31, 32, **35**, **36**, **37**; musical instruments *12*, 28, 29; sculptures 28, **35**
Minangkabau people, West Sumatra, bamboo and plaiting **114**, 118, **126**; brasswork 29; carving 60; houses 57, 59, 60; jewelry 30, 30, 31, **37**; literature 57; pottery 45, **50**; textiles and costume 30, 31, **88**, **94**, 106, **107**, **152**; glossary
Mogul empire, influences of 8, 29, 58, **94**
mother of pearl **62**
museums 146, 152
music 7, *12*, *12*, *13*; musical instruments **16**, 28, 31, 61, 77, 114, 116, **123**, *131*, *133*, **151**

Ndao island, Nusa Tenggara, jewelers 31
Nias island, Sumatra, appliqué 95; architecture 58; jewelry 25; literature 14; furniture 58; woodcarving *10*, *11*, **21**, 60; glossary
Nusa Tenggara 8, 9, 10, 14, 31, 89, 92, 95, 115, 116, **146**; *see* Alor, Flores, Lembata, Lombok, Ndao, Roti, Savu, Sumba, Timor

Ottoman empire, influences 29, 94

paintings, batik 91, 92; modern, Bali 22, 62, 63, 64, **80**, **81**; traditional, Bali 62, 63, 92, **97**
Palembang, Sumatra 8; lacquerware 58, **73**, 119, **121**; plaiting 119; pottery 43, **50**; textiles 93, 94, **104**; *see* glossary South Sumatra
palm leaf manuscripts 14, **116**, **122**; decorations 26, 116, *117*
pastimes, birds and pets 16, 53, 59, 69, **123**; cock fights 28, 32, **113**; toys and games 16, 43, 44, 55, **76**, **86**, **87**, 113, 117, 130, *133*, **138**, **151**
pedlars 64, 76, 114, 117, 130, *133*, **138**, **151**
perada 92
plants, products and fibres, bamboo 23, 42, 68, 113, 114, *114*, 115, *115*, 116, 117, 120, **123**, **124**, **127**; bark 9, 23, 95, **109**, 118, 120, **127**; coconuts 113, **125**, **144**; *doyo* leaves 118; gourds 113, **125**, **147**; *lontar* palms 22, **115**, 116, **122**, **123**; orchid fibre **109**, **120**; pandanus (screw pine) 113, 118, **119**; rattan (*rotan*) 19, 58, *115*, 116, 117, 118, 120, **121**, **126**; *see* bark string, barkcloth, baskets, furniture, houses, matting, palm leaf manuscripts and decorations
Portuguese people 8, 58, **116**
puppets, theatre 12, *133*; beliefs and ceremonies 11, **136**; *wayang golek* (rod or doll puppets) **19**, *133*; narratives **135**; techniques for making 136, **141**, **142**, **143**; *wayang klitik* (flat wooden puppets) 134, **135**; *wayang kulit* (leather shadow puppets) 20, 22, **140**; narratives **132**; performances 132, *133*, *133*, **136**; technique of manufacture **134**

Ratu Kidul, goddess of the southern ocean 11, 53, **64**
Roti, Nusa Tenggara 116, **123**; glossary
royal courts 7, *12*, *12*, 13, 25, 26, 31, 32, 53, 89, 90, 94, **130**

Savu, Nusa Tenggara, ironsmithing **34**; pottery **49**; textiles **102**; glossary
silk weaving 89, 93, **94**, **104**, **105**
silkscreening 92
shell ornament 9, 23, **34**, 44, 51, 62, 70, 95, 95, **109**, **110**
Solo *see* Surakarta
songket 30, 31, **94**, 106, **148**, **152**; glossary

stone-carving *frontispiece*, 8, **63**
Sulawesi 7, 26, 30, **120**; Central Sulawesi, barkcloth **120**; Kendari, Ujung Pandang, metalwork 30; Gerontalo, North Sulawesi, costume and metalwork 26; *see* Buginese, Makassar, Toraja *and* glossary
Sumatra *see* Aceh, Batak, Gayo, Lampung, Minangkabau, Palembang; glossary
Sumba, Nusa Tenggara 8, 11, 13, **152**; beading 95, **110**; ironsmithing **34**; jewelry 31, **36**, **37**; pottery **50**; textiles 13, 14, **103**, **144**; wood, shell and bone-carving 22, **34**, 62, **74**, 75; glossary
Surakarta (Solo), Java 18, 26, 28, 44, 55, 90, 93, **98**, 130, **140**

tapis embroidery 6, **22**, 75, **94**, **107**
teeth, tusks as ornament 95, 70, **109**, *148*
textiles, beliefs and ceremonies 10, 11, 31, 89, 92, 93; selecting and caring for textiles 148, 149, 150; *see* appliqué, bark string, barkcloth, batik, dyes, embroidery, ikat, lace, looms and weaving, *perada*, silk weaving, silkscreening, *songket*, *tapis*, tie-dyeing, glossary
tie-dyeing (*pelangi* and *tritik*) 93, **104**
Timor, Nusa Tenggara, bamboo 114, **124**; beading 95, **96**, **110**, **111**; carving 22, 57, 62, **72**; houses 57; jewelry **36**, **37**; plaiting 22, **115**, 116, **126**; pottery 41, 46, **49**, **50**; textiles 90, 92, **102**, **103**; *see* glossary Atoni, Belu (Tetum) peoples
tobacco equipment 27, 32, **36**, **78**
tortoiseshell 62
Toraja people, Sulawesi 8, 13, **92**; bamboo and plaiting **112**, **114**; beading **96**, **111**; carving 60, 61, 62, **72**; fine metalwork **36**, **96**, **111**; houses 57; ironsmithing 25, **62**; textiles **112**; glossary
tourism 14, 15, 61, 62, 117, **145**
trade, early 7, 8, 9, 41

weapons, blowpipes 113, **147**, glossary Dyak; cutlasses (*parang*) 26, 27, **34**, 116, **147**; daggers (kris and *rencong*) 11, 25, 26, 26, 27, 30, 31, 32, **34**; *see* metals
wood, woodcarving, beliefs and ceremonies 10, 11, 57, 117, **131**; sculptures *10*, *11*, **21**, **22**, 56, 60, 61, *61*, 62, 63, 64, **71**, **73**, 79, **82**, **84**, **85**, **86**, **87**; utilitarian items 16, 21, 60, 61, 62, 69, 70, 72, 73, **74**, 75, 77, *78*, *115*; *see* houses, furniture
Western fashions and popular culture 13, 15, 64, 92, 96

Yogyakarta, Java 17, 18, 26, 31, 44, 53, 56, 90, **99**, 128, 130, 135, **140**